THE PRINCES OF GERMANY

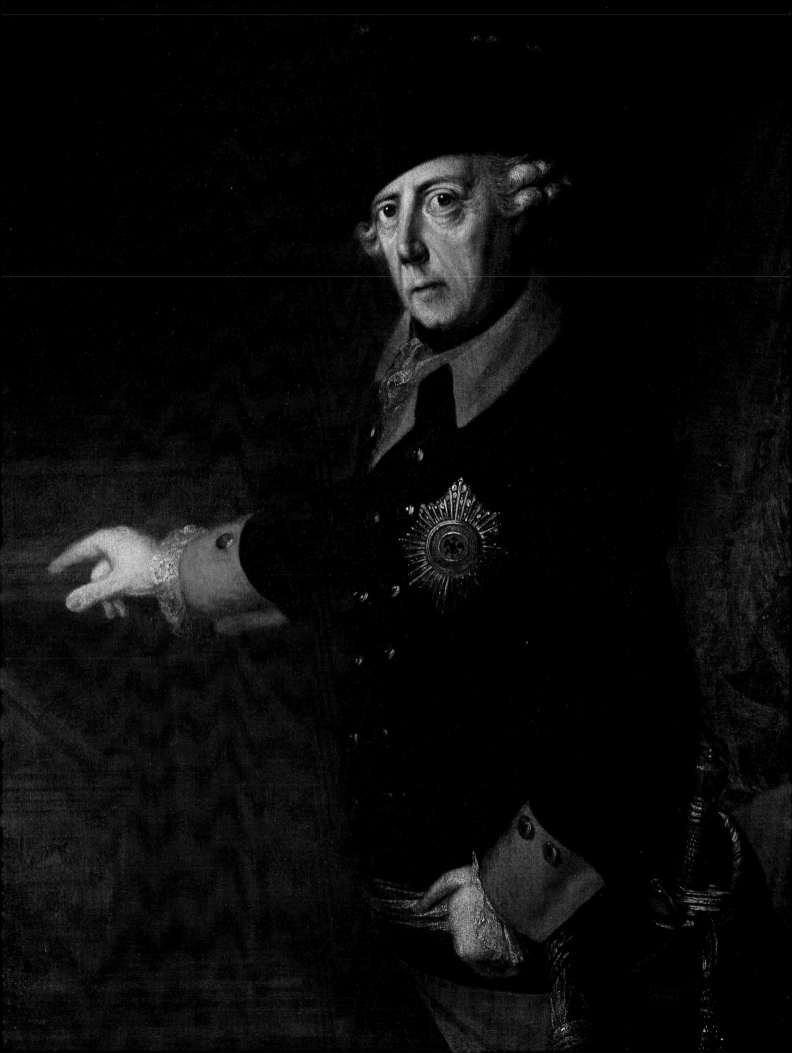

THE PRINCES OF GERMANY

by

Frederic V. Grunfeld

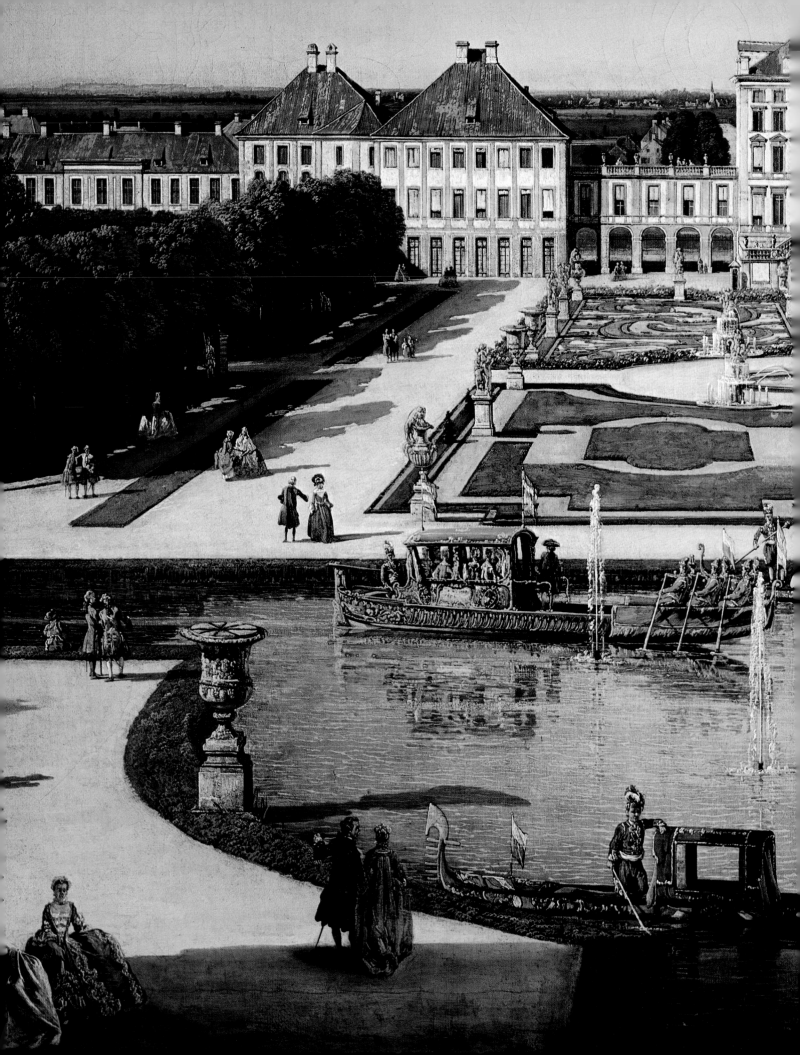

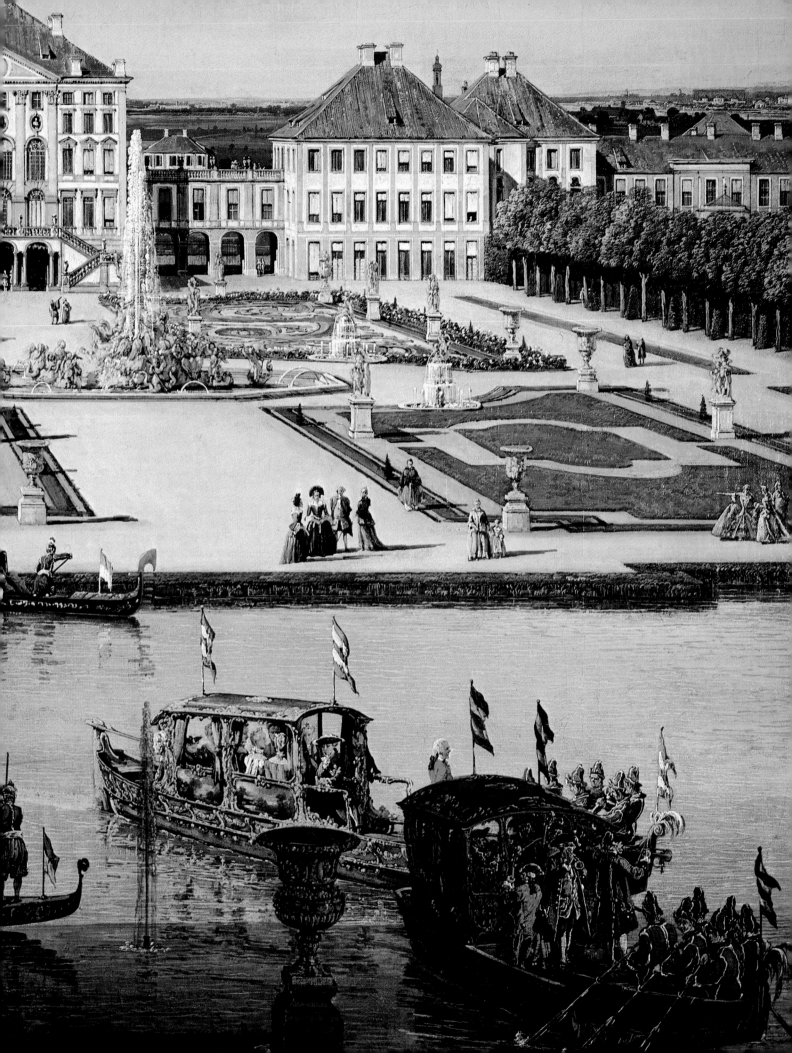

Treasures of the World was created by
Tree Communications, Inc.
and published by Stonehenge Press Inc.

TREE COMMUNICATIONS, INC.

PRESIDENT
Rodney Friedman

PUBLISHER
Bruce Michel

VICE PRESIDENTS
Ronald Gross
Paul Levin

EDITOR
Charles L. Mee, Jr.

EXECUTIVE EDITOR
Shirley Tomkievicz

ASSISTANT EXECUTIVE EDITOR
Henry Wiencek

ART DIRECTOR
Sara Burris

PICTURE EDITOR
Mary Zuazua Jenkins

TEXT EDITOR
Thomas Dickey

ASSOCIATE EDITORS
Vance Muse Artelia Court

ASSISTANT ART DIRECTOR
Carole Muller

ASSISTANT PICTURE EDITORS
Deborah Bull Carol Gaskin
Charlie Holland Linda Silvestri Sykes

MANAGING EDITOR
Fredrica A. Harvey

ASSISTANT COPY EDITOR
Cynthia Villani

PRODUCTION MANAGER
Peter Sparber

EDITORIAL ASSISTANTS
Carol Epstein Martha Tippin
Holly McLennan Wheelwright

FOREIGN RESEARCHERS
Rosemary Burgis (London) Karen Denk (Munich)
Bianca Spantigati Gabbrielli (Rome) Patricia Hanna (Madrid)
Alice Jugie (Paris) Traudl Lessing (Vienna)
Dee Pattee (Munich) Brigitte Rückriegel (Bonn)
Simonetta Toraldo (Rome)

CONSULTING EDITOR
Joseph J. Thorndike, Jr.

STONEHENGE PRESS INC.

PUBLISHER
John Canova

EDITOR
Ezra Bowen

RESEARCHER
Eric Schurenberg

ADMINISTRATIVE ASSISTANT
Elizabeth Noll

THE AUTHOR: Frederic V. Grunfeld's best-known work is *Prophets Without Honor, A Background to Freud, Kafka, Einstein, and Their World.* He is also the author of many articles for *Horizon* on the music, history, and art of Europe.

CONSULTANT FOR THIS BOOK: *Helmut Nickel,* formerly curatorial assistant at the Staatliche Museen in West Berlin, is the curator of the Department of Arms and Armor at the Metropolitan Museum of Art in New York.

First Printing.
Published simultaneously in Canada.
Library of Congress catalogue card number 82-61025
ISBN 0-86706-086-7
ISBN 0-86706-087-5 (lib. bdg.)
ISBN 0-86706-088-3 (retail ed.)
STONEHENGE with its design is a registered trademark of Stonehenge Press Inc.
Printed in U.S.A. by R.R. Donnelley & Sons.
For reader information about any Stonehenge book, please write: Reader Information/
Stonehenge Press Inc./303 East Ohio Street/Chicago, Illinois 60611.

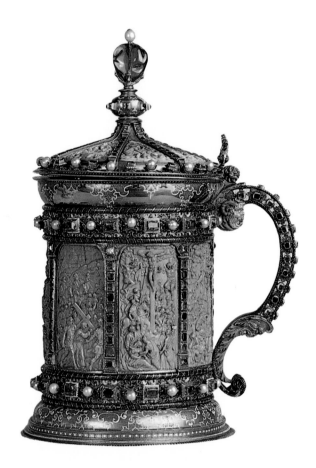

COVER: *This royal lion pendant of sixteenth-century Germany, wearing a collar of diamonds and a crown of rubies and tiny pearls, grasps a circlet of emeralds.*

TITLE PAGE: *Frederick the Great, the military genius who ruled Prussia from 1740 to 1786, stands proudly in a regular officer's coat (he disdained kingly garments) and wears the badge of the Prussian order of the Black Eagle.*

OVERLEAF: *Pleasure boating was a princely pastime in the summer on the waters at Nymphenburg palace in Munich. The palace, with its parks and pavilions, was built about 1664 as a residence for the Wittelsbach family—the ruling dukes of Bavaria.*

ABOVE: *Scenes carved in relief on narwhal ivory insets tell the life of Christ on the gold tankard above—bedecked with pearls, diamonds, and emeralds—made for Duke Albert V of Bavaria in 1572.*

CONTENTS

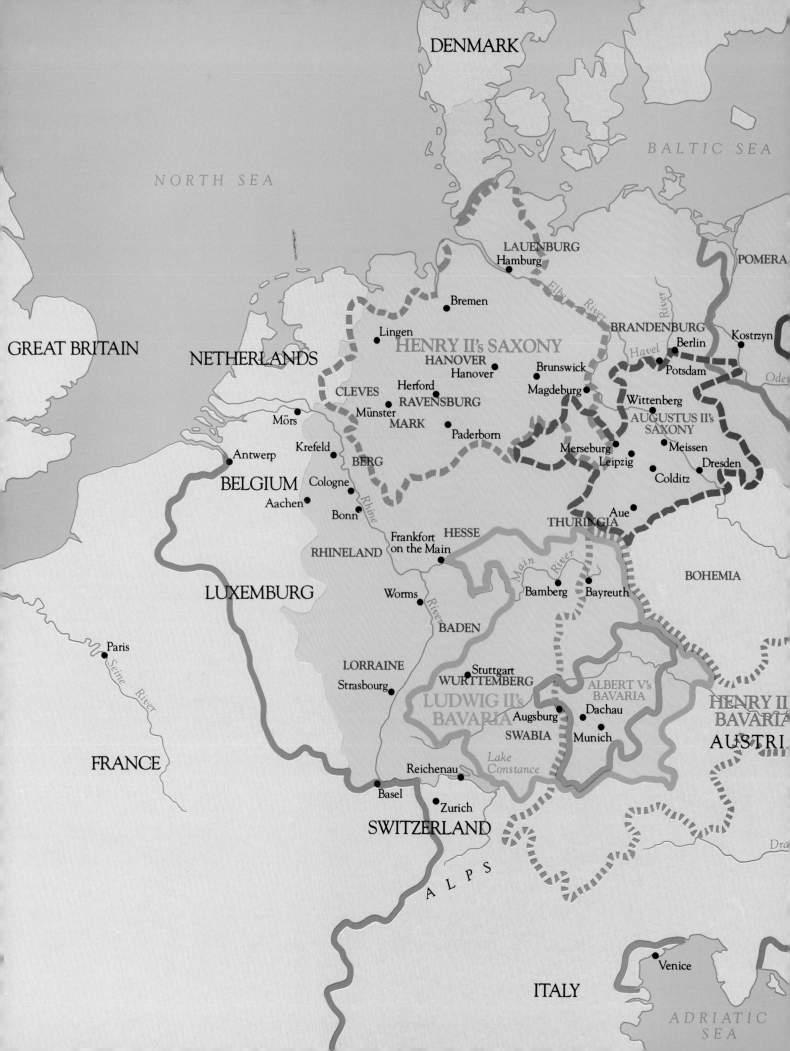

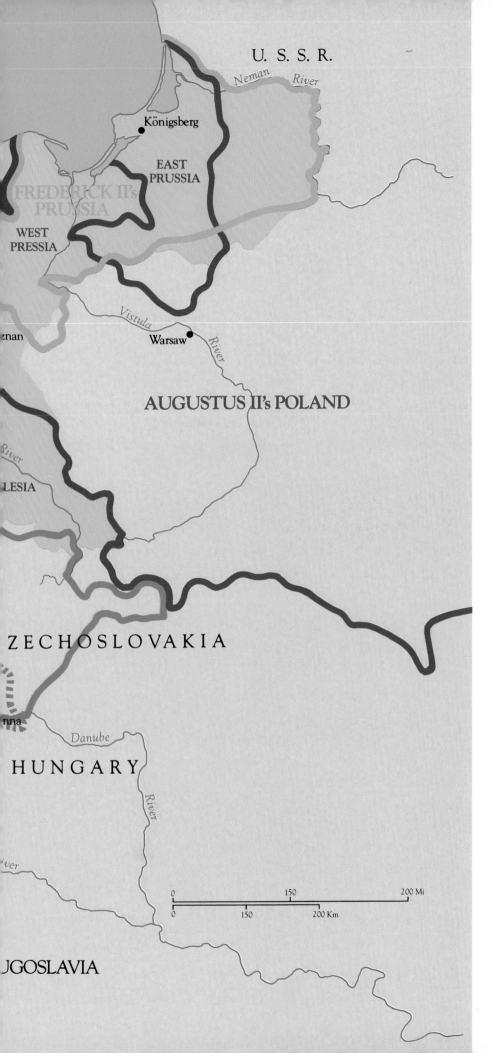

U. S. R.

Neman River

Königsberg

EAST
PRUSSIA

FREDERICK II's
PRUSSIA

WEST
PRESSIA

Vistula

znan

Warsaw

River

AUGUSTUS II's POLAND

River

LESIA

ZECHOSLOVAKIA

nna

Danube

HUNGARY

River

0 150 200 Mi
0 150 200 Km

JGOSLAVIA

Germany

Before 1871, when the Prussian statesman Otto von Bismarck forged it into a unified nation, Germany was a patchwork of numerous realms with ever-changing political roles and geographical boundaries. The princes of this book ruled various parts of Germany between the eleventh and nineteenth centuries. The dates and color codes below correspond to the colors on the map showing the dominions of Henry II, Albert V, Augustus II, Frederick II, and Ludwig II. The Holy Roman Empire, which extended deep into Italy to Rome, is outlined in red, and nineteenth-century Germany is tan.

Henry II's Holy Roman Empire 1002-1024
Henry II's Saxony 1002-1024
Henry II's Bavaria 995-1024
Albert V's Bavaria 1560
Augustus II's Poland 1721
Augustus II's Saxony 1721
Frederick II's Prussia c. 1786
Ludwig II's Bavaria 1866
Germany 1871

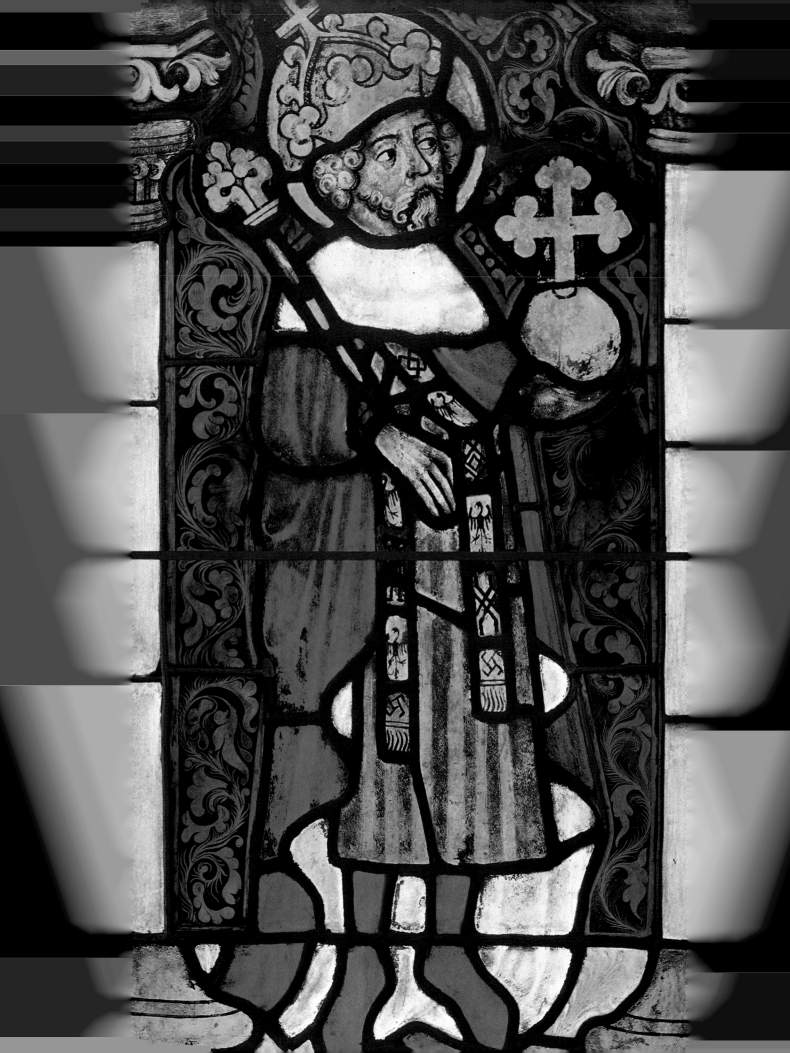

I

A SAINT ON THE THRONE

EMPEROR HENRY II

An old monkish chronicle relates a legend of the emperor Henry II that was an oft-told tale in medieval Germany. On the night of the emperor's death, a great debate raged between the angels from heaven and the devils from hell as to who should have the right to take his soul. Finally, after much dispute, they agreed to settle the issue by weighing all of Henry's deeds in a balance—the good deeds to go onto one side of the balance, the bad deeds onto the other. Just as the accumulated bad deeds began to tip the scales, Saint Lawrence came rushing up and flung a golden chalice onto the pan holding the good deeds, which went down like a plummet and thus saved the emperor's soul for the heavenly host. The golden chalice was the one that Henry had donated to the basilica of St. Lawrence in Merseburg—one of his many splendid gifts to the Church. But Saint Lawrence had flung the chalice in such haste that, after tipping the scales in Henry's favor, it fell to the ground and lost a handle—or one of the devils may have torn it off in chagrin. At any rate, anyone can verify this story by going to

Henry II's stained-glass halo, liturgical stole, crown, scepter, and orb betoken his rise from duke to king to Holy Roman Emperor, and finally to saint.

Merseburg, where the guardian of the basilica will display the golden chalice with the missing handle.

Such legends usually contain a kernel of truth: in this case the truth is that, although Henry committed his share of errors and misdeeds, he was a generous patron and supporter of the Church at a critical time in the evolving relationship between the prelates of the Church and the lords of the castles. His reign began in the year 1002, when nothing was settled in medieval Germany—neither the realm's frontiers with other nations, nor its internal political divisions, nor yet its social and religious institutions. The various inhabitants of the region had recently begun to speak of themselves as *deutsch*, "German," to indicate a common linguistic bond that transcended tribal differences; but the German nobles resisted any strong central authority. In the face of this opposition, Henry cannily used the Church to enhance his power. He appointed bishops loyal to himself, then enlarged the domains they had under their spiritual jurisdiction, and gave them political power in those lands. But even with the support of the bishops, Henry's grip on Germany's contentious nobles was never completely secure.

A thousand years earlier the Romans had tried to establish a colony in Germany, but with scant success. Though the Romans extended their sway to the Lowlands, southern Britain, and what are now France, Bavaria, and Austria, they were unable to conquer the fierce German tribesmen who inhabited the region between the Rhine and the Elbe. When the Roman emperor Octavian sent one of his armies to extend Rome's boundaries beyond the Rhine, the result was a bloody massacre of legendary proportions that took place in A.D. 9 in the Teutoburg Forest, in lower Saxony. Under the formidable chieftain Arminius, who is known in German legend as Hermann der Cherusker, a horde of Cherusci and other tribesmen wiped out three Roman legions, or about twenty thousand troops. To this day one of the German army's favorite drinking songs is a lusty ballad that pours derision on the Romans for having had the temerity to set foot in Teutoburg.

The Romans had to content themselves with setting up a chain of

Hunched over their desks, two monks copy manuscripts in a scriptorium, or writing shop. Many eleventh-century monasteries produced handwritten copies of the Bible and liturgical works, often embellished with brilliant painting meant to charm the eye and thus help spread the word of God.

forts and towns along the banks of the Rhine, starting at a point near Bonna—later the town of Bonn—and reaching some three hundred miles southeast to the Danube. For over four centuries the Romans remained behind this frontier, as the tribes of northern Germany, their populations ever increasing, restively moved across the land searching for new pastures for their livestock and new fields for adventure and conquest. Intermittently they breached the Roman fortifications in brief but devastating raids; more often they warred with each other.

The subjugation of these warrior peoples was finally achieved by a closely knit group of other Germanic tribes, the Franks, who took over much of western Europe from the Romans as their Empire collapsed. Charlemagne, the Frankish king who was crowned emperor of the West in A.D. 800, regarded himself as the lineal successor to the caesars of Rome.

Charlemagne's armies were accustomed to winning quick victories, but it took him thirty-three years of warfare to subdue the Saxons, a proud pagan tribe of farmers and seafarers who had been the scourge of northern Europe, especially Britain. Only then did the Saxons accept a modicum of civic discipline along with the rudiments of Christianity. And when the Frankish empire disintegrated, a Saxon duke, Henry I—surnamed the Fowler—picked up the pieces. After Charlemagne died, in 814, his Empire fell apart; in Germany four great tribal duchies emerged—Saxony, Bavaria, Franconia, and Swabia. Various lords contended for control of Lorraine, a fifth duchy west of the Rhine, but ultimately Henry the Fowler secured the loyalty of Lorraine's duke by giving him the hand of his daughter in marriage.

Henry the Fowler was crowned king of the Germans in 919, at a time when a new and seemingly invincible threat had appeared in the southeast. The pagan Magyars, based in Hungary but originally from central Asia, came pouring into Saxony and the Saxon-dominated lands of Thuringia on their swift, wiry horses, killing and plundering with impunity. The Saxons, used to fighting on foot, had no defensive tactics against cavalry. But Henry the Fowler used a

TEXT CONTINUED ON PAGE 18

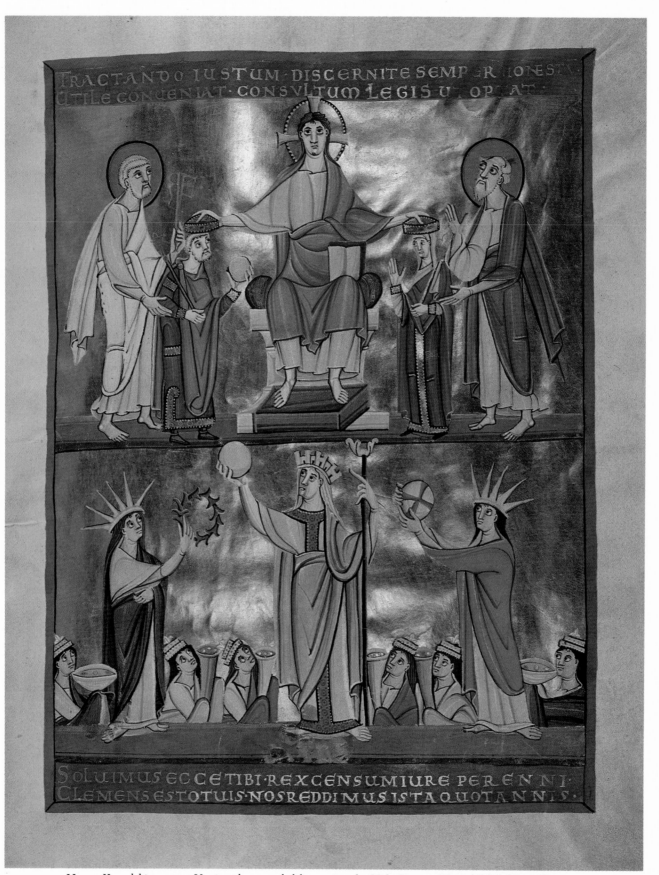

Henry II and his queen, Kunigunde, attended by Saint Peter and Saint Paul, are crowned by a beardless Christ in the upper half of this page from Henry's pericope. In the lower panel three women symboliz-ing the Holy Roman Empire hold aloft emblems of kingship, as others below offer gifts. With this dedicatory page, the monastic artists honored their royal patron and depicted his fealty to the divine sovereign.

HENRY'S
GOLDEN TOME

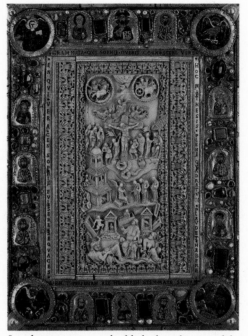

*Jewels, portraits, and gilded silver frame a deli-
cate ivory panel on the pericope's cover, depicting
Christ's crucifixion and resurrection.*

Books were still rare and precious objects in the eleventh century, found only in the hands of the wealthy and powerful. As king of Germany, Henry II indeed possessed wealth and power and was famed for his piety as well—he would be sainted by the Roman Catholic Church a century after his death. In 1002, Henry ordered a magnificently bound and illuminated pericope—a compilation of biblical texts—as a gift for a cathedral.

To make the book Henry turned to the Benedictine abbey at Reichenau, one of the premier religious centers of Germany, which had been producing fine manuscripts for over a century. The monks of Reichenau labored for years on Henry's book, which turned out to be one of the peaks of the abbey's artistic achievement.

Heavily outlined in black and painted in bold colors, the figures on the pericope's pages, of which three are shown on pages 14–17, stand against gold backgrounds. The illuminators painted on parchment—polished animal skins—using vegetable dyes and affixing the gold with a thin adhesive. By their craft and vision, the monks created biblical characters as bold as actors in a passion play, large hands emphatically clutching or reaching, robed bodies twisting and bending to evoke vividly the stories of Christ's life. With this combination of stark simplicity and fervid expressiveness, the Reichenau monks made Henry's jeweled pericope a wonderful masterpiece of medieval art.

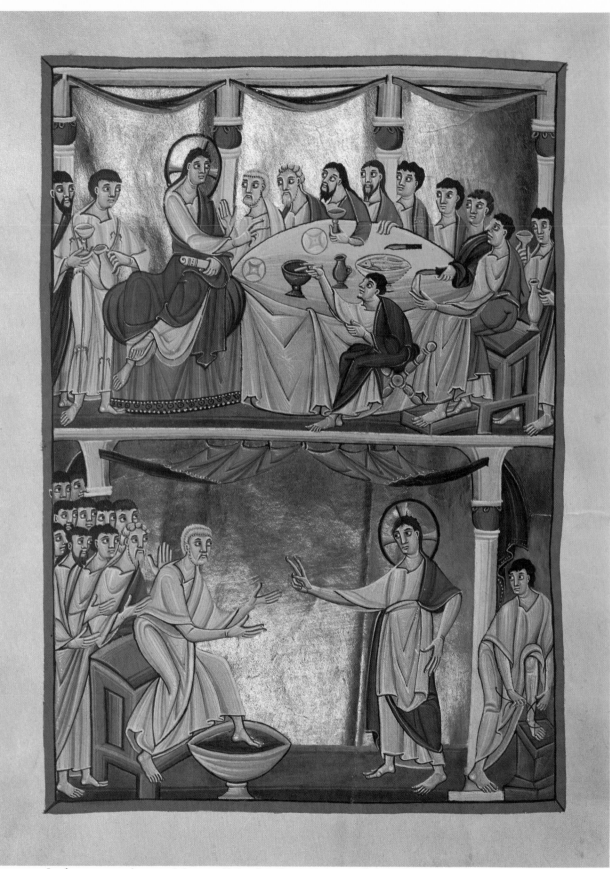

In the scene on the top of this panel, the disciples listen intently as Christ speaks to them at the Last Supper, on the night before he was crucified. Judas, the disciple who would betray Christ later that night, gestures to him in the foreground. In the bottom scene Christ prepares to wash Saint Peter's feet during the Last Supper, as the disciple at right removes his sandals in anticipation of his turn.

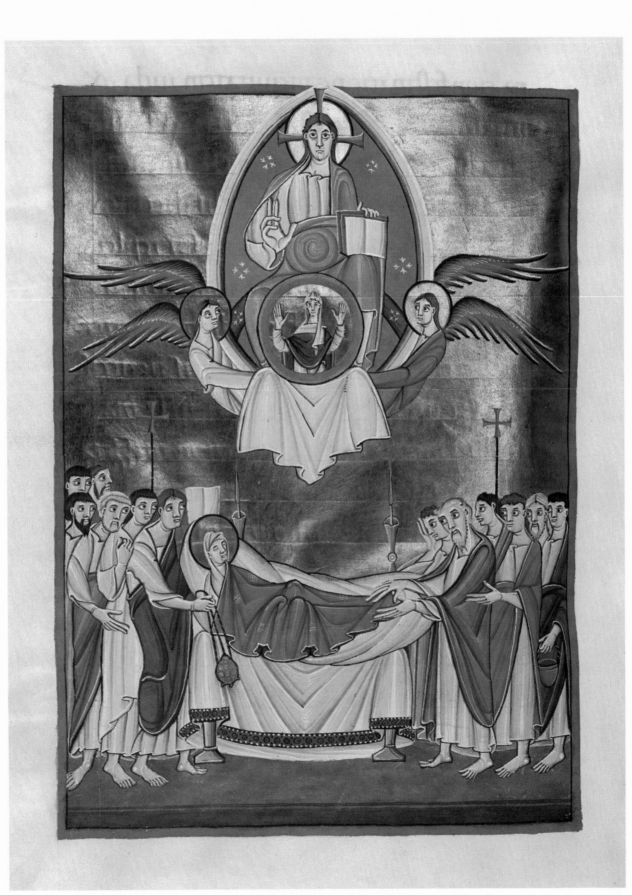

Long-winged angels raise the mother of Christ into heaven in a scene based on the traditional Roman Catholic belief that Mary was assumed—taken up, body and soul—into heaven before or shortly after she died. In the foreground Mary lies on a bed near death, surrounded by anxious disciples, just before her assumption. Writing from the reverse of the page shows through the golden background.

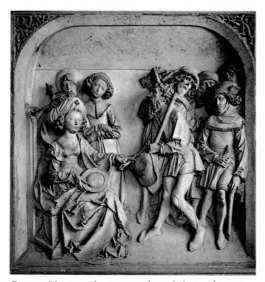

Queen Kunigunde is seated at left in this stone carving that illustrates one of the legends about her superhuman virtue, for she was Henry's partner in good works as well as in life. When she pays a group of workmen, above, one takes more than his share of coins, which then turn into hot coals in his hand.

TEXT CONTINUED FROM PAGE 13

brief period of truce to organize a cavalry of his own, and, when the Magyars launched their next raiding expedition, his carefully prepared army all but wiped out the invaders. A generation passed before they attempted another large-scale incursion, in 955, only to be defeated just as decisively by the Fowler's son and heir, Otto I.

This warrior-king was to go down in history as Otto the Great, partly because he revived the idea that, as successors to Charlemagne, the rulers of Germany were also Roman caesars. In 951 he conquered northern Italy and eleven years later marched an army to Rome, where he received an imperial crown from Pope John XII. His son and grandson, Otto II and Otto III, followed his example; henceforth, the German kings claimed the right to coronation by the pope in Rome. The German kings exercised no power over Rome itself; nor did the so-called Holy Roman Empire of the German Nation ever have more than nominal control over other European nations. Nevertheless, the idea of this shadowy Empire exerted an abiding fascination on German and Austrian monarchs, for it served to throw a cloak of unity over the fractious assortment of petty states and principalities into which Germany was divided for most of the next nine hundred years.

Otto III, the last of the Ottonian dynasty, was crowned Holy Roman Emperor when he was not yet sixteen, in 996, and died at twenty-two during a pointless, ill-starred campaign in central Italy. In the absence of a direct heir, a distant Bavarian cousin succeeded to the throne as Henry II. The new king was seven years older and a good deal wiser than his predecessor. Henry realized from the first that campaigning in Italy could only distract him dangerously from the main task at hand—consolidating his power in Germany itself. The Ottonians had talked of restoring the glories of the Roman Empire; Henry made it clear that his priorities were simpler and closer to home. For his royal seal he chose the motto *Renovatio regni Francorum,* serving notice on his subjects that his primary intention was to "restore the Frankish kingdom"—a far more attainable goal.

Henry's immediate problem was to achieve a semblance of harmony among the dissonant chorus of German dukes and counts and

to secure his borders against attack, particularly the vulnerable eastern frontier along the Elbe. These two concerns run through German history as a recurrent theme. Subsequent centuries brought Germany a seemingly unending cycle of strife and disunity at home, accompanied by countless wars, or threats of war, along the borders.

Henry was, in name at least, the sovereign of all the Germans, in a realm that stretched from the Rhine to the Elbe, from the Alps to the North Sea. To rule and defend its diverse collection of dukedoms and countships required a great deal of flexibility and a willingness to deal with the various tribes and nations on their own terms. But tact and diplomacy were Henry's strong points. His subjects and allies respected his authority to the same degree that Henry respected their traditions.

In 1002, after some but not all of the great German lords had confirmed his right to be their king, Henry made a special journey to Merseburg to meet an assembly of Saxon holdouts. Though Saxon blood ran in Henry's veins, he had been born and raised a Bavarian—and hence was deeply suspect to the fiercely independent Saxons. Henry dispelled their misgivings, however, by assuring them that, as king, he would do nothing to tamper with their traditional rights and prerogatives. "I appear here in this royal dignity by your invitation and your consent," he told the nobles. "I pledge myself not in any point to corrupt your law, but to fulfill it clemently in all respects while I live." Whereupon, as one of Henry's chroniclers relates, Bernard, duke of Saxony, handed Henry a thing more precious than a scepter—the sacred lance of the Saxons—and "on behalf of the whole assembly, loyally entrusted the care of the kingdom to him."

Henry's new wand of office was a miracle-working lance that Henry the Fowler, his great-grandfather, had acquired from Rudolf I of Burgundy in 935. Enclosed in its iron point was a nail thought to be from the true cross on which Christ had been crucified. Saint Helena, the discoverer of the remains of the true cross, was said to have brought the lance to her son the Roman emperor Constantine the Great, who in the fourth century made Christianity a lawful

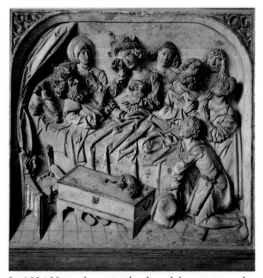

In 1024 Henry lies near death with his crown on his head and his sorrowing queen and friends at his bedside. After he died Kunigunde kept the crown and nominal control of the Empire for two months, until Conrad II was elected king. She renounced her imperial interests, then, to live modestly as a nun. She was canonized in 1200.

religion. In the hands of the German emperors, the lance symbolized their claims to Italy and their right of succession to the Empire of the Roman caesars. In 1014 Henry received the emblem of that imperial power—the glittering crown of the Holy Roman Empire. Originally fashioned for the coronation of Emperor Otto I in 962, the crown was an octagon of pure gold almost entirely covered with gems. A cross and a delicate arch, trimmed with small pearls, surmounted the crown, which Pope Benedict VIII laid upon Henry's head in Rome.

Though Henry could command fealty and obedience, not all the powerful lords were willing to obey his orders. Throughout the twenty-two years of his reign, a few of the nobles were always in open rebellion against their liege lord. They fought one another in bloody feuds that took precedence over Henry's royal edict that there must be peace in the land. They took up arms against Henry for territory or prestige; they defied his wishes in marital matters. One lord abducted his bride (with her connivance) rather than wait for Henry's permission to marry her. Four of Henry's own brothers-in-law launched a small-scale civil war against him.

Henry could not even rely upon the lords of the Church to keep the peace. He had granted bishops and archbishops civil powers comparable to those of counts and dukes and allowed them to maintain small armies. Inevitably the prelates found opportunities to use these armies—sometimes against other bishops, more often against predatory nobles. Ongoing feuds between "families" of monks sometimes erupted into violent clashes. Henry had to intercede in a number of these conflicts, but he had superb talents as an arbitrator and knew how to resolve them in such a way that both sides came away reasonably satisfied. He won his vassals' respect as a judge and peacemaker and forced nobles to end their bitter feuds by bestowing on each other a formal kiss of peace.

Like other medieval rulers Henry had no fixed capital but traveled from place to place administering justice. In Zurich he held a colloquy at which he required all men, from the least to the greatest, to swear to keep the peace and put down theft. In Merseburg he enjoined the nobles to maintain peace for at least five years. In

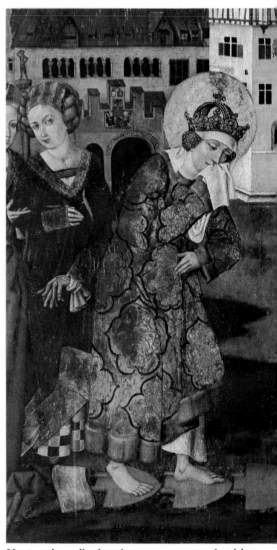

Kunigunde walks barefoot over a row of red-hot plowshares, her witnesses a crowd of murmuring nobles and ladies. According to legend, superstitious gossips accused her of having sexual relations with the devil, and the queen offered to prove her virtue in this trial by fire. She emerged unscathed.

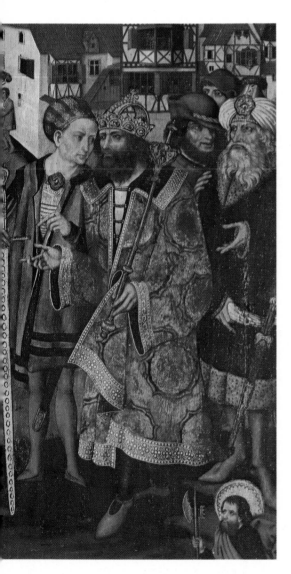

Strasbourg he decreed that any man who killed another during a truce, or after the kiss of peace had been given, should lose the hand that had held the weapon.

It was an age when men were accustomed to spilling blood at the slightest provocation. On Henry's return journey from his meeting with the Saxon lords at Merseburg, for example, his Bavarian retainers caused an uproar at Paderborn when they tried to steal some grain from a Saxon farmer. The farmer and his friends took up their weapons and chased the Bavarians into a courtyard, where they killed one of the king's men with a lance thrust. Henry had to step in personally to restore order: he decided to let the farmers go and to punish his own retainers, who had already gained notoriety for their larcenous habits. "These Bavarians are insatiable in their greed," commented the chronicler Thietmar of Merseburg. "At home they have to content themselves with the little they have; abroad there is no end to their avarice."

This incident would not have been worthy of mention in a royal chronicle, except that it happened to spoil the atmosphere at the coronation of Henry's queen, Kunigunde, which took place at Paderborn that very day—August 10, 1002. She was one of the daughters of the count of Luxemburg and a niece of the duke of Upper Lorraine. Henry was very much in love with her—"for we two are of one flesh," as he says in one of his letters. When he was not in the field with his army, Henry and Kunigunde would lead a life of courtly pleasures as circuit-riding sovereigns. They visited the great market towns during the folk festivals, which Henry loved to watch, with their musicians, jugglers, and wandering tellers of tales. These minstrels sang songs in praise of the royal couple and spread the news of this shrewd, valorous king throughout the whole of Germany, for ballads were the newspapers of the day.

The royal marriage proved to be childless, and Henry thus became the first and last of the eleventh-century dukes of Bavaria to be crowned Holy Roman Emperor. As he had "given up hope of ever having children," Henry told a council of bishops in Frankfort he had decided to make God his heir: he would found a new episcopal

see in the city of Bamberg and build a splendid cathedral there. To do so he needed the consent of the council, since it would mean redrawing some of the existing Church boundaries and depriving two adjoining sees of some of their lands. During his address, Henry fell to his knees several times before the assembled lords spiritual—and they could not find it in their hearts to refuse him.

Bamberg had long been one of Henry's favorite towns; he had given it to Kunigunde as a present on the morning of their wedding. Now it became a beehive of building activity. Its energetic prelates began to convert the neighboring Slavonic tribes from paganism to Christianity and to create new agricultural settlements. Thus, the churchmen helped transform one of Henry's more vulnerable frontiers into a prosperous farming region whose tithes swelled the coffers of both Church and crown.

Most probably Henry had had this on his mind all along; it was part of his plan for "restoring a Frankish kingdom" that would serve his successors as a more solid base for empire. He was a pragmatist, after all, who regarded the Church as an economic as well as spiritual enterprise; its monasteries and workshops were extensions of his royal power, almost like state-owned corporations, and their abbots and overseers were the best-trained intellects of the day. Accordingly, Henry's benefactions were of the most practical kind: the lands he gave freely with one hand he was prepared to take back with the other, nor did he make any bones about his intentions. "It is necessary that the church should own many properties," he once explained in a letter to one monastery. "From those to whom much has been given, much can also be taken."

However, the emperor Henry had no thought of reclaiming the art treasures he so liberally bestowed on the Church (see pages 23–39), which expressed his great love for the Church and his deep piety. The chalice that Saint Lawrence flung into the balance to save Henry's soul was but one of many beautiful gifts from the emperor. In the twelfth century, about 120 years after Henry's death in 1024, the Church did in fact weigh the emperor's good deeds against the bad and canonized him Saint Henry.

HEAVENLY GIFTS

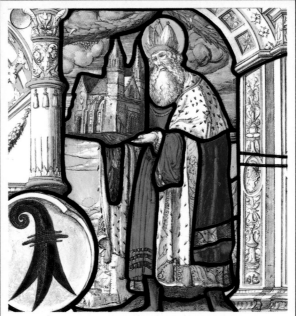

In this stained-glass portrait, Henry II, who enlarged the role of the Church and its bishops in imperial government, holds one of the cathedrals he endowed with riches.

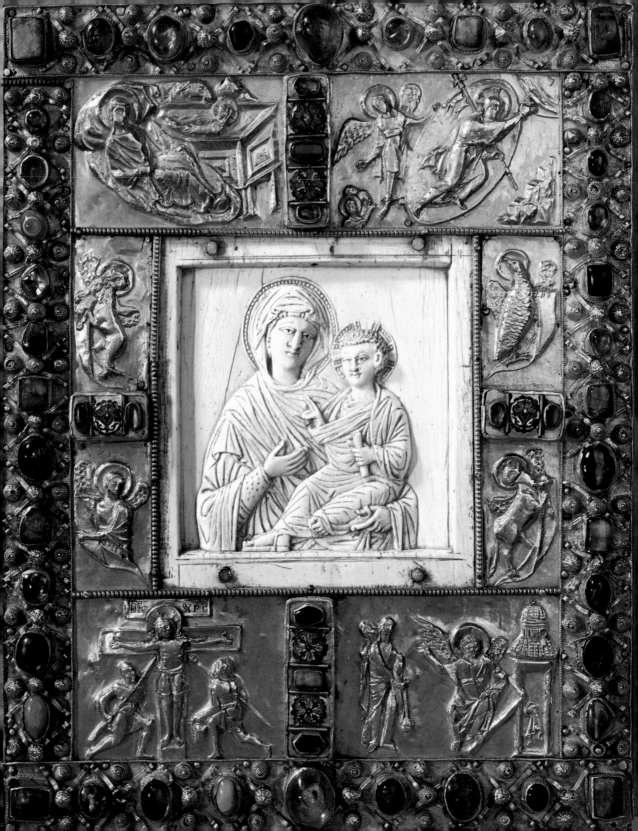

I have made Christ my heir," Henry II said to a convocation of bishops, as he announced his plans to build a new cathedral at Bamberg and to fill it with riches to proclaim his love of God. It was fitting for Henry to make Christ his heir: he had already made Christ his ally. Henry, who had a special sympathy for the religious life and lacked exceptional military skills, effectively used the Church as an arm of imperial power. Instead of fortresses Henry built cathedrals—and lavished gifts upon them—to define the extent of his power.

Three important cathedrals stood in the western, central, and southern sectors of his Empire: the Aachen Cathedral, founded by Charlemagne—king of the Franks in the ninth century; the Basel Cathedral, built by Henry; and the Bamberg Cathedral, which Henry also built and dearly loved. Each of these received, from the emperor and his queen, beautiful liturgical objects such as the ones on these pages.

Henry commissioned and donated altar ornaments, book covers, and ritual vessels of costly ivory, gold, fine cloth, and gems. The richness of his gifts bespoke his piety, but the scenes and images on the objects also served to symbolize the Empire's historical validity and Henry's role as one of Christ's deputies. For example, an image of Henry in the company of a pope, an apostle, or Christ himself declared the imperial family's divine franchise. Artistic styles borrowed from ancient Rome and the contemporary Byzantine Empire suggested that Henry's realm was the successor to and the equal of those other great empires.

Finally, the master craftsmanship of the objects made them fit rewards for Henry to present to the cathedrals' presiding bishops, as another emperor might reward his knights or lords. A worthy bishop managed the economy and politics of his diocese for the practical benefit of Henry's Empire, promulgating a faith that was not only the path to salvation, but the strongest bond Henry relied on to unite his subjects.

The Virgin Mary and the Infant Christ gaze dreamily from an ivory plaque in the book cover opposite. The four large, gold reliefs around the plaque illustrate, from top left counterclockwise: Jesus's birth; the crucifixion; a woman and an angel at Jesus's tomb after the resurrection; and Jesus's ascension into heaven. The reliefs, the jeweled cross radiating from the plaque, and the jeweled borders are probably the work of goldsmiths employed by Henry to prepare this gift for the cathedral at Aachen.

OVERLEAF: *These seventeen panels of embossed gold, making a composition about four feet long and three feet high, hung in the choir at Aachen Cathedral. They recount events of Christ's last days on earth—from his entry into Jerusalem at top left to his resurrection from the dead at bottom right—and his final enthronement as judge and savior of men in the central oval. Henry was probably the donor of these panels, which, like other such artworks, told illiterate worshipers the stories of scripture.*

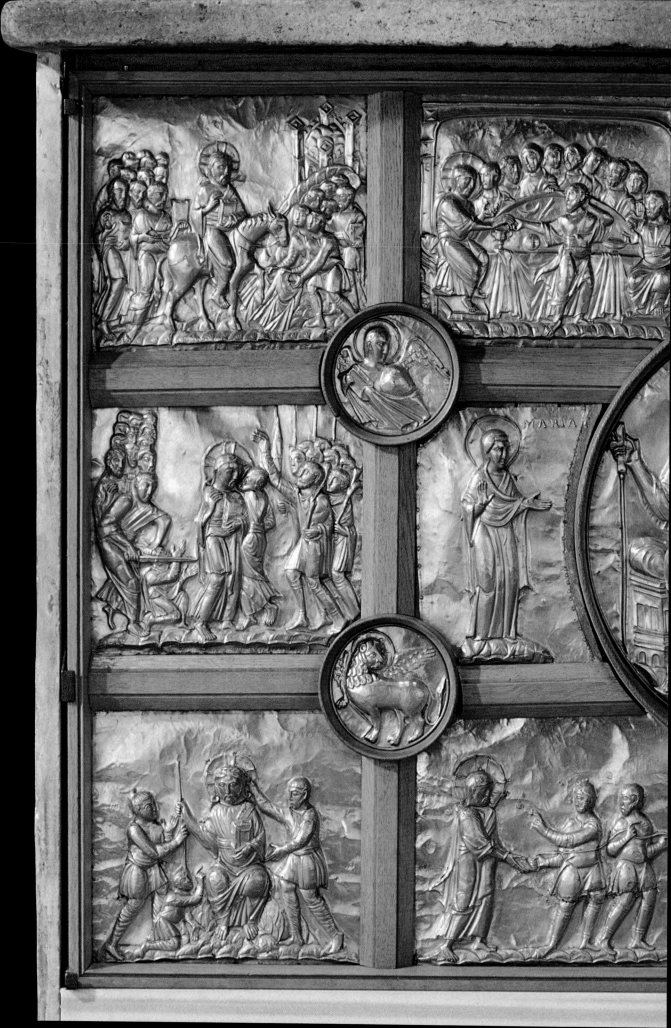

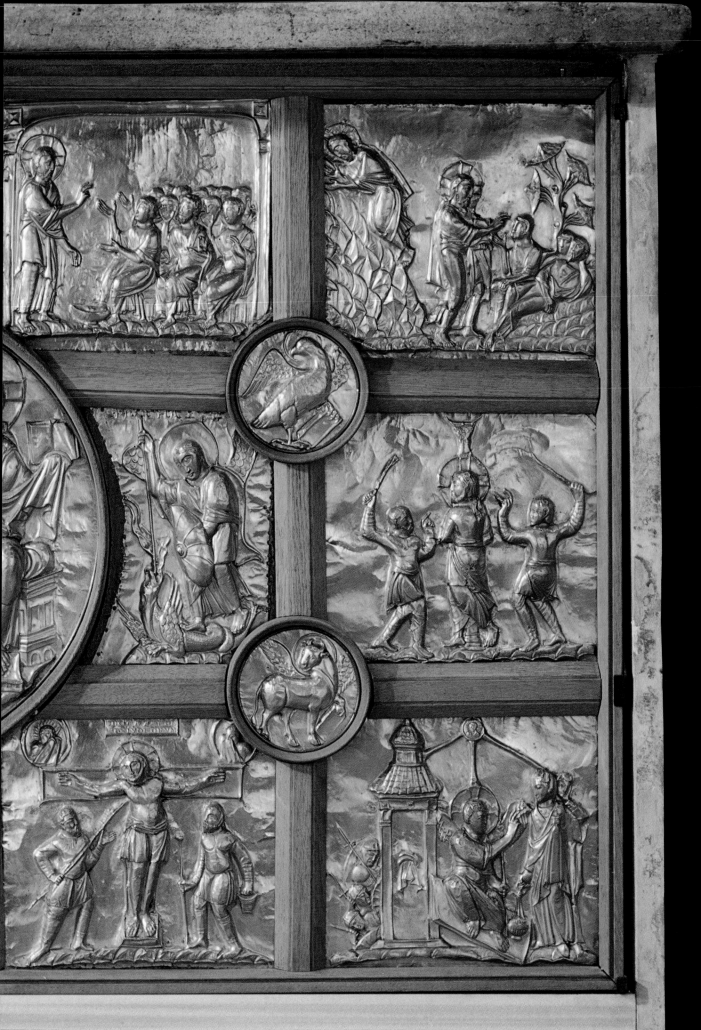

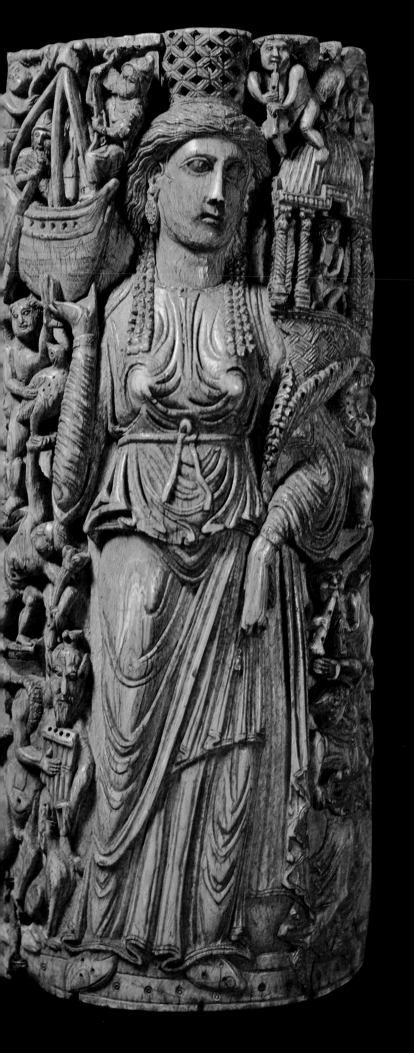

The deep color of old ivory pervades a sixth-century carving of Isis, mother goddess of Egypt, at left. The figure wears Roman costume and came from Alexandria—an Egyptian city once ruled and treasured by Rome. Henry had this carving mounted on a pulpit he ordered for Aachen Cathedral. For him this Isis probably personified Germany's inheritance of the Roman imperial tradition.

Although the holy-water vessel opposite is less than seven inches tall, each of the sixteen ivory figures stationed around its sides is carved in telling detail. In the center of the colonnade on the upper part of the vessel, an emperor—either Henry or his predecessor, Otto III—holds up his sceptor and orb, flanked by Saint Peter on his right and a balding archbishop on his left. Below these ministers of the faith, soldiers lean informally on their spears and shields, waiting to go to its defense. Henry probably gave the ivory vessel to the cathedral at Aachen, where it was later adorned with metal and gems.

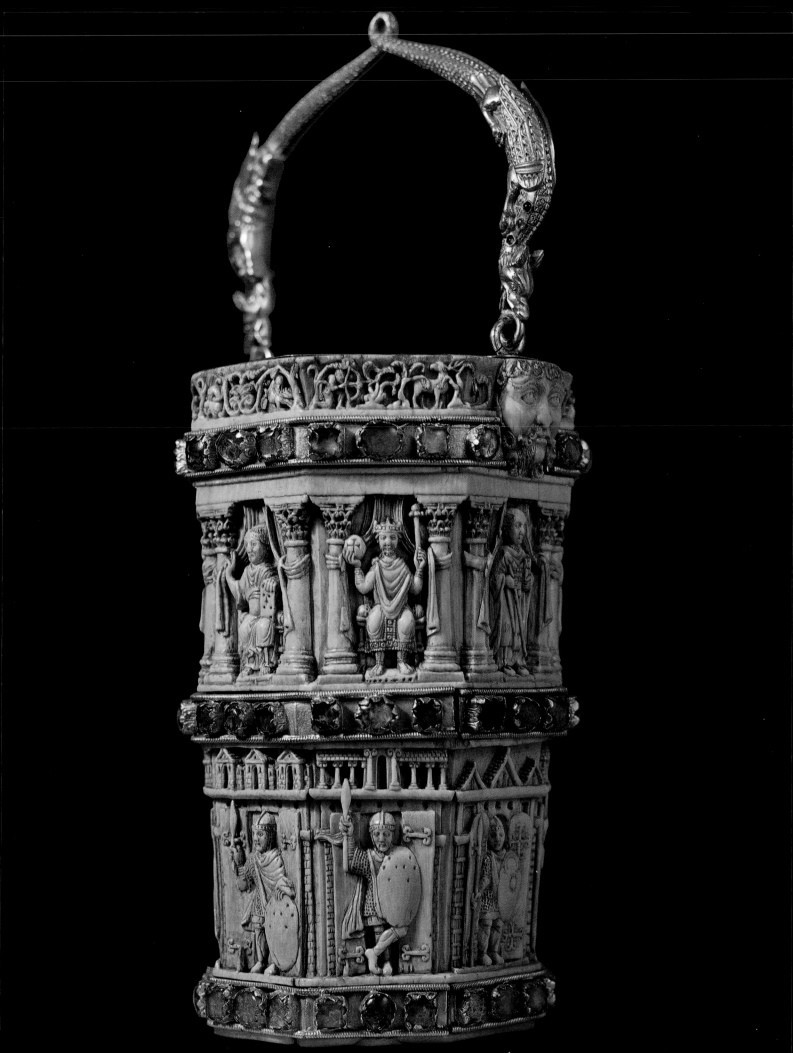

The elaborate Star Mantle of Henry II, above, depicts heavenly and earthly bodies interspersed with inscriptions describing the images. To emphasize the Empire's grounding in Christianity, such imperial ceremonial robes intentionally resembled vestments of the clergy.

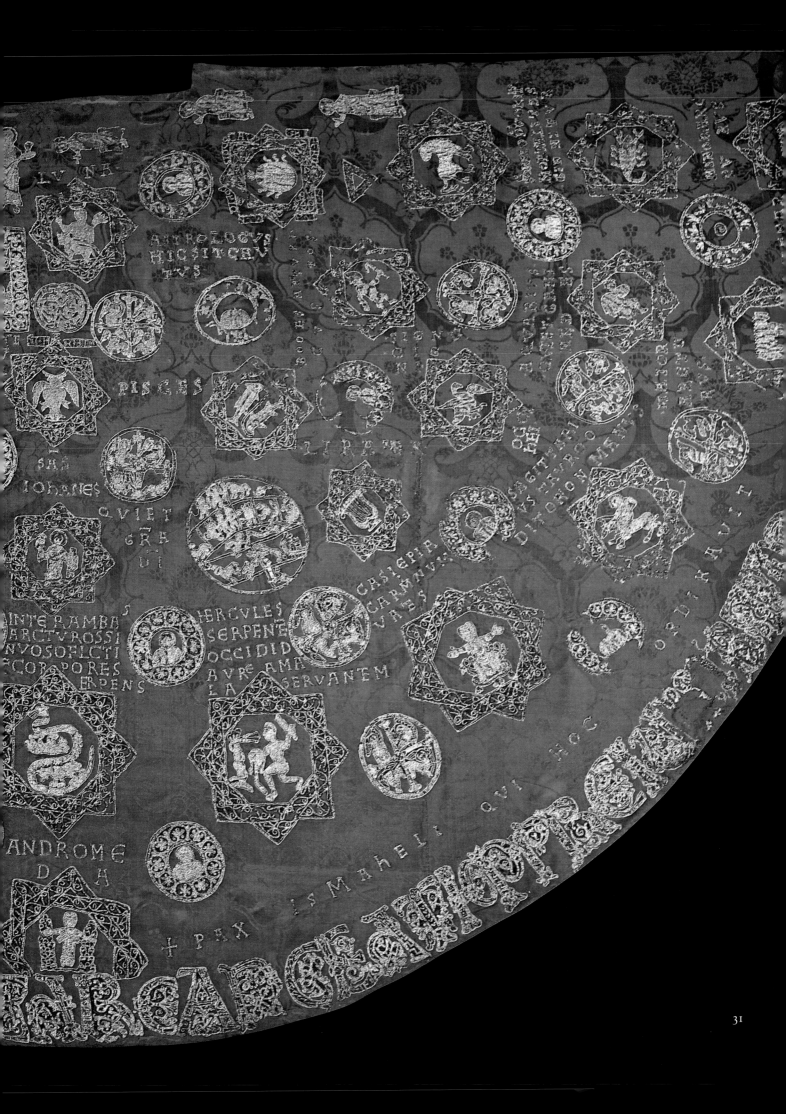

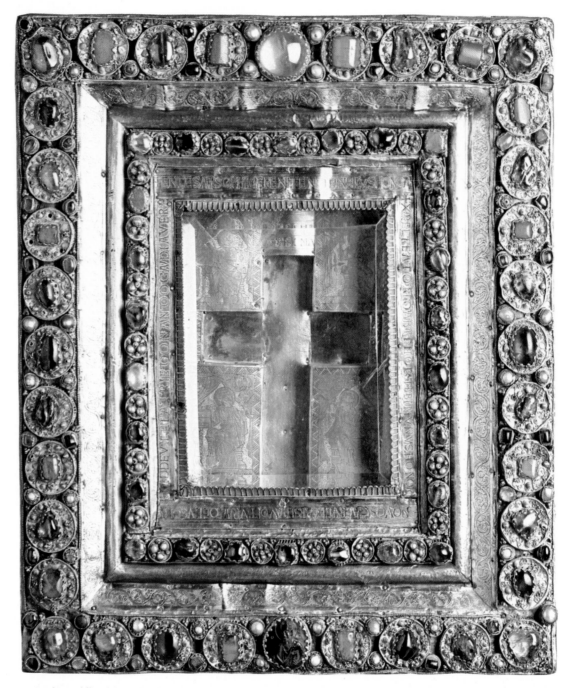

In the middle of this splendid reliquary, behind a rock crystal window, lies a cruciform recess that may have held pieces of the cross on which Christ died. The religious privilege of owning such relics was granted to Bamberg Cathedral by Henry, who—so the Latin legend beneath the window states—gave it this gift. The rich use of gold foil and jewels on the reliquary's frame (in detail opposite) may have been directed by Henry's brother-in-law, who was a bishop in the city where the present was made.

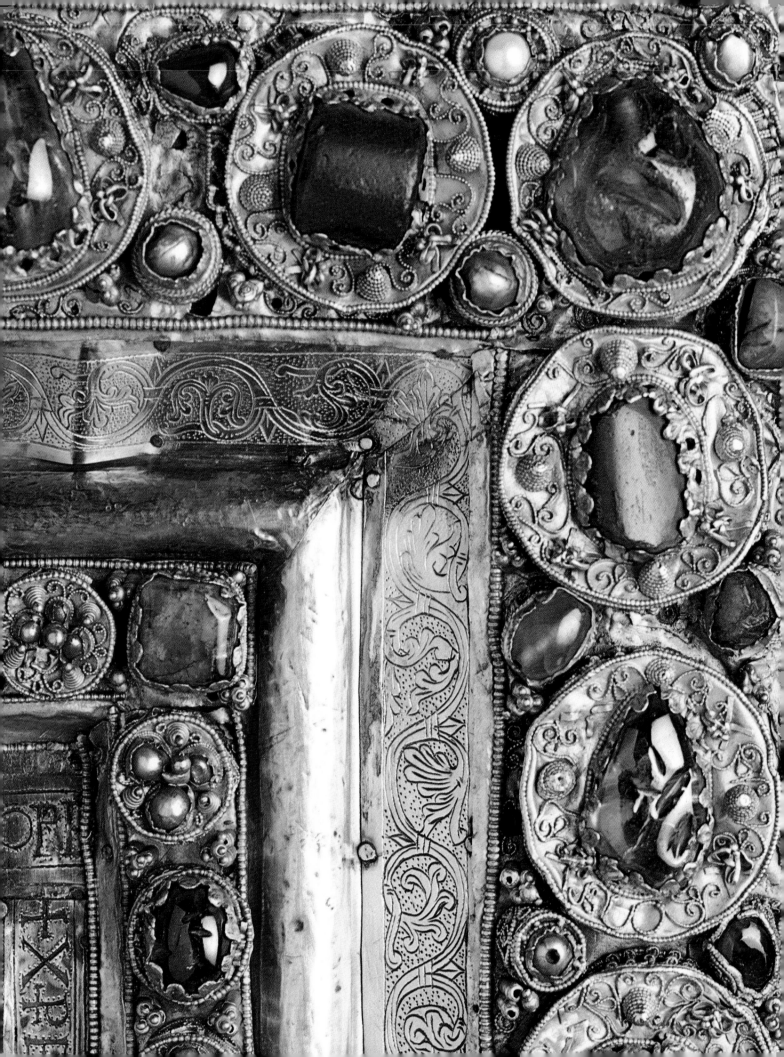

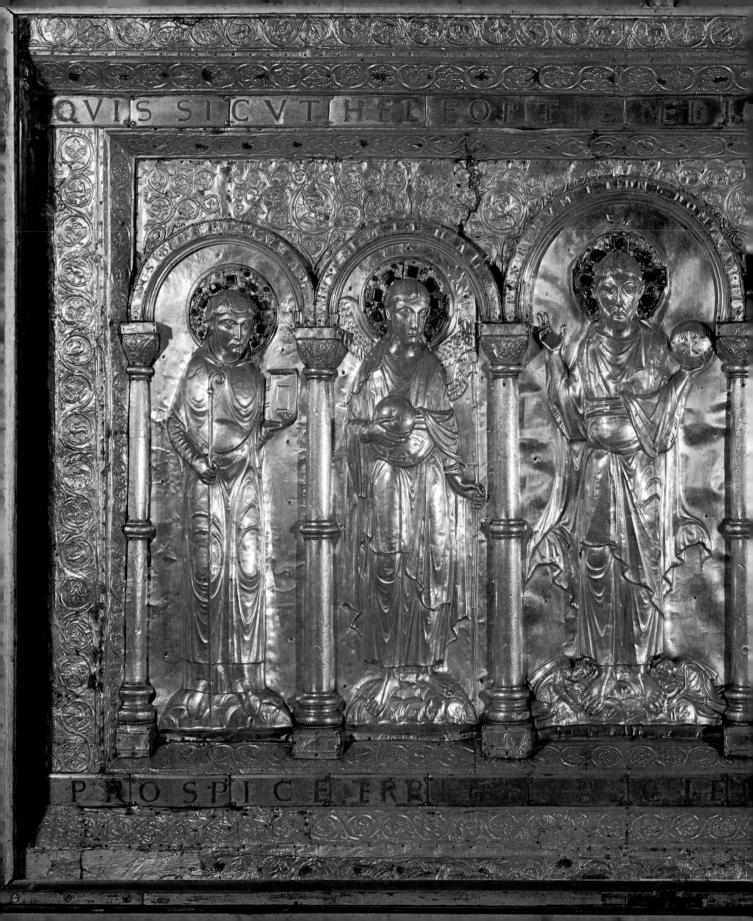

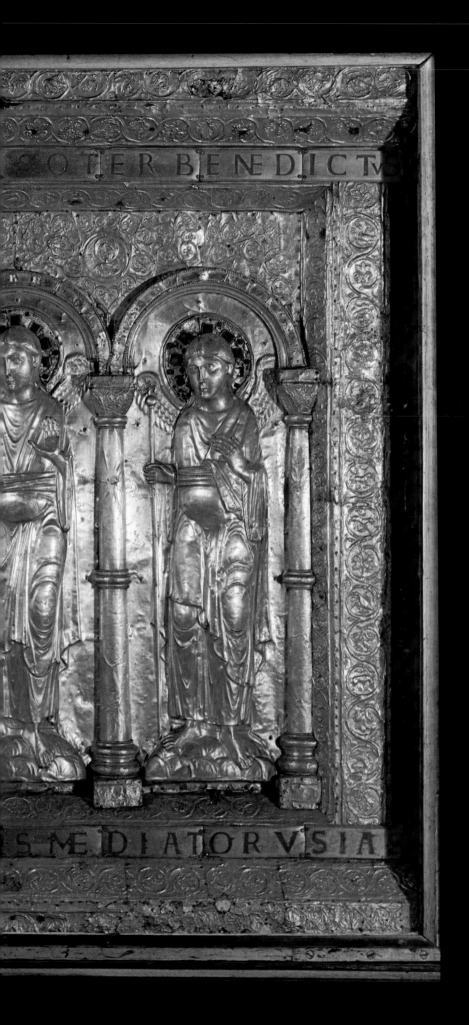

Christ regards the world with a hypnotic stare from the central arch of the gilded altar front at left, while his robes waft about his knees, perhaps ruffled by a heavenly wind. The arch's inscription and the globe in Christ's hand emphasize his role as sovereign of Christendom and thus the celestial exemplar for the mortal emperor Henry, who donated this large relief to Basel Cathedral about 1019. In lower arches on either side, Saint Benedict and three archangels—each haloed, like Christ, in gems—turn deferentially toward their ruler. Embossed tendrils, representing the tree of life, swirl around the arcade where the figures are standing.

OVERLEAF: In a detail of the altar front at left, Henry and Kunigunde crouch at the feet of the towering Christ. Their open hands express respect and submission, for their authority as emperor and empress derives from Jesus Christ's higher power. Like the others on the altar front, these tiny figures were fashioned from a sheet of gold.

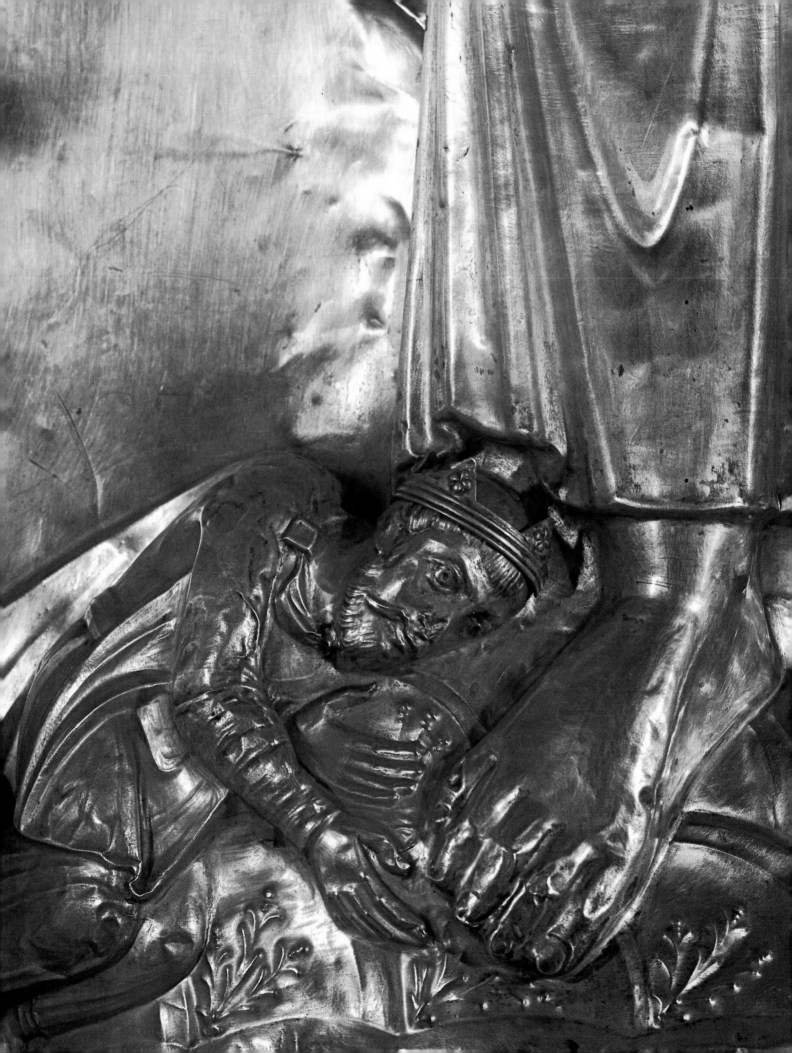

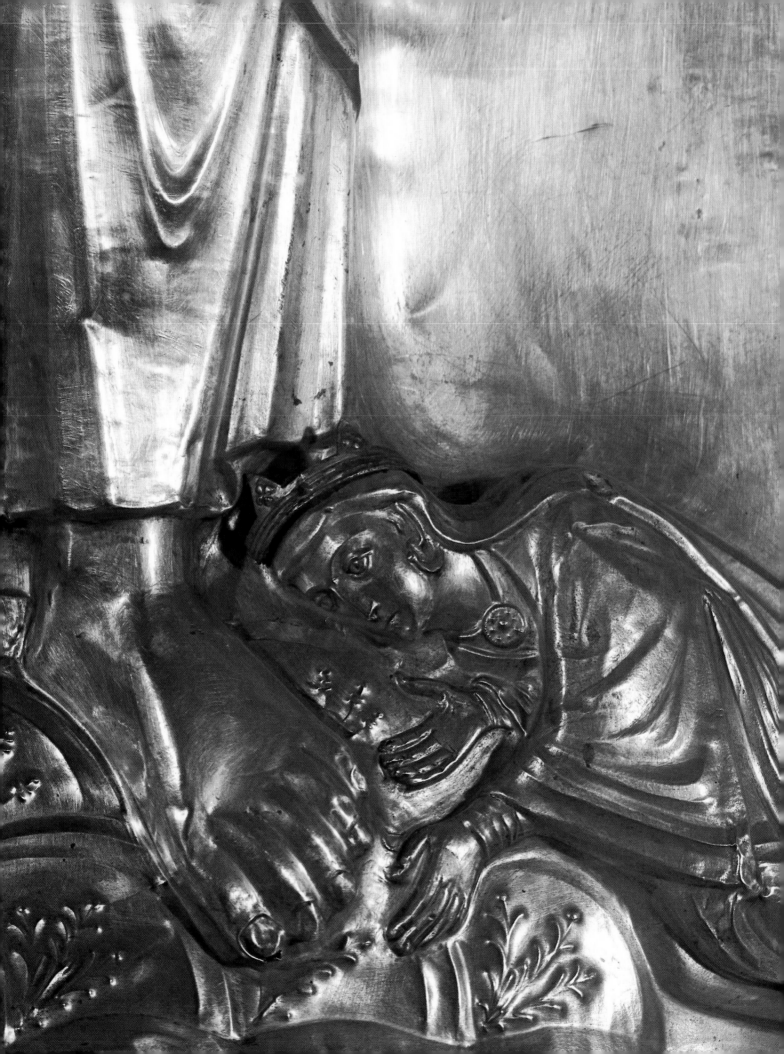

Amid angels perched on leafy pinnacles, gilded fleurs-de-lis emblazon this fourteenth-century crown, richly adorned with golden foliage, pearls, and semiprecious stones. The central onyx cameo, engraved with a warrior's head in profile, is a work of the Italian Renaissance that was added to the crown at a later date. This treasure did not belong to Henry in life, but it crowned him in death—it was laid atop his reliquary when he was proclaimed a saint.

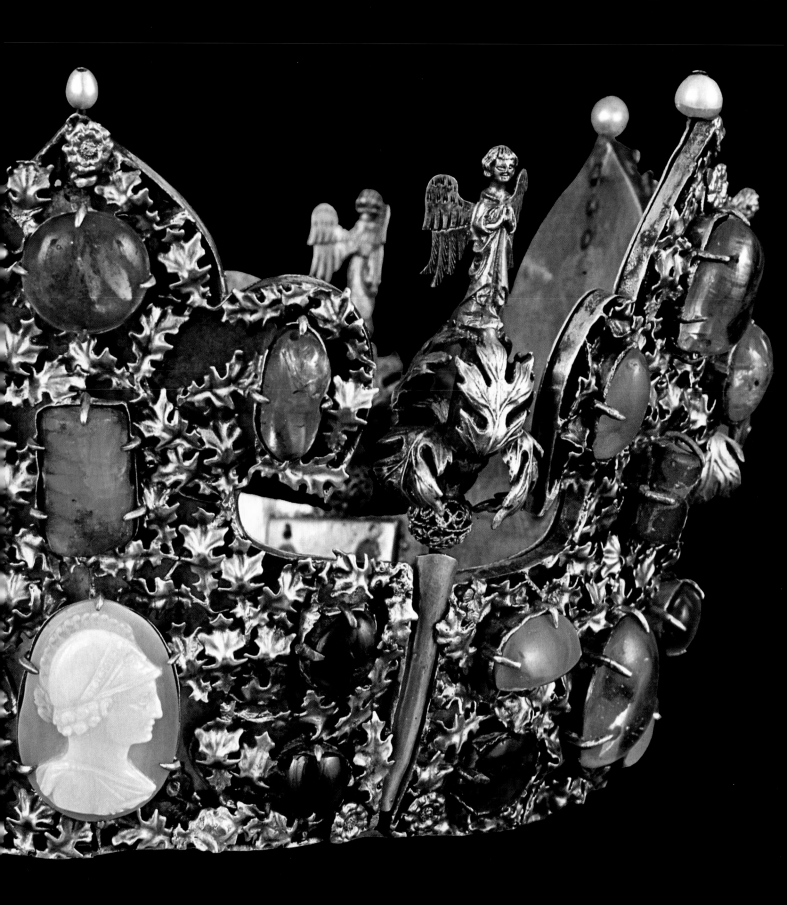

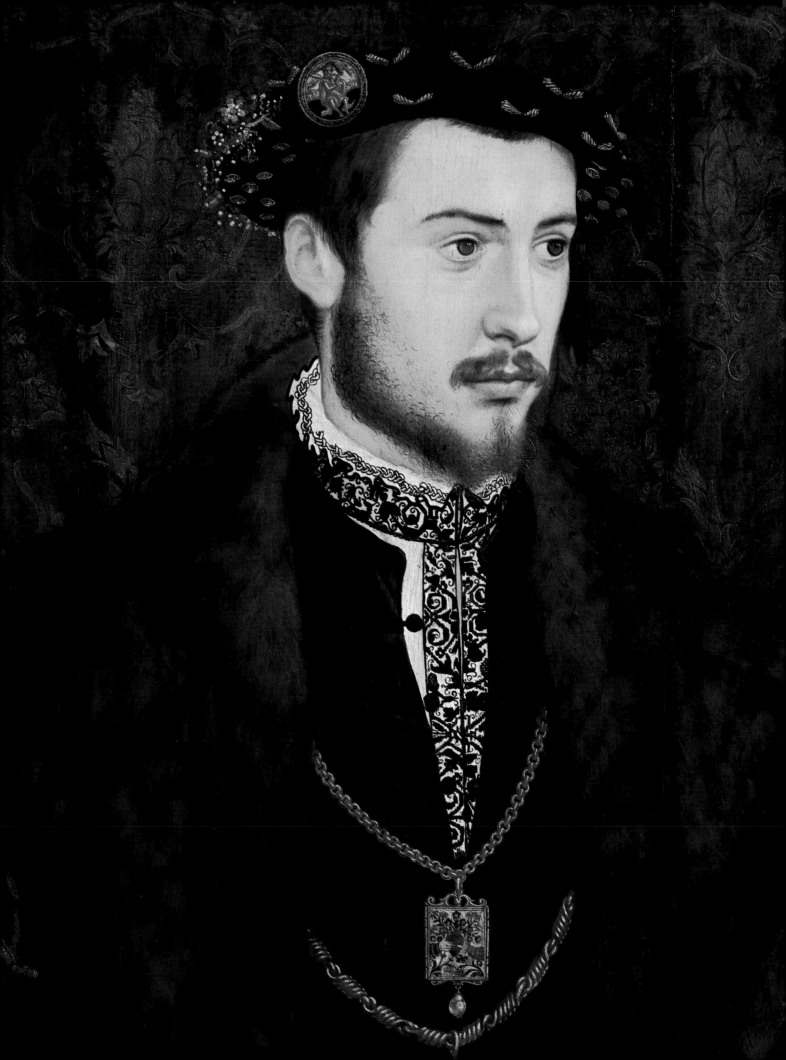

II

THE ULTIMATE PARTY

ALBERT THE SPENDTHRIFT

Stately, plump Albert V, duke of Bavaria, cut an imposing figure in the saddle as he set out from his palace on the morning of February 21, 1568. He led a parade of wedding guests—some 3,500 of them, all on horseback—on an 11-mile ride from Munich to Dachau, where his future daughter-in-law was waiting with her bridal party, encamped in a large, well-heated tent. Albert's equestrian welcoming committee provided the ceremonial upbeat for what was to be, by general consent, the greatest, most sumptuous, most memorable state occasion in the history of the Bavarian monarchy—the marriage of Albert's son and heir, Duke William, to the princess Renata, oldest daughter of the duke of Lorraine. The ceremony would unite two great ducal houses: Albert's family, the Wittelsbachs, rulers of Bavaria since the thirteenth century; and the bride's house of Vaudemont, which claimed descent from Charlemagne.

Albert and his entourage escorted the princess as she rode back to Munich in a carriage—a present from the young duke to his bride-

Wearing gold chains and a bespangled beret, a youthful Albert V—the duke of Bavaria from 1550 to 1579—appears pensive and aloof in the 1545 portrait opposite.

A calculating Duchess Anna awaits Duke Albert's move at a game of chess attended by somber courtiers. Court artist Hans Mielich made this painting for the frontispiece of his illustrated catalog of the duchess's jewelry. The artist's choice of scene is witty: Albert often settled his gaming debts with Anna by presenting her with jewels.

to-be—that was something out of a fairy tale. "The six white horses were caparisoned with scarlet and silk trimmed with rich gold fringe," noted the Italian musician Massimo Troiana, who wrote daily reports of the nuptial festivities. "The horses were harnessed to the carriage two abreast and cinched with golden buckles bearing the three-letter monogram of the bridal pair." Still more riders swelled the procession until there were 5,640 of them, filling up the whole of the road from Dachau to Munich. The vanguard reached the city gates while the princess was still in her tent, warming herself by the stove. "After 4,000 horsemen had ridden ahead, there came the ambassadors, the princes and the bridegroom with his father, riding alongside the Grand Master of the Teutonic Order and [the] Archduke…of Austria. When they reached the city, the walls and towers resounded with salutes fired by mortars and cannon. Trumpets, horns, timpani and the drums of citizens and horsemen mingled in jubilation for fully half an hour."

After the wedding ceremony the city and court took two weeks off to celebrate the event with banquets, dances, processions, plays, concerts, tournaments, and fireworks displays. The wedding guests had arrived in large numbers from most of the princely families of Germany and the neighboring countries; Archduke Ferdinand of Austria—Holy Roman Emperor Maximilian II's brother—alone had brought seven hundred of his nobles. During the great ducal banquet attended by all the visiting dignitaries, dinner music was provided by Albert's choir alternating with the instrumentalists playing viols, lutes, sackbuts (the medieval trombone), flutes, and shawms (an early double-reed woodwind); as yet no one thought of calling such a group an orchestra. They were led by the duke's music director, Orlando di Lasso, whose music was so ravishing that, according to one ear-witness account, "one imagined oneself to be in an earthly paradise." In the course of the meal, a giant pie was wheeled into the banquet hall—and to everyone's astonished delight, out sprang Archduke Ferdinand's court dwarf.

On the banqueting tables Albert's cooks and bakers had arranged a giant display of show foods—edible pictures and sculptured sweet-

meats depicting some of the great moments in history and mythology, including Adam and Eve in the Garden of Eden, the baptism of Christ, and the Judgment of Paris, an episode from Greek myth in which a mortal prince judges a divine beauty contest. It was an age that doted on allegories, even if one could eat them afterward.

During the festivities the guests staged a series of allegorical pageants. Archduke Ferdinand appeared as the Roman statesman Agrippa, in a chariot drawn by six white horses; his younger brother costumed himself as a woman to represent Diana, the Roman goddess of the hunt. Other princes disguised themselves as bears, wolves, and vestal virgins; and, to complete the reversal of identities, horses were dressed up to look like human giants walking on all fours. Duke Albert's corpulence normally kept him on the sidelines, but on this gala occasion he bestirred himself on the dance floor with the rest of his family, though he left the more strenuous turns to the younger generation.

At the special request of the groom, the celebrations included an Italian commedia dell'arte—the folk theater that William had greatly enjoyed during a three-year stay in Naples—staged by Orlando di Lasso. Orlando himself, then in his thirty-sixth year, played the part of a pompous but impecunious Venetian and reduced the illustrious audience to tears of laughter. Though rulers all over Europe were competing for di Lasso's services, it was Duke Albert who retained possession of this jewel without price, the most gifted and versatile of sixteenth-century composers, a man who could write a Mass or a love song with equal fluency and beauty. The duke was well aware of how much di Lasso's presence at his court contributed to his growing reputation among the princes of Europe. Albert never missed an opportunity to reward and encourage his star kapellmeister: he paid di Lasso a salary that was six to eight times the going rate for court musicians and hired nearly fifty people to serve under him. His patronage of music was one of the main reasons Albert acquired the reputation of being the first German ruler who could compete with the great Renaissance princes of Italy. And the magnificent fetes Albert orchestrated for his son's wedding burnished his reputa-

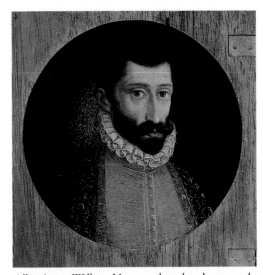

Albert's son William V, a neat beard and moustache nearly hiding his pursed lips, is a frail ducal presence in this 1578 portrait by an unknown artist. Though he loved the glitter of gold as much as his profligate father, William grew sickly and pious: his contributions to the Wittelsbach family treasury were chiefly sacred vessels and reliquaries.

tion as the master impresario of *bayrische Pracht*—"Bavarian splendor"—a phrase that entered the language shortly after Albert came to power.

As Albert busied himself with his musicians and artists, all around him many of the German states were, as usual, engaged in making war on one another. The Holy Roman Empire of the German Nation was still theoretically in existence, but, in the five hundred years that had elapsed since Henry II, it had become more fragmented than ever. The Hapsburgs of Austria, with their capital at Vienna, had held the imperial crown more or less as a family monopoly since the fifteenth century, but they were unable to unify these loose-knit cities and principalities. Often they had only language in common; as one historian expressed it, "other noble families fought the Hapsburgs, and the cities fought the nobles. Cities conducted their own affairs, made trade alliances and political alliances, declared war and concluded peace, just as the Italian city-states did. Sometimes a bishop or archbishop would press a claim to a city—not in the name of the Roman church or in the name of the emperor, but simply as another worrisome independent power."

Albert remained resolutely at peace, avoiding the expense and aggravation of war, so that he could spend his money on art and music. Accordingly, he was to go down in the annals of Bavaria not as a military hero but as the great spendthrift duke who imported to Munich as much of the Italian Renaissance as he could. From Venice, Mantua, and Rome, Albert's agents sent him a stream of sculptures, paintings, jewels, and books until the treasures of Italy filled Albert's palaces almost to overflowing.

Even as a young man, Albert had the air of princely magnificence that marked him as a patron of the arts. It was reported that when the sultan of Turkey was shown the portraits of all the leading German princes, he pointed to Albert's picture and remarked that surely this one must be the emperor. The young duke had visited many of the great palaces of Italy and had been duly impressed by their spacious, colonnaded architecture. Now he had the trusty masons and carpenters of Munich build him a new palace along the

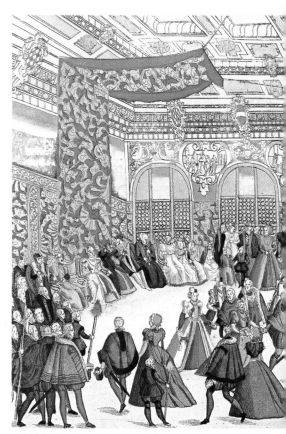

Newlyweds William V and Renata of Lorraine sit beneath a canopy of tapestry, cheering on their guests at a Mummenschanz, *or "masquerade," in a grand ballroom of the ducal castle located in Munich. This colored etching and the one on pages 46–47 illustrate a book commemorating the nuptial festivities of the future duke and duchess.*

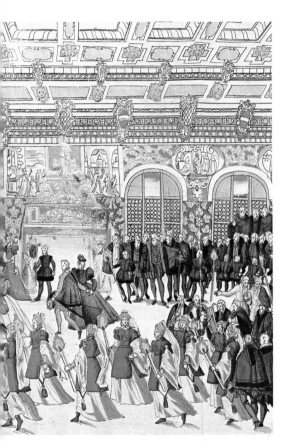

same lines, next to the one he had inherited from his father—a castle still stamped with the siege mentality of the Middle Ages. His gardeners created a series of pleasure gardens that opened up his residence to light, air, and art: they were decorated with statues, fountains, and vases, many of them imported from Italy.

Like other princely collectors of the day, Albert regarded art not so much as an object of sheer aesthetic delight but as a link to the classical past, a mirror of history in which he could catch his own reflection as a great ruler. Albert set his heart on collecting a complete set of portrait busts of the Roman caesars and their wives, as well as the great generals and poets of antiquity. He bought 192 busts, but neither the Bavarians nor the Italians had any systematic knowledge about classical antiquities; therefore, hardly a dozen of the portraits were correctly identified—a head of the Roman general and statesman Pompey was listed as a portrait of the first emperor of Rome, Octavian; a bust of the Greek philosopher Epicurus became the Roman emperor Lucius Septimius Severus, and so on.

The duke's agents also sent him freestanding figures, torsos, and various fragments, often of doubtful authenticity. Albert had his court sculptors restore them to the best of their ability, filling in missing pieces with plaster, joining miscellaneous heads to any torso that happened to fit. No matter: the results were painted black in any case, to give them a semblance of uniformity so that they could be displayed in the orderly rows and geometric arrangements so beloved by connoisseurs in the sixteenth century. Albert designed a hall for them, the Antiquarium, which measured 2,165 feet in length, and he filled its niches, mantels, benches, and windowsills with a vast array of busts and figures.

A second gallery, known as the Kunstkammer, or "Art Room," occupied the floor above the ducal stables. It held a cornucopia of natural and man-made curiosities. Paintings of famous murderers, dwarfs, bearded women, and human deformities stared down from the walls at displays of exotic seashells, strangely shaped coral, unusual deer antlers, and the horns of a narwhal and a rhinoceros. Standard objets d'art—ivory carvings, majolica, glass, polished

stones, embroideries, and carpets—competed for space with the bizarre, such as plaster casts of feet with six toes. Here Albert exhibited an alabaster jug said to have been used at the biblical marriage of Cana, models of Bavarian cities, and a miniature palace, in which tiny models of the duke and duchess prayed in a chapel complete with courtiers, singers, instrumentalists, and priests. Those who were lucky enough to gain entry to view these remarkable treasures were absolutely fascinated: after Albert's death one gentleman remarked that if one wanted properly to see everything in the Kunstkammer, it would take two to three months!

Albert also accumulated books as fast as his agents could find new works—or entire libraries—to purchase. He bought rare manuscripts in Greek, Hebrew, Syriac, and Latin from a distinguished orientalist and a priceless library assembled by Johann Jakob Fugger, a member of the famous Augsburg banking family who had exhausted his immense fortune pursuing his passion for collecting books. "No other prince on earth possesses such a treasure of books," boasted the duke's agent in Mantua. Indeed, Albert's library of eleven thousand volumes was to form the nucleus of what is now one of the world's great libraries, the Bayerische Staatsbibliothek. By 1563 his court payroll included four secretaries who did nothing but catalog his books.

But the most expensive items in Albert's burgeoning collections were the jewels and *Kleinodien,* or "jeweled works of art." As time went on, his advisers became increasingly alarmed at his extravagance in this and other departments. "Whatever he sees that is precious, foreign or curious he has to have," they grumbled in an assessment of the ducal finances for 1557. "Two or three goldsmiths are continually at work producing things only for the duke. What they create one year is broken or pawned the next."

To forestall such criticism, Albert eventually followed the example of Francis I of France and created a special category of Kleinodien that he declared to be inalienable heirlooms of the crown "and henceforth and for all time to be the property of our princely house, and to remain in our new palace in Munich." Initially Albert

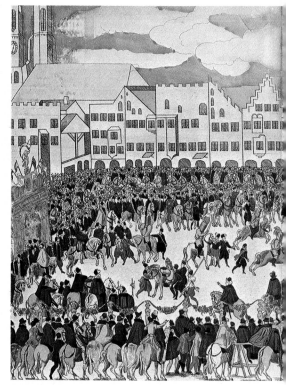

In a great courtyard, guests of William and Renata join in a mock jousting tournament, one of the many diversions that Albert planned for his son's wedding celebration. As spectators watch from garlanded sidelines, players in the game wear buckets for helmets and swat at each other with blunt lances.

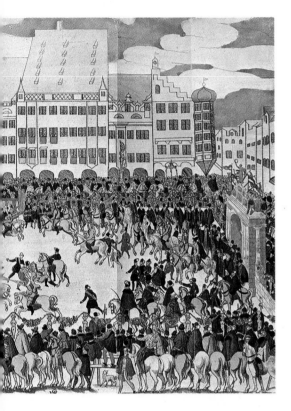

designated seventeen items; later he added ten more to be placed in the so-called Silver Tower of his palace in order, as he put it, to enhance his "princely reputation and distinction." They constituted the beginning of the famous Schatzkammer ("Treasure Chamber") of the Munich Residenz, as Albert's new palace came to be known.

Although these precautions prevented the jewels from being pawned or sold, they were not sufficient to pacify Albert's financial advisers, who had to find the means of paying for them in the first place. His ministers were hardworking burghers, and they had never seen the duchy's money flung about with such reckless abandon. "The painters and sculptors hardly leave the palace the whole year round," they complained. "And in addition there are the picture carvers, wood turners, stone masons; and the tremendous expenditure for clothes, decorations, costumes; the excesses of eating and drinking, banquets and invitations." It was politely suggested that Albert should stop indulging his tastes and devote more time to religion and read some good books on German or Bavarian history. His advisers could not understand why anyone would want to hear music all the time and why it should be performed by overpaid fellows who had wandered in from nobody knew where. Too much music in the ducal chapel probably distracted the mind from prayer, and music at table was another unnecessary expense.

It was all very exasperating to the exacting fiduciary mind, and the worst of it was that this duke, whose yearly income was 112,000 florins, had managed to incur debts of 812,000 florins in his first 6 years of rule. The Bavarian *Landschaft*, or parliament, had to foot the bill by imposing a stringent wealth tax. But by 1563 he had contracted debts amounting to 500,000 florins more, costs that were again defrayed by taxing farmers, merchants, and artisans.

When Albert died in 1579—for some years he had been so obese that he could hardly move—he left his son a splendid legacy of palaces, pictures, sculptures, jewels, and books and a debt that amounted to the staggering sum of 2,360,000 florins. The young duke, now reigning as William V, was never able to pay off his father's debt, but passed it on to the next generation. Yet he was able to finish his father's palace and the Antiquarium and brought in new

painters and sculptors to decorate Munich's public buildings. In one instance William managed to surpass his father's magnificence as a patron of the arts. When William arranged for his brother Ernst to be appointed bishop of Cologne in 1583, Ernst presented him with a sacred relic of Saint George. William thereupon commissioned a jeweled reliquary (see pages 66–71) that eclipsed every other jeweled sculpture of sixteenth-century Germany. It was to be the most sumptuous of all the exhibits in the Wittelsbach treasure chamber. The reliquary acquired a magnificent new base in 1641 to celebrate the fact that the next duke, Maximilian I, had persuaded the emperor to make him an elector—one of the seven German princes who were entitled to cast a vote in the ceremonial election of the emperor. At last the dukes of Bavaria had become part of the inner council of the Empire.

By then, however, Germany had split apart in the most violent and destructive of all its internal wars—the Thirty Years' War—the climax of a series of religious conflicts between Catholics and Protestants. Albert had generally held himself aloof from the religious turmoil in Germany that was touched off by Martin Luther's 1517 demands for reform in the Catholic Church—demands that he nailed to the door of a church in Wittenberg. The reform movement quickly grew into a rebellion and attracted wide support from the nobles in northern Germany, who wished to throw off the authority of the Church and the Holy Roman Emperor.

The Thirty Years' War, which began in 1618, turned Germany into a vast and interminable battlefield, fought over by marauding armies whose generals had long since lost sight of the original causes of the war. The 1648 Peace of Westphalia, which ended the war, effectively dissolved the Holy Roman Empire—though the Empire continued to live in name, and emperors continued to reign in Vienna. In Germany the war left behind a ravished countryside, a decimated population, and a legacy of political division that has persisted to this day. It would take more than a century to efface the scars of the war. Perhaps Albert had been right after all: statues and musicians were a better investment than cannons and musketeers.

TO BEAUTIFY
BAVARIA

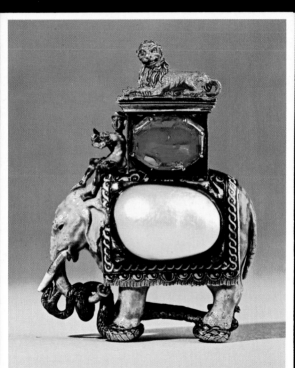

An enameled gold elephant, tangled in a snake, totes the lion symbol of Bavaria. The pendant, set with an enormous ruby and a pearl, was a favorite of Duke Albert V.

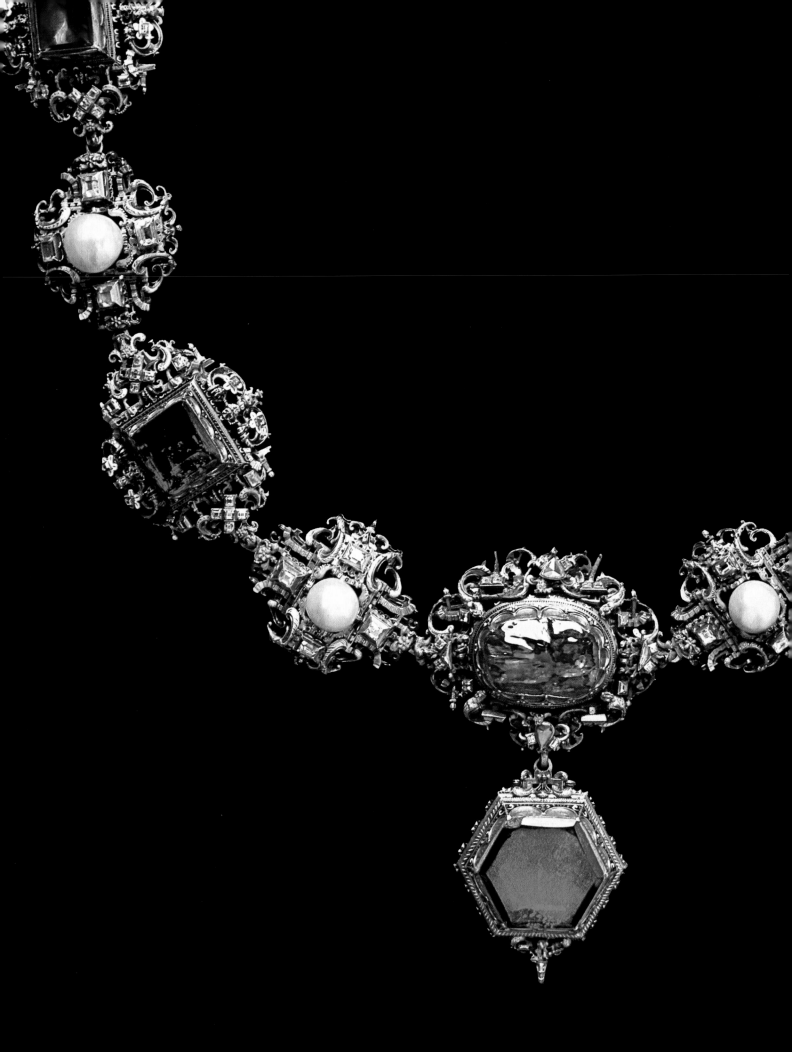

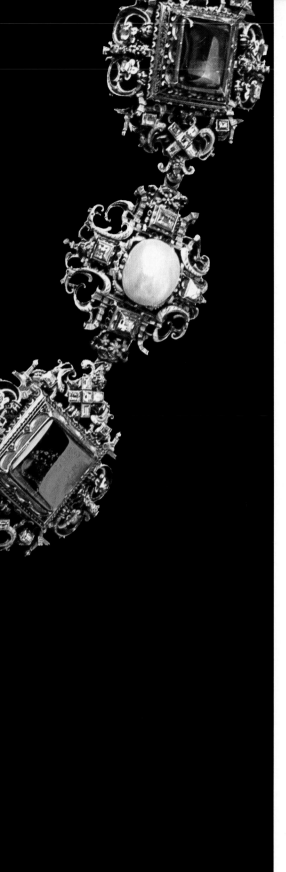

Albert V, notoriously voracious at the dinner table, also had an insatiable appetite for practically anything made of gold, crystal, jewels, or shimmering enamel. In the Schatzkammer, the "Treasure Chamber" of his Munich palace, the duke amassed necklaces, pendants, vases, pitchers, and religious shrines. A member of Albert's court, amazed by his lord's obsession, wrote that the duke was driven to possess "anything precious, strange, or unusual." But Albert regarded his treasures as more than his own private indulgences; in 1565 he proclaimed them to be the inalienable property of his family and powerful symbols of its rule.

A bibliophile, Albert filled his library with fine editions of Greek and Latin classics and developed a passion for antiquities. Albert brought this classical sensibility to the new works he commissioned from goldsmiths, jewelers, and enamelers, whose works were often tributes to the duke's favorite mythological and biblical stories.

With Albert's doting support these artists never lacked work or appreciation. Augsburg and Munich goldsmiths hewed closely to the high standards of their guilds and created the masterpieces in precious metal that most delighted their princely patron. Albert also sent commissions to Italy to the five Saracchi brothers of Milan, renowned throughout Europe for their exquisite engravings in rock crystal. Albert, practically delirious over Saracchi crystal, tried to woo the brothers away from Italy; though they declined the duke's invitation, they lost none of his admiration or business.

Albert's son and heir, William V, added substantially to the Schatzkammer, focusing on sacred—though opulent—objects, such as the Saint George reliquary on pages 66–71. Between the two of them, father and son created a fabulous storehouse of family jewels—and fulfilled their stated wish to beautify Bavaria.

Albert V could remove any jewel in the ornamental chain at left—pearls, rubies, and emeralds in distinctive settings—to wear as an individual brooch. At ceremonies the duke wore them as a necklace, its forty-four inches of gold and gems so heavy it had to be sewn onto the yoke of his velvet cloak.

Drunken satyrs and maenads, the merrymakers of classical mythology, revel on this bottle made of rock crystal, which is surrounded by a gold band and set with rubies, emeralds, diamonds and pearls. A floral stopper tops the oval vessel its crystal engravings celebrating the classical world, which Albert V idealized.

A wild procession honoring Bacchus, the Roman god of wine, circles the engraved amphora at right. More than twenty inches tall, with handles and a stand fashioned of gold, enamel, rubies, and emeralds, the vessel was the largest ever wrought in rock crystal when the famed Saracchi brothers made it in about 1579.

OVERLEAF: A nude Neptune, the Roman sea god, stands over a coiling serpent and looks heavenward in a detail from the amphora at left. Flanked by elaborately sculpted handles—which all but writhe with human and beastly figures— the gold deity seems to lord over the high-spirited Bacchanalia below him.

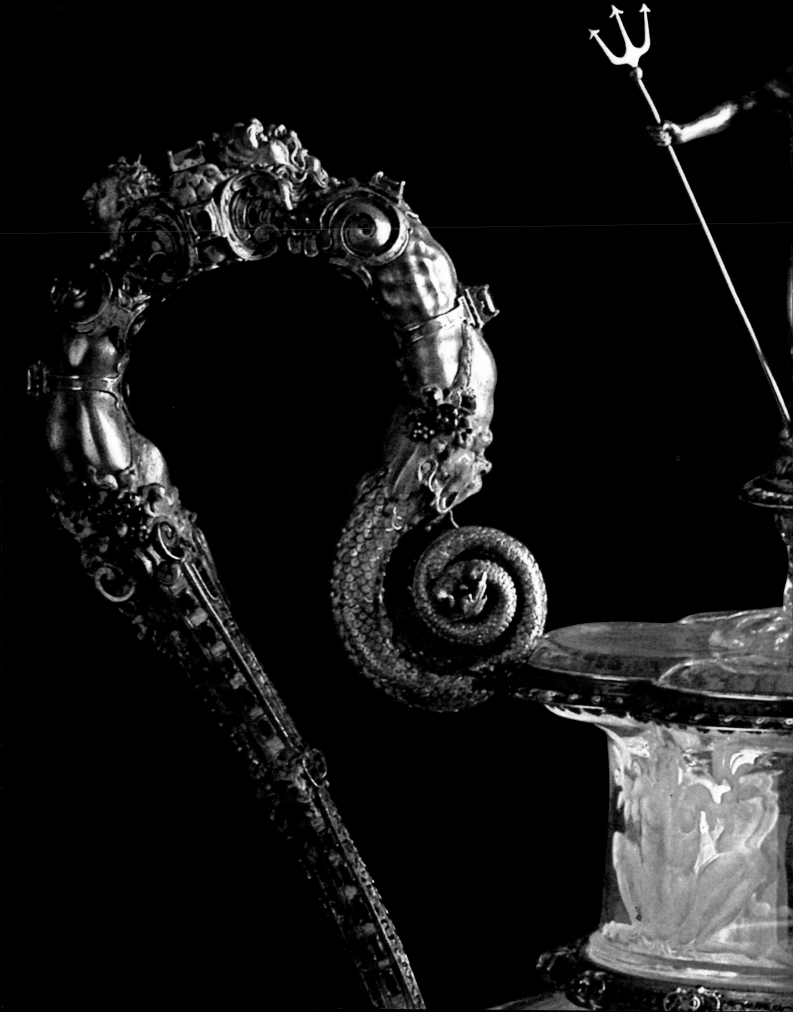

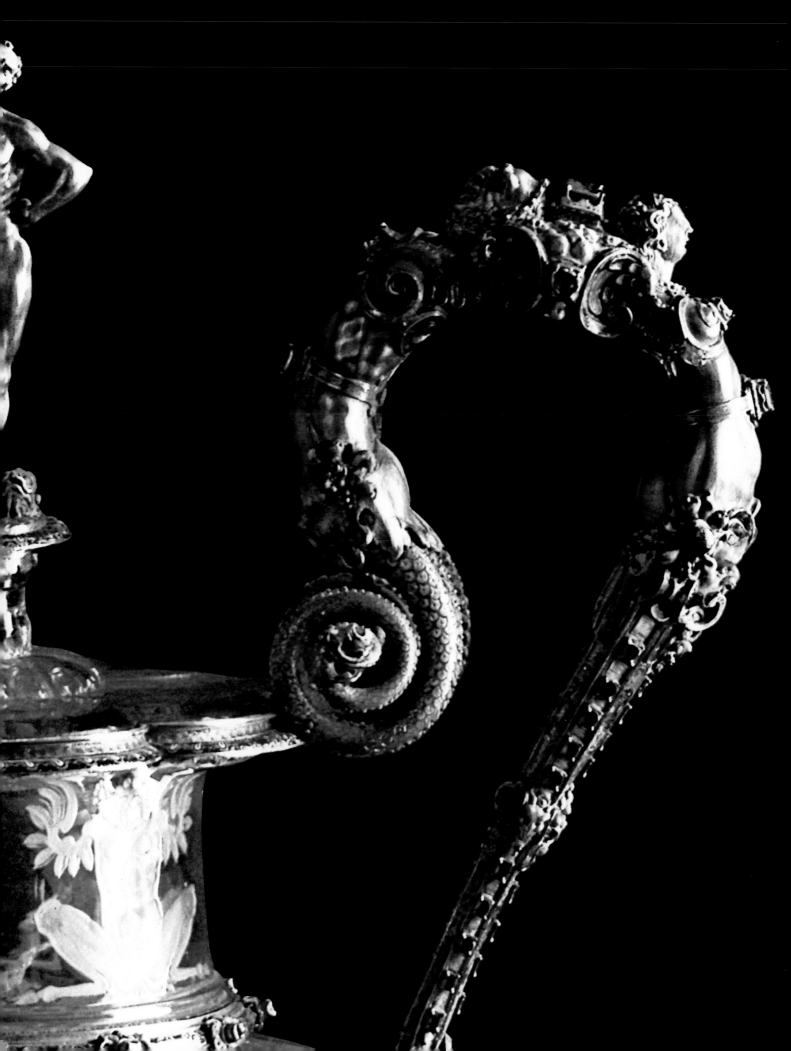

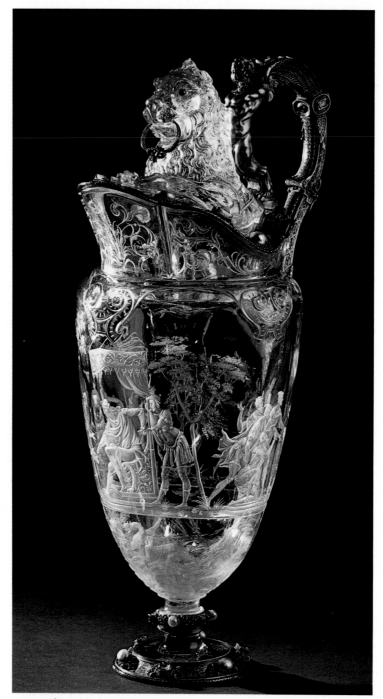

Among decorative tendrils and arabesques, the engravings on the rock crystal pitcher above include scenes from the life of the Old Testament figure Joseph. Enamels and jewels trim the vessel's gold foot and handle, and the garnet-eyed lion surmounting it, in detail opposite, bites an enameled gold ring. The Saracchi brothers made the crystal treasure for Albert V about 1575.

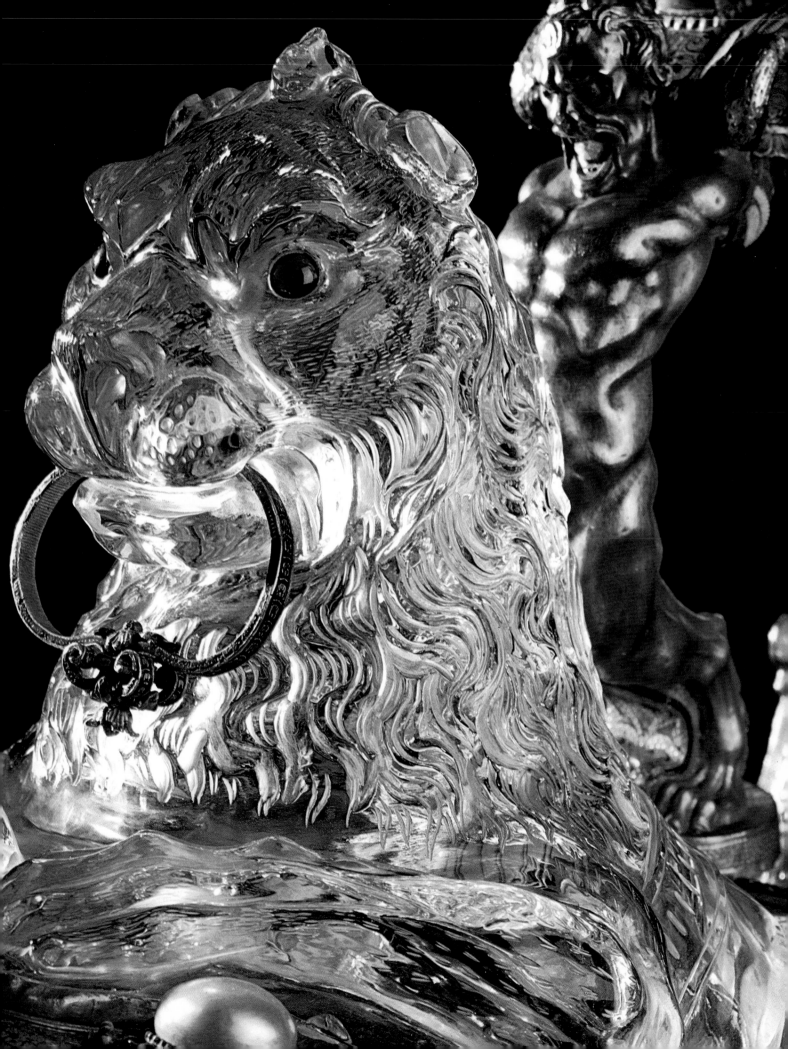

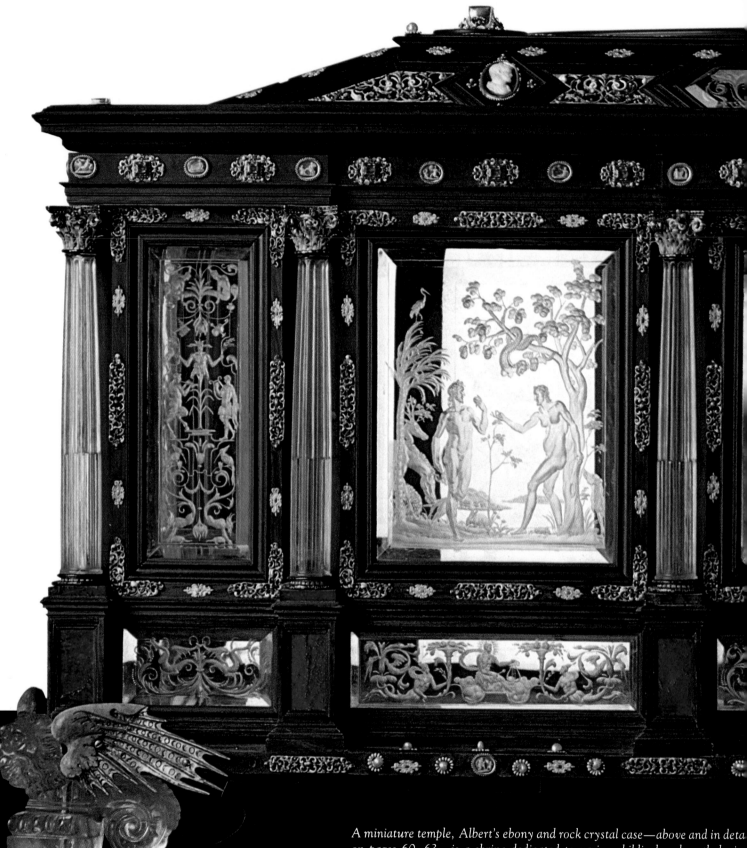

A miniature temple, Albert's ebony and rock crystal case—above and in deta
on pages 60–63—is a shrine dedicated to various biblical and mythologica
stories. The framework, approximately three feet long and two feet high, is o
ebony, an exotic wood to the German princes. A jeweler, probably fro

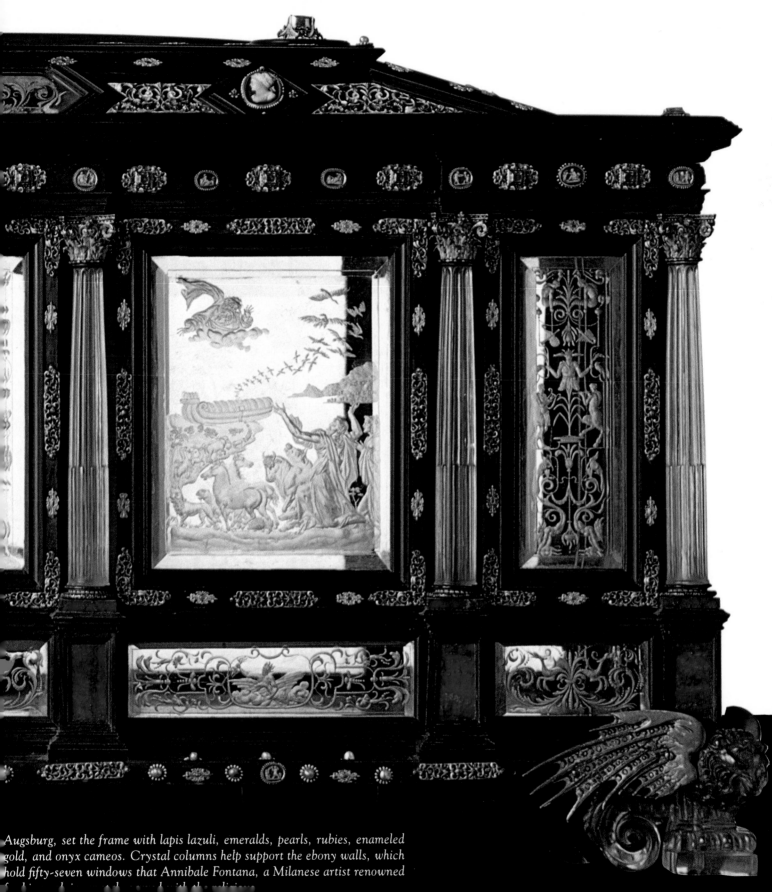

Augsburg, set the frame with lapis lazuli, emeralds, pearls, rubies, enameled gold, and onyx cameos. Crystal columns help support the ebony walls, which hold fifty-seven windows that Annibale Fontana, a Milanese artist renowned

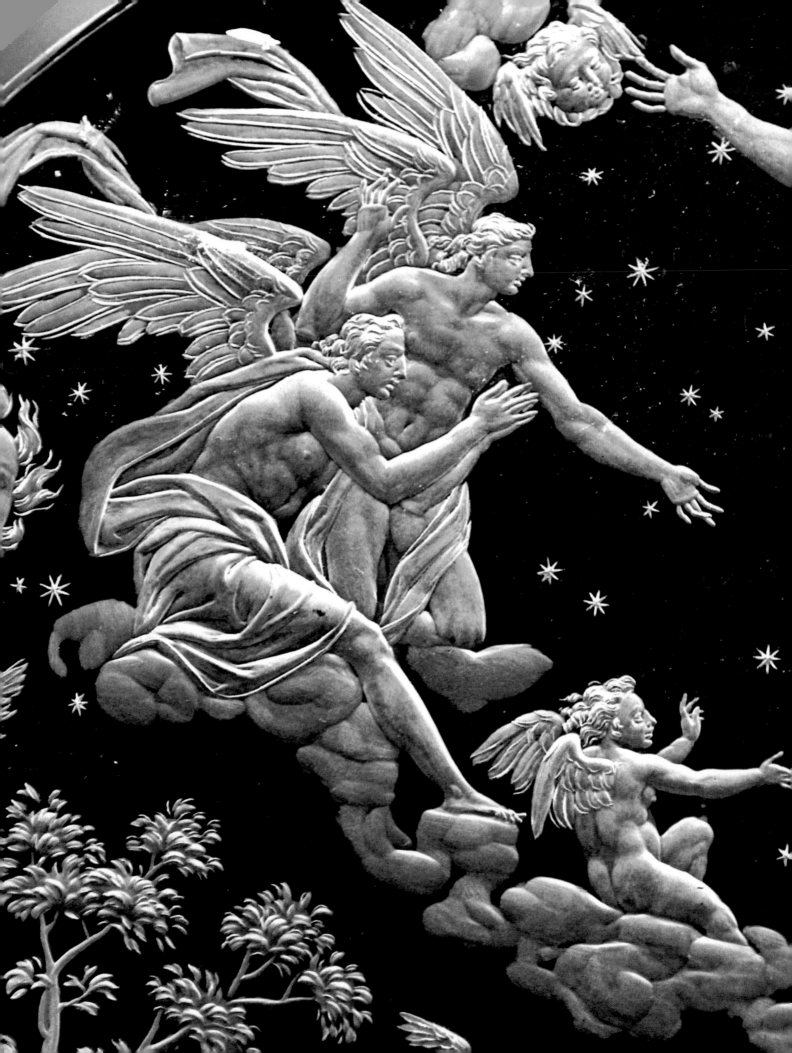

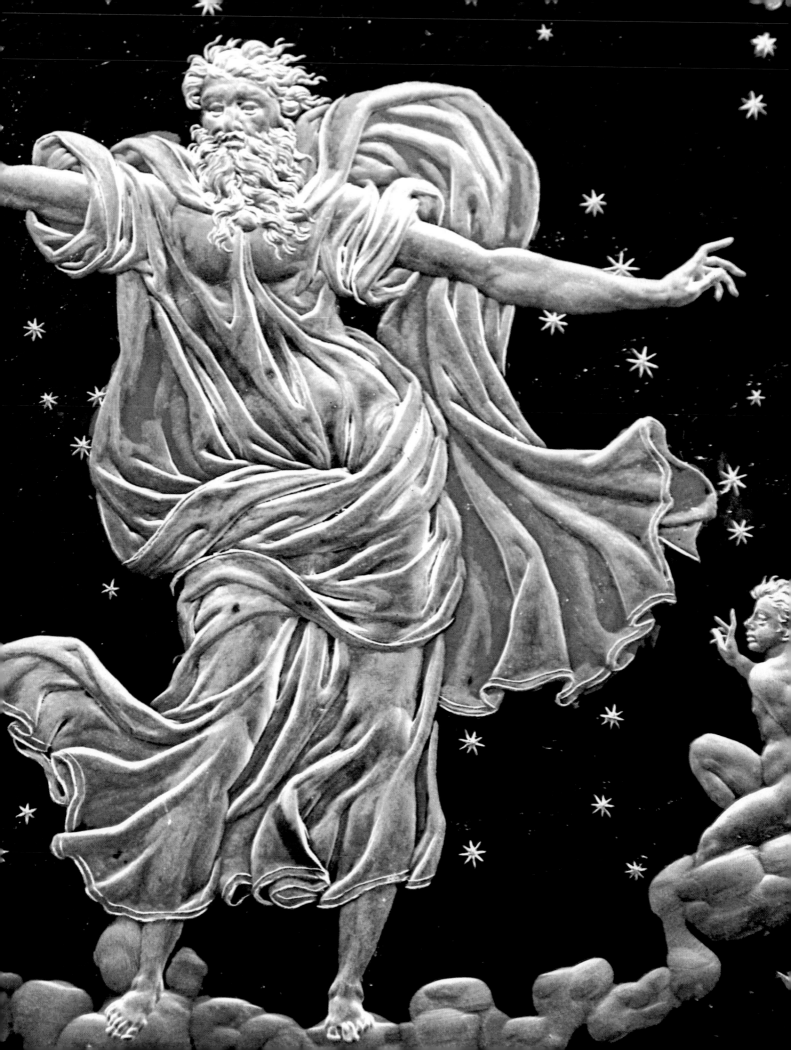

One of four, this crystal lion supports Albert's shrine of ebony and etched crystal on the preceding pages. Its golden wings spread like spiked fins, this big-headed beast makes an imposing guard for the duke's treasured box.

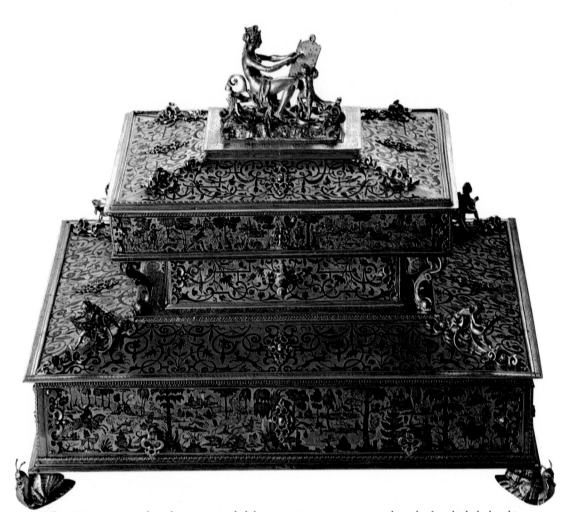

Albert V, passionate about letters, owned elaborate writing accessories such as the foot-high desk cabinet above. The gilded, tiered boxes—with drawers for storing pens and stationery—are riotously colored with translucent enamels of scrollwork and hunting scenes. Golden figures affixed to the cabinet make allegorical references to the duke's pursuit of art and learning: the woman seated on the lid teaches the alphabet to a cherub, whose companions (one is in detail opposite) seated on the corners of the lower box represent grammar, mathematics, astronomy, and music.

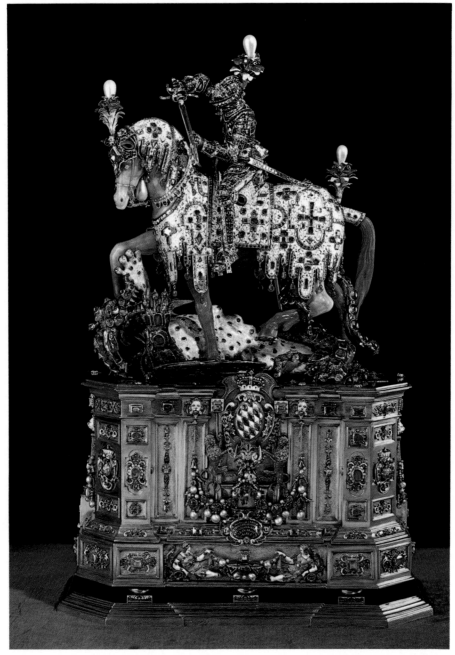

A veritable monument, the dazzling sculpture above—also in detail opposite and on pages 68–71—is a twenty-inch-tall reliquary of Saint George, the dragon slayer. William V, devout but by no means ascetic, commissioned the treasure in about 1586, giving his favored goldsmiths, lapidaries, and enamelers free rein in the lavish creation: a contemporary estimate held that the cost of the reliquary was equivalent to that of raising a small army. Thousands of diamonds, pearls, rubies, and emeralds cover the figures of the saint and the dragon. The heroic saint has broken off his lance in the trampled beast and prepares to finish off his foe with his sword. Early in the seventeenth century, William's heir, Maximilian I, ordered this new silver-gilt pedestal, emblazoned with the white-and-blue crest of Bavaria. The base was designed to hold a sacred relic from the body of Saint George.

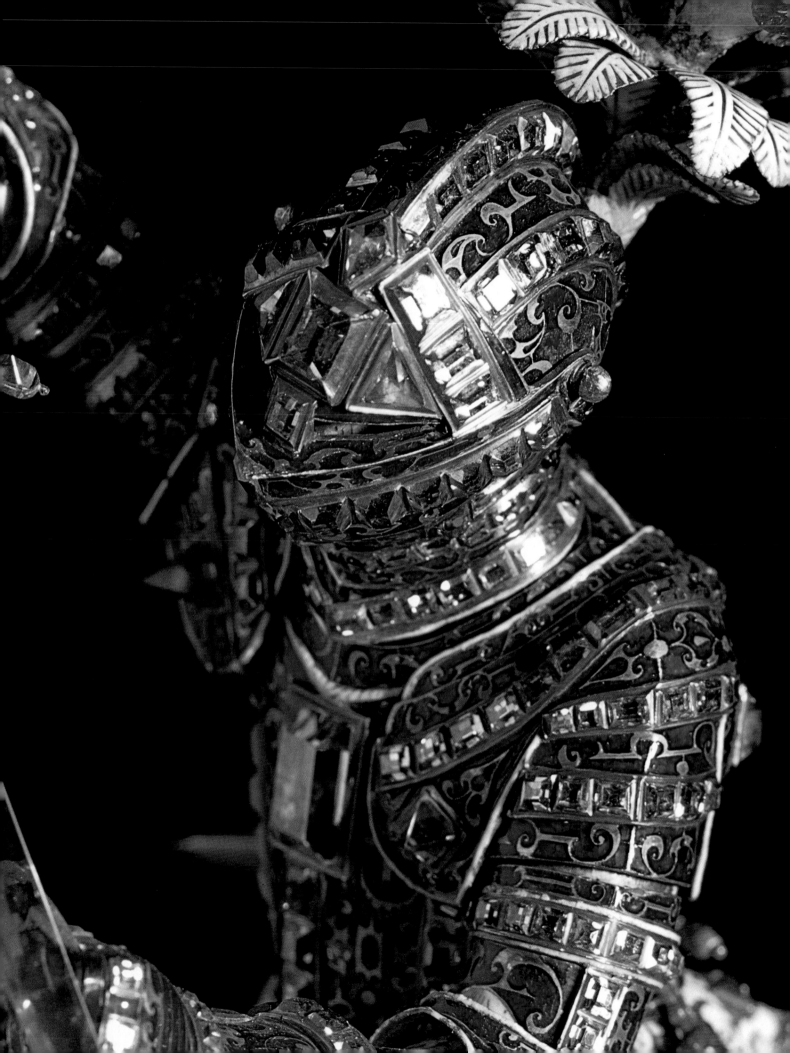

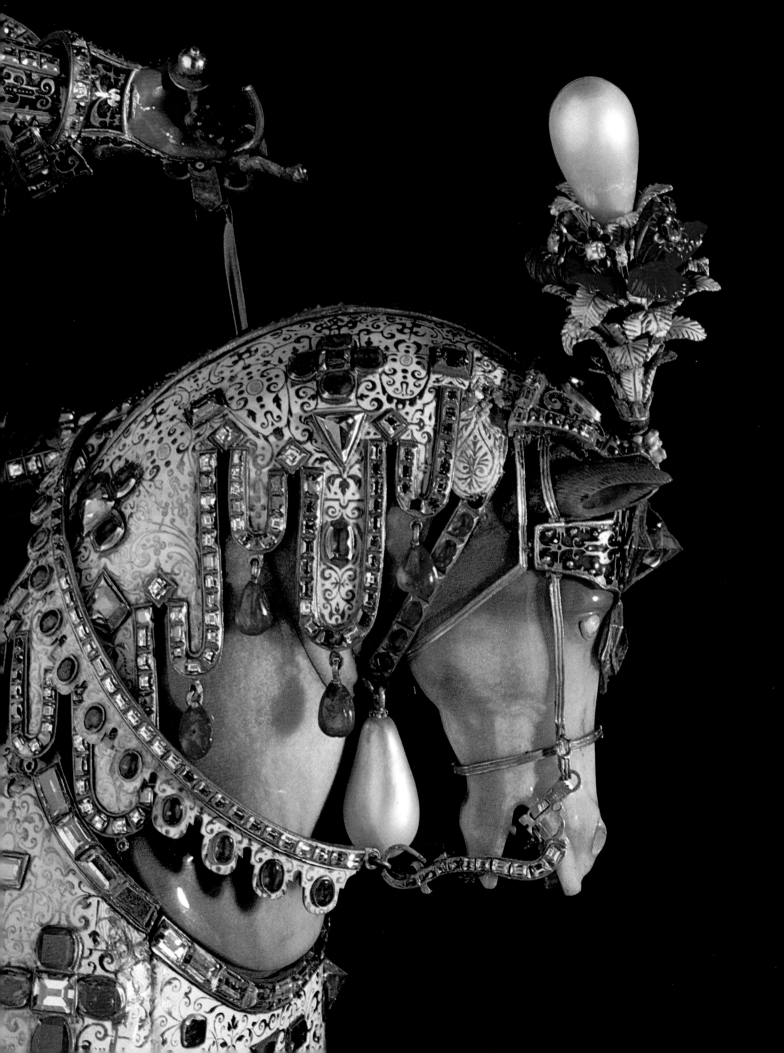

Saint George's opal-eyed horse, here in two views, is as magnificently arrayed as his chivalrous rider: the steed's armor and harness are trimmed and hung with precious stones. Swirling patterns in gold decorate the glossy enamel surfaces of the caparisons. The horse, carved of agate and with hooves of chalcedony, also wears a crest of ruby feathers and a great pearl plume. At right the knightly saint, having closed the visor of his diamond- and sapphire-studded armor, raises his gold-hilted sword to plunge its blade of rock crystal into the dragon.

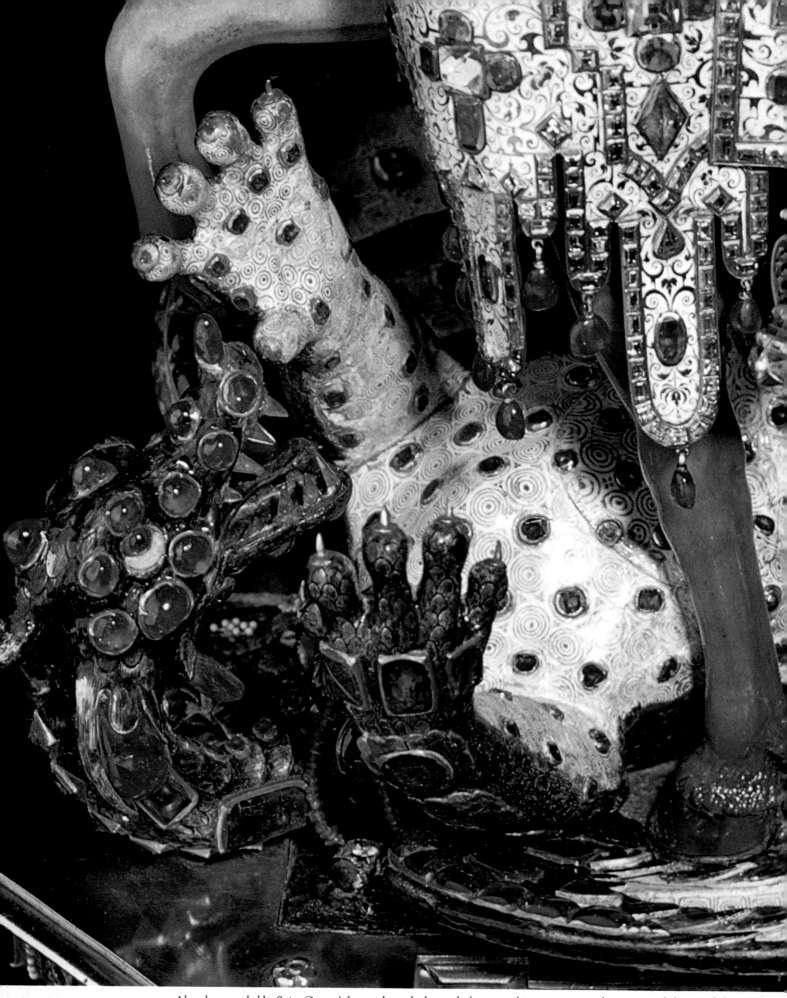

Already wounded by Saint George's lance, the scaly dragon lashes out at his conqueror one last time, with fangs and claws. The gre

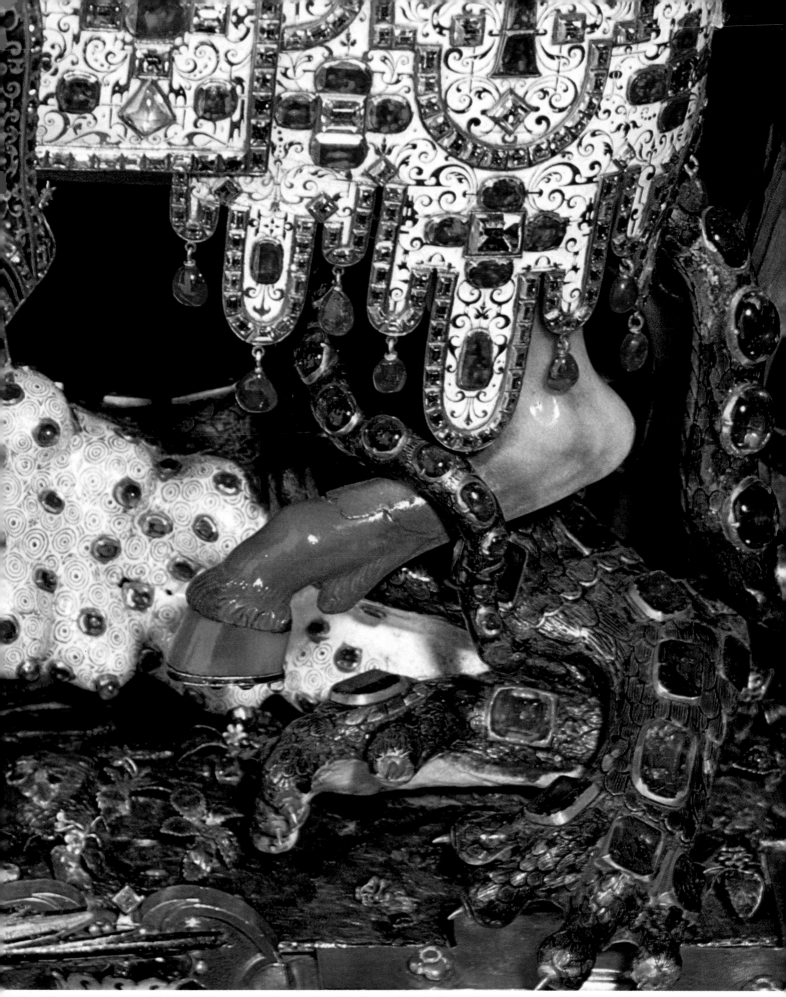

...ast has fallen on his back amid the horse's hooves, revealing a vulnerable white underbelly that will soon receive the death blow.

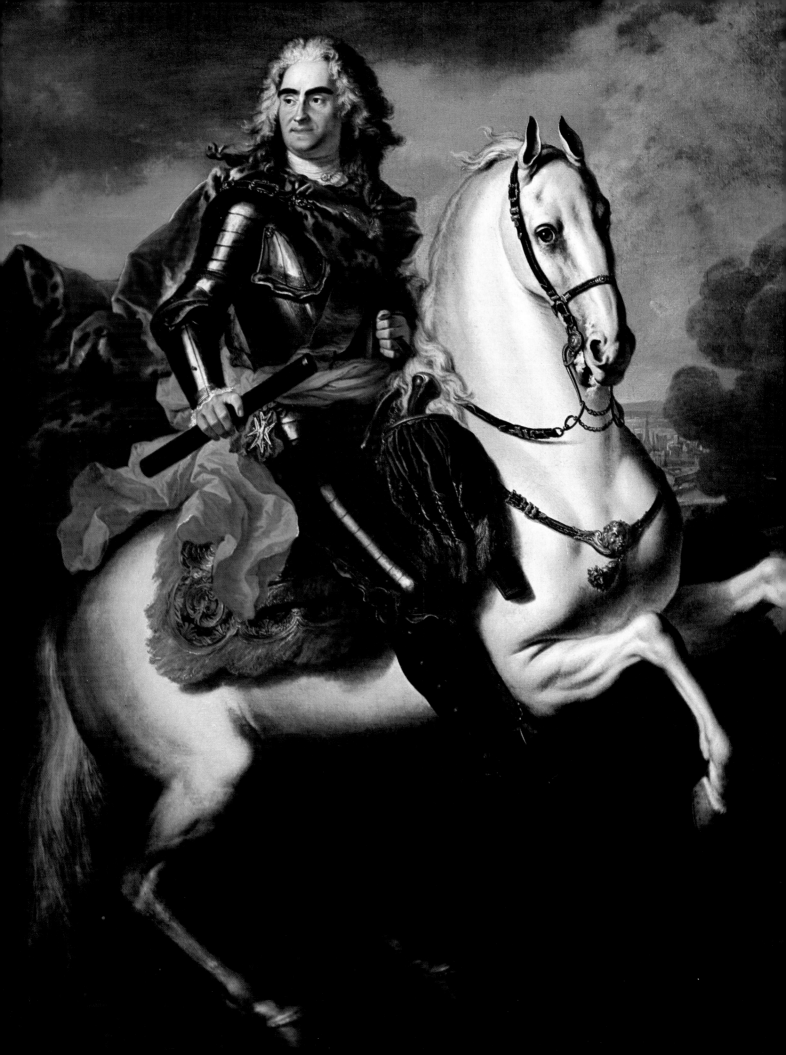

III

AUGUSTUS THE STRONG

MASTER OF THE REVELS

A man who could turn lead into gold was too valuable an asset to be allowed to run around loose; hence Augustus II in 1701 had this reputed alchemist arrested and brought to Dresden, where he was made to demonstrate his recondite arts and sciences. As king of Poland and prince-elector of Saxony, Augustus had the power to act in so arbitrary a fashion. A spendthrift monarch desperate for gold, he had need of the services of a man rumored to be a veritable *Dukatenscheisser*—an "excreter of gold coins." As it turned out, the object of Augustus's fevered attention, one Johann Friedrich Böttger, was merely an apothecary's apprentice who had conducted some abortive experiments in Prussia and had fled to Saxony before the authorities could discover his secret—that he was quite unable to make gold.

Böttger's reputation became a burden he could not throw off. Though Böttger denied he had ever made gold, Augustus hustled him into a laboratory, ordered him to continue his experiments, and kept him under the strictest surveillance. His supervisor was the

Fully armored on a soulful white horse, Augustus II, the eighteenth-century ruler of Saxony and Poland, strikes a pose evoking his sobriquet: Augustus the Strong.

court scholar and chemist Walter von Tschirnhaus, who had spent years in the royal laboratories trying to duplicate white, translucent, hard porcelain, like that Augustus imported at enormous expense from China and Japan. The Chinese had invented porcelain in the seventh century and the Japanese in the seventeenth century. They had successfully kept the manufacturing process a secret and enjoyed a lucrative worldwide monopoly on porcelain as a result.

All the most advanced ceramists in Europe were hard at work trying to copy Chinese porcelain, yet no one had arrived at a solution. A thick, opaque ceramic called ironware was the best they could do. Tschirnhaus himself had produced nothing better than a kind of milky glass. He taught Böttger everything he knew; and not long after the old scientist's death, in 1708, the prisoner in the laboratory produced the first tentative pieces of a very hard red pottery that had all the qualities of porcelain except its translucency. Still it was sufficiently salable that Augustus moved Böttger to the Albrechtsburg, a disused Gothic castle in nearby Meissen, where the prisoner now had charge of a factory as well as a laboratory.

The white clay Böttger used in his porcelain experiments left much to be desired; and for three more years he struggled with the problem. Then, according to an old account of the matter, "a certain Johann Schnorr, an ironsmith traversing the environs of Aue, observed the white mire in which his horse was stepping, and imagined it would prove a cheap substitute for the flour then used for powdering wigs." Schnorr collected some of it in his handkerchief, "made experiments with it, and ultimately sent it out largely for sale. Some time after, Böttger was surprised at the unaccustomed weight of his peruke [wig]; he shook it, examined the white powder that flew out, had the remainder of the packet brought to him, and chancing, as he took it between his fingers, to manipulate it like plastic clay, he perceived suddenly, in a delirium of joy, that he had discovered the chief substance of porcelain—kaolin."

The white clay of Aue enabled Böttger to produce a white porcelain in every way comparable to that used in the magnificent statuettes and tableware imported from the workshops of Asia. The

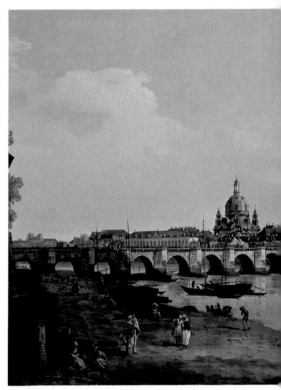

The rhythmic arches of a stout stone bridge span the Elbe River in the heart of Dresden. The city was an ordinary market town until Augustus II and his son Augustus III made it into a showplace of eighteenth-century architectural styles, some of which are captured in this sweeping view by Augustus III's court painter, Bernardo Bellotto, called Canaletto.

Meissen, sometimes called Dresden, china factory thus gained a head start on every other European porcelain factory.

Augustus himself became the best and most enthusiastic customer. He commissioned, and even designed himself, individual pieces that he could put on display or give to other courts as a form of royal self-advertisement. Whole rooms in his palaces were decorated with porcelain ornaments; not understanding its limitations, he hoped eventually to have furniture made of it.

Meissen china remained the most sought after and widely imitated of European porcelains; soon even the Ottoman Turks (who had far easier access to Chinese production) were importing it for their palaces in Istanbul. As for Böttger—a goose that laid golden eggs—he remained a prisoner in the Albrechtsburg, for his processes were now state secrets. He died at thirty-seven, poisoned by some of his own laboratory experiments, one of the earliest victims of occupational disease.

Thanks to Böttger, Augustus won renown as the ruler who had sponsored the invention of European porcelain; and renown was something Augustus valued as highly as gold. His greatest ambition, Augustus once wrote, was "to achieve lasting fame, and I shall strive for it to the end of my days." With fame as the spur, he undertook a great many hasty and ill-considered adventures that nearly cost him his crown, and he was always willing to risk life and limb for the most frivolous reasons, whether on the battlefield or in the arena. Perhaps the problem was that he had not been raised to be a ruler and had never been taught to check his impulses. It was his older brother, Johann Georg IV, who had inherited the electorate of Saxony from their father. Augustus, born in 1670, was seemingly destined for the carefree life of a younger son. But smallpox suddenly carried off his brother, in 1694, and Augustus found himself the new prince-elector of Saxony.

He was a man of immense stature and weight—for much of his life he weighed 260 pounds—and he loved fighting for the sheer pleasure of it. In the absence of a suitable enemy in the field, Augustus would take on the biggest, toughest antagonists in the lists, or

display his skill before festival audiences, fighting bears and bulls. At the coronation of the Hapsburg emperor Joseph I in Augsburg, Augustus caused a great stir when he practiced his gladiatorial talents against an angry bear, which he decapitated with two blows of his mighty sword. At home, in the courtyard of his palace in Dresden, he would amuse himself and the townspeople by having his servants release wild boars to run at him. Only once did he miss his target with his hunting spear; but as the boar charged him he dodged, caught it by the hind leg with one hand, drew his sword with the other, and killed it with a single stroke.

The stories about his physical strength abound and are still told by the Saxons as they sit around a fire. When it came to bending and unbending iron bars, he put even the strongest blacksmiths to shame. According to one tale, when Augustus's horse threw a shoe, and a village blacksmith made a replacement, Augustus decided to have a little fun with the smith. As if testing the workmanship, he took the new horseshoe in his hands and snapped it in two. He tossed the smith a silver coin to pay for another shoe, and the blacksmith—not to be outdone—crumpled the coin in his hand. With a laugh Augustus handed the blacksmith a gold coin and thus purchased one of history's most costly horseshoes. In Dresden, he liked to ride through the streets at a full gallop, holding the reins between his teeth and a street urchin in each hand. It was no wonder that he was known as *August der Starke*, "Augustus the Strong." To the educated classes, who greeted him with flowery poetry full of mythological and historical allusions, he was the Saxon Heracles, a monarch who was worthy of comparison to that great strong man of classical mythology.

For a man of Augustus's insatiable ambition, to be a mere elector was not enough: he wanted to be king. His opportunity came in 1696, at the death of John III Sobieski, the king of Poland. Since Poland was not a hereditary, but an elective monarchy, the great Polish nobles had to elect a new king, and Augustus persuaded most of them, by means of bribes and promises, that he was the right man for the job. In some respects it was an impractical union of crowns:

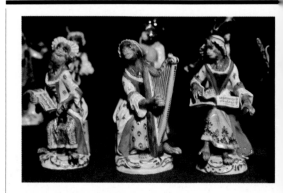

The monkey musicians above, and the tailor on goat back below, are among the many whimsical and exquisite figures made for Augustus II and III by the porcelain works founded at Meissen. In 1708 a scientist working for Augustus had discovered how to make porcelain; before then Augustus and Europe's other royal collectors could obtain the porcelain they loved only from Asia.

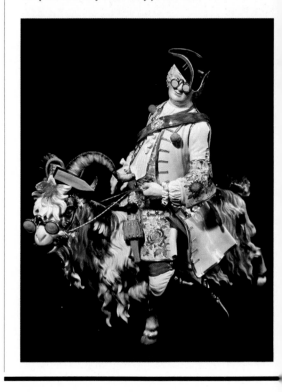

EUROPE'S NEW TREASURE: PORCELAIN

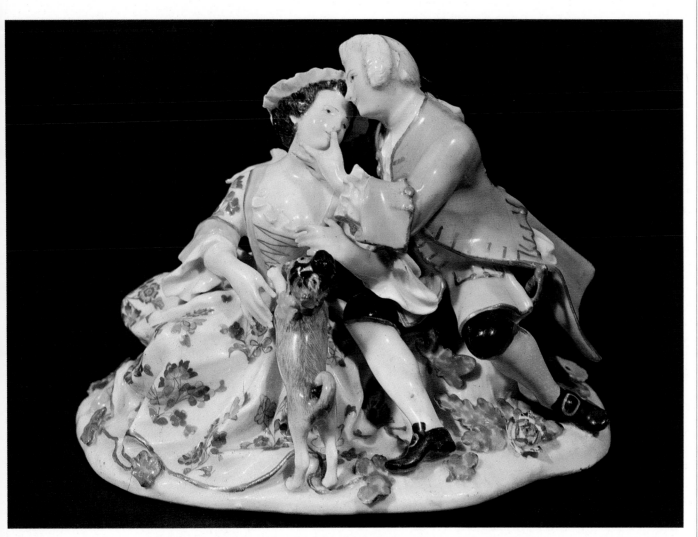

A little dog paws his mistress's knee but fails to distract her from the young man with whom she exchanges ardent looks and caresses. This delicately modeled group was probably inspired by the commedia dell'arte, a form of Italian comic theater much enjoyed at the Saxon court. Eighteenth-century Meissen figures were often based on the commedia, which featured slapstick buffoonery alternating with flirtatious or bawdy encounters between maidens and their suitors.

Saxony and Poland were separated by a wide strip of Austrian and Prussian territory, not to mention the broader barriers of language, custom, and religion. The Saxons were Protestants, and the Poles among the most devoutly Catholic people of Europe. Augustus could not qualify for the Polish crown until he had formally converted to Catholicism—a ceremony that took place just two weeks before his election as Augustus II, king of Poland, on June 27, 1697.

His conversion caused a furor in Saxony, which had been the very cradle of Protestantism. As Augustus explained in a letter to Pope Clement XI a few years later, "There is no country where the feeling against Catholicism runs so high as in Saxony; any undertaking that favors Catholicism will only stir up trouble." Yet somehow he managed to persuade the Saxons that his conversion had been only a tactical maneuver—while convincing the Poles that it had been sincere. Despite his impetuosity he was to prove adept at treading the fine line between two antagonistic religions, doing nothing in Saxony to upset the Protestants and nothing in Poland that would trouble the Catholics.

He had become ruler of a nation twenty times larger than Saxony, a land stretching from the Oder to the Dnieper, and from the Baltic to the Black Sea. In many ways the economies of his two dominions complemented each other, for Poland was rich in agricultural products and raw materials—grain, timber, cattle, flax, leather, furs—while Saxony exported manufactured goods, notably weapons, jewels, glassware, pottery, linen, lace. But Augustus lacked the patience to let nature and economics take their course so that he could grow wealthy on customs and excise taxes. He had spent lavishly to buy votes and establish his court at Warsaw, had pawned his jewels with the Jesuits of Vienna for a great sum, and had sold his rights to the duchy of Lauenburg to the elector of Hanover for another immense fortune. Yet there was not enough left over to pay the Saxon regiments that constituted his royal guard in Warsaw. "You can imagine how I feel, in a strange country with my army around my neck, and it's been six months since I've had a penny to pay them," he wrote to his regent in Saxony. "So do your utmost to obtain some

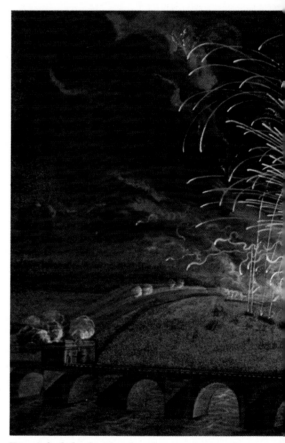

Fireworks light the Dresden sky on a June night in 1709: the climax of Augustus's extravagant reception for his cousin King Frederick IV of Denmark. Denmark and Saxony were allies in an ongoing territorial war against Sweden, and Augustus planned the fireworks in the form of a mock battle, doubtless to salute their combined military strength.

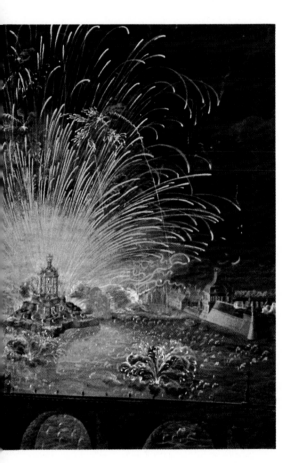

money for my army or it will fall apart and be completely ruined."

Financial reinforcements arrived in time to underwrite Augustus's most disastrous enterprise—an alliance with Denmark and Russia designed to deprive his cousin, Charles XII of Sweden, of Riga (a principal Baltic port) and the rest of Sweden's possessions in Livonia, a region east of the Baltic Sea. Before the allies could unite their forces, Charles's fast-moving regiments counterattacked and defeated their armies one at a time. After Charles had routed a good part of the dispirited Saxon army, the defeated general wrote ruefully to Augustus in a classic after-action report: "It is impossible to bring a battle to a successful conclusion if most of one's cavalry and infantry lack the will to use either heart or hand."

Swedish troops occupied Saxony for more than a year and made the local authorities pay dearly for the dubious privilege of quartering them. Augustus had to sign away the Polish crown before they agreed to withdraw. But Charles XII also overreached himself. He marched into Russia only to meet defeat. This allowed Augustus to return to the Polish throne in 1709 and begin the second, more peaceful and productive, phase of his double life as ruler of Saxony and Poland. And it was during these last years of his reign that he was able to demonstrate his formidable talents as a builder of palaces and patron of the arts.

Dresden then had a population of fewer than thirty thousand souls. Augustus turned it into a capital of striking beauty—the so-called German Florence—with towers, bridges, spires, cupolas, and superb palaces bedecked with copper-green roofs. As a young man he had made the grand tour through the major European cities and seen most of the great palaces of Italy and Austria, as well as Versailles—in France—and the Escorial, in Spain. Now he wanted a comparably imposing residence for himself. The main audience rooms of his family palace had been gutted by fire in 1701: Augustus sketched out an ambitious plan for a total renovation of the old structure. He extended the building to include part of the city fortifications where the *Zwinger*, or "kennels," were located. The kennels gave their name to the Zwinger Palace, which was to

TEXT CONTINUED ON PAGE 84

FLASHING FINERY FOR THE KING

BUTTON

Throughout his life Augustus II took very seriously indeed all the forms of ceremony and display that, he reckoned, were indices of princeliness. Not the least of these was the display he made with his clothes. In the 1600s Louis XIV of France had exemplified the view that royalty must always be fashionably dressed and that great jewelry was the acme of royal fashion. Louis' example became a creed for many succeeding monarchs including Augustus, who changed his clothes and jewels several times a day so that he would be properly turned out for his various activities.

From his youth on, Augustus was a clever connoisseur of the jeweler's art, ordering sword hilts, watch fobs, pins for his wigs, clasps for his tricorn hats, and myriad buckles and buttons and other ornaments. He had everything made in matching, gem-encrusted sets, including these emerald pieces for daytime wear and diamond pieces for the evening—for so fashion dictated. And when Augustus became a member of various chivalric orders—aristocratic honor societies such as the Order of the Golden Fleece—he commissioned jeweled badges of the orders that were the capstones of his ensembles.

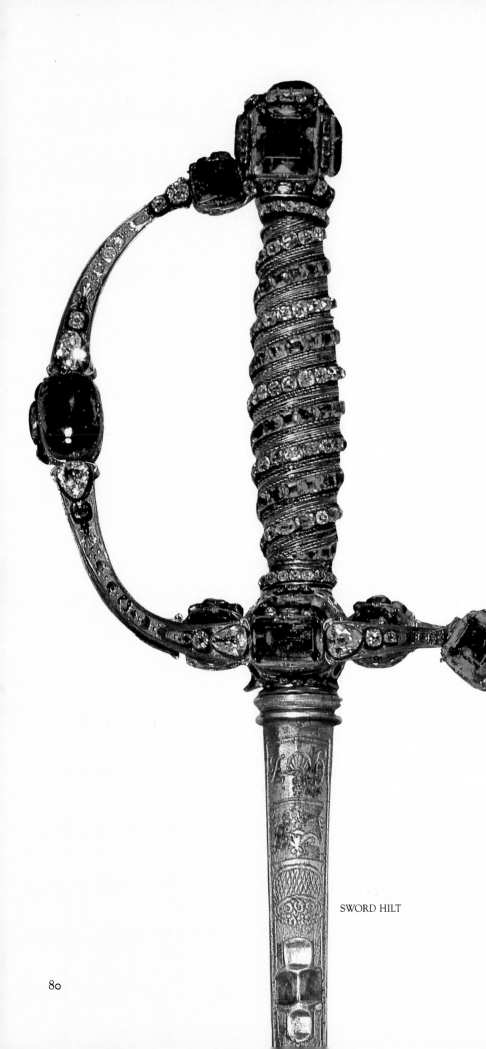

SWORD HILT

The sword hilt and button on this page, and the buckle and two badges opposite, belong to a fifty-nine-piece set of emerald jewelry trimmed with diamonds and red enamel, first owned by Augustus II and added to by Augustus III. Green was the color favored for hunting clothes, which these jewels probably adorned. Even while chasing deer, the Saxons dressed to impress with these badges of the orders of the Golden Fleece and the White Eagle, the latter an old Polish order that Augustus revived.

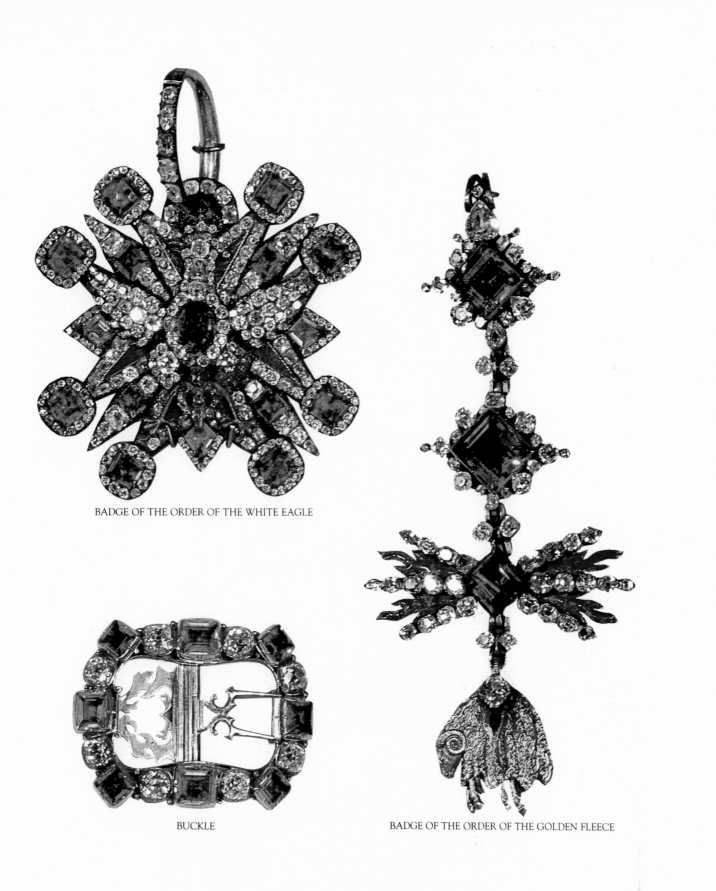

BADGE OF THE ORDER OF THE WHITE EAGLE

BUCKLE

BADGE OF THE ORDER OF THE GOLDEN FLEECE

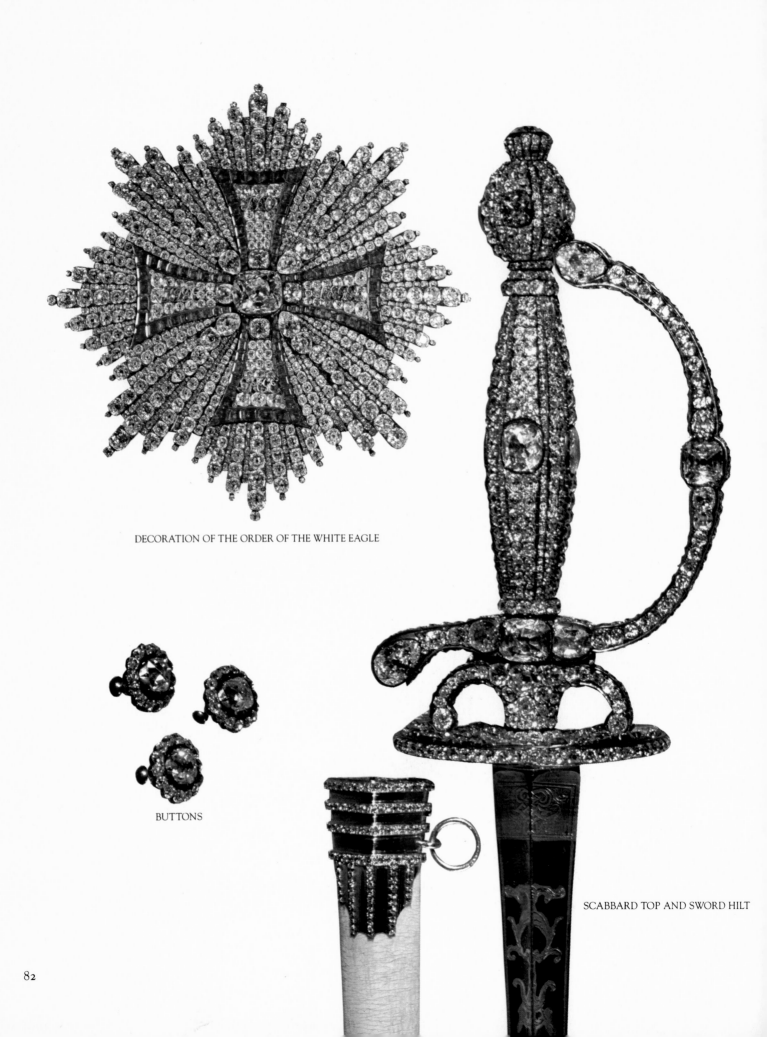

DECORATION OF THE ORDER OF THE WHITE EAGLE

BUTTONS

SCABBARD TOP AND SWORD HILT

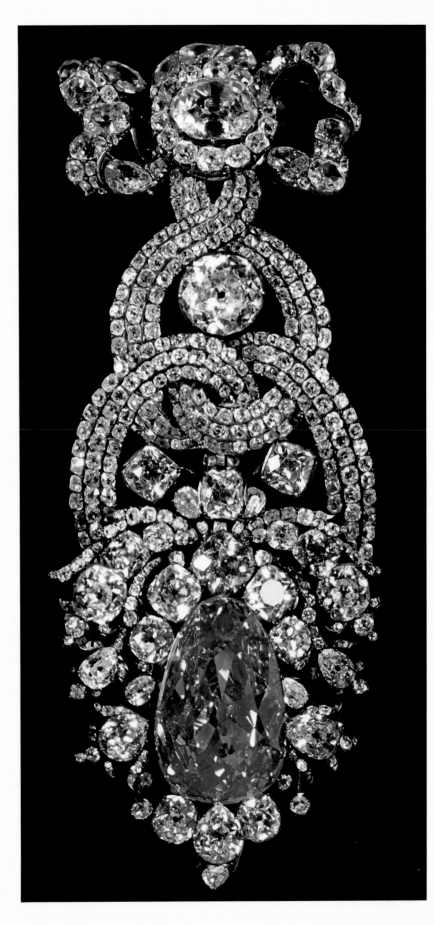

For the balls he attended almost every night, Augustus's evening ensembles included, opposite, a sword and scabbard aglow with scores of diamonds, a decoration of the Order of the White Eagle accented with rubies, and jeweled shirt buttons. The king's jewelers made liberal use of diamonds, cut them to form many facets, and virtually paved his ornaments with them so that Augustus glittered and flashed on the dance floor.

At forty-one carats, the great pear-shaped gem on the hat clasp at right is the world's largest green diamond—a particularly rare variety of the stone. It came to be called the Dresden Green after the home city of Augustus III. He purchased it in 1743 and had it set among white diamonds, probably to wear with the pieces opposite. The arrangement of the gems forms a posy, suspended from ribbons, and a bow—a popular ornamental motif of the period.

TEXT CONTINUED FROM PAGE 79

become the finest baroque palace in all of Germany, the palace where Augustus displayed his art collections and presided over sumptuous court festivities.

Long before the buildings were completed, in 1722, he had already amassed the paintings and sculptures with which to decorate them. He bought Flemish and Dutch masterpieces in Antwerp and imported vases and sculptures from Italy, as well as such pictures as Venetian master Il Giorgione's *Venus Asleep* and the Italian painter Palma Vecchio's *Reclining Venus*—both from the turn of the sixteenth century. But some of Augustus's most dazzling acquisitions were the jeweled ornaments and statuettes made for him in Dresden by the court jeweler Johann Melchior Dinglinger—a name as euphonious as one of his own chiming clocks—who was among the foremost craftsmen of the century.

Dinglinger flattered his patron's vanity with a chalcedony bowl surmounted by a reclining Heracles, and another of Egyptian jasper depicting the fighting Heracles. He carved a maiden (see page 96) from rhinoceros horn and draped her in gold and diamonds; and he created a breathtaking table decoration entitled *Diana in the Bath*—in which an ivory image of that Roman goddess reclined in a chalcedony bowl amid surroundings of gold, silver, and jewels (see pages 86 and 94). These treasures were put on display in the famous Grüne Gewölbe, the "Green Vault," of the Dresden palace, described by a contemporary of Augustus's as the place "wherein the lord of the land keeps the most precious curiosities and the most meaningful creations of the most famous artists of Europe." Colored marble covered the floors of the three-room vault, and mirrors sheathed their columns, reflecting the golden tables on which the king's favorite pieces were arrayed. Among them was Dinglinger's most curious and complex invention, a jeweled oriental fantasy in miniature that was entitled the Court at Delhi on the Birthday of the Mogul Emperor Aurangzeb. Over 130 figures—some carrying tiny birthday presents—populated Dinglinger's charming little court (see the foldout, pages 98–103).

These costly bibelots mirrored the splendors of court life in

Parading a huge sausage coiled on a pole, Saxon soldiers cavort at a lustlager, or "pleasure encampment," featuring feasts, drills, and band music. In 1730 Augustus held one of these festivals for his entire army—about thirty thousand men—and erected a city of tents for the occasion.

Dresden as well as Delhi, for Augustus's fetes and birthday celebrations were hardly less sumptuous than those of Aurangzeb. It has been estimated that he spent five times more on pageants and court festivities than he did on art objects and paintings. But the fetes were actually all-encompassing works of art, with music, theater, fine arts, and ballet blending to create a supreme artistic effect. Though the subject matter of the fetes was usually borrowed from history or mythology, their significance was inescapably contemporary. At the height of his great love affair with the Swedish beauty Maria Aurora von Königsmark, Augustus led a procession of Greek gods, two and a half miles long, through the streets of Dresden. The monarch himself was dressed as the divine herald Hermes; near the head of the parade, his wife appeared on a float as a Roman temple virgin; toward the rear rode a general arrayed as the Greek god Apollo, followed by a carriage bearing four poets and twelve musicians serenading Maria Aurora. She was costumed as the Dawn—a wreath of the sun's rays plaited in her hair. The parade was Augustus's unsubtle way of telling his subjects that he now possessed the most beautiful woman in the entire realm.

Masked balls were a frequent and favorite diversion at Augustus's court. At outdoor balls in the courtyard of the Zwinger Palace, nobles on horseback appeared as African lords, Asian satraps, and American Indian chiefs. Everyone was expected to contribute to the fun; the royal children—besides the crown prince there were eight officially recognized illegitimate children—impersonated Greek gods and recited verses that the court poet had cobbled together for them. A specialty was the so-called farmer's feast, where princely guests disguised themselves as rural yokels in colorful costumes—Italian peasants, Norwegian woodcutters, Swiss dairymaids—the quainter, the merrier. The only one who had trouble vanishing into the anonymity of a carnival costume was Augustus himself: there was no disguising that immense height and bulk.

Once, when the court poet expressed his surprise that his majesty could give such magnificent parties despite the demands on his time made by the governing of Saxony and Poland, Augustus told him in

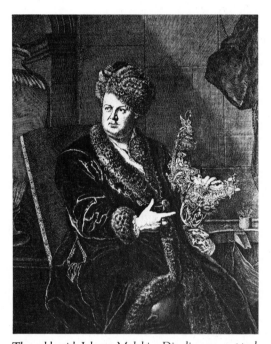

The goldsmith Johann Melchior Dinglinger, wrapped in a fashionably fur-lined housecoat, holds Diana in the Bath *(also see pages 94–95)—one of the elaborate creations he wrought for Augustus. Dinglinger was an obscure jeweler when he came to Saxony in 1692, but his novel designs and awesome craftsmanship soon made him the prosperous court favorite he clearly is here, in 1722.*

all earnestness: "Magnificence is necessary for a ruler, since he is God's representative on earth. Just as God reveals His magnificence in His manifold works, thus the ruler, too, must shine and glitter in all his public manifestations."

As his own chief master of the revels, Augustus surpassed himself at the famous *Lustlager,* or "pleasure encampment," of Zeithain, near the Elbe River. The purpose of the affair, which lasted for four weeks in June 1730, was not only pleasure but politics, since the guest list included most of the great princes of Germany. Augustus used the occasion to display his nation's evident prosperity and its splendidly drilled army of thirty thousand men. They went through their paces with great precision and élan, like so many ballet dancers, performing parade-ground drills and mock battles involving artillery, pontoon bridges, and other spectacular bits of the latest military hardware. The guests enjoyed banquets, balls, and garden parties amid pyramids and metaphorical sculptures. They camped in a sumptuous city of tents made after both the German and Turkish fashions; even the chamber pots were gilded. The bakers' guild of Dresden provided a festival cake in their ruler's honor. An 8-horse wagon carried the cake to the encampment, for the confection weighed 1,600 pounds and measured about 40 square feet; some 3,600 eggs had gone into it—a cake fit for Heracles!

Augustus laid plans for organizing another Lustlager three years later, this time in Warsaw. But he had long suffered from diabetes and had already lost a toe to gangrene. On the bumpy journey to Warsaw, his left leg became gangrenous, and in 1733 he died—the greatest showman of a profoundly theatrical age. He had already prepared the way for his son to become the next elected king of Poland, "for if he fails to retain the crown," Augustus said, "he will lose his status as a king and sink back into the generality of German princes." But this unnatural union of crowns was not destined to outlast his son. The balance of power within Germany was too precarious; the future lay with his tougher and less demonstrative neighbors to the north, the Prussians, who never bothered to turn their military maneuvers into pleasure camps.

THE FABLED
GREEN VAULT

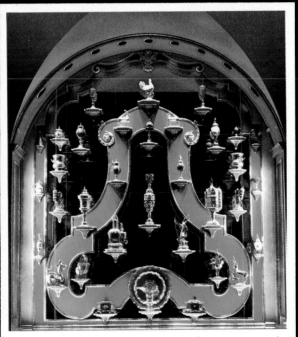

Ornate animals, vessels, and a toy ship are among the trinkets Augustus II displayed against a background of mirrors in the Green Vault, named for Saxony's national color.

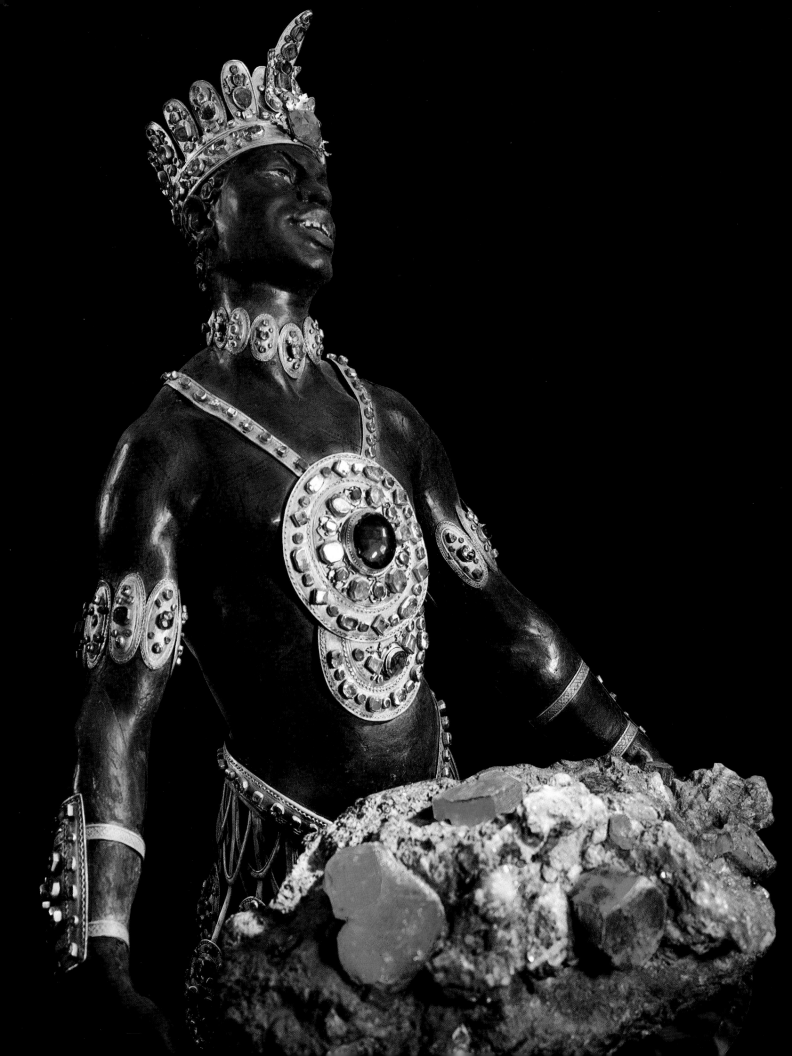

During the four decades Augustus the Strong ruled Saxony and Poland, he spent a good deal of time in neither place, but in a gorgeous realm of fantasy shaped only by his imagination and his wealth. Despite his massive body, his strong-man stunts, and his love of fighting, he was a voluptuary to the core. He indulged himself in whimsy and conspicuous consumption and thus displayed his absolute authority and freedom from mundane cares. He was equally the master of the revels and the master of the state.

Augustus filled his days with pleasant diversions: pageants, picnics, ladies' carriage races, and balletic parades of nobles on horseback, garbed in outlandish costumes. In the same spirit of play, he filled his palaces with beautiful treasures that were expensive, largely impractical, and exquisitely imbued with make-believe. Many of these treasures were the work of the royal goldsmith Johann Melchior Dinglinger, who was blessed with imaginative energy equal to his patron's. Augustus lived out his fantasies—pretending he was a sultan, he hosted an elaborate oriental feast in a palace park—and Dinglinger wrought them in silver and gold, with sculptures such as the miniature court of a Mogul emperor in the foldout. Since Augustus liked to surround himself with mementos of the Greek and Roman gods, Dinglinger made a specialty of vessels shaped like these mythic figures. One especially beautiful cup, on page 94, rendered the myth of Diana, the virginal goddess of the hunt who fascinated the womanizing Augustus. The cup may have alluded to a particular amorous escapade at the prince's woodland retreat, where a court lady dressed as Diana presented a new mistress to Augustus, who was costumed as the ribald nature god Pan. For Augustus it was not sufficient simply to bed the lady; first she had to be ceremonially initiated into his romantic realm of fantasy.

Augustus amassed a huge collection of objects from the workshops of Dinglinger and other artists, as diverse as the maiden on page 96 and the altarpiece on page 104. Perhaps feeling his age after decades of collecting and frolics, Augustus decided in 1723 that his fantastical trove of exotic, comic, and mythic figures should be displayed, for all time, in an appropriately splendid setting. He reconstructed and expanded the green-painted room where the state treasure had been housed. In this Green Vault, behind a secret door and seven-foot-thick walls, his make-believe could live on.

His featherlike headdress, massive breastplate, and other ornaments alight with many-colored gems, the laughing man in detail opposite holds a cluster of rough emeralds embedded in their original rocky matrix. The figure—whose carved wooden body is painted with tattoos—probably represents a native of the New World, whence the emeralds came.

Three gilded silver drinking vessels, each mounted with a nautilus shell, make a gleaming parade of mythical sea creatures. A vessel shaped like a siren—a winged seductress of sailors—leads two sea horses that are urged on by charioteering sea sprites. These charming figures, which Augustus inherited, are ill suited for drinking, although their removable heads hide openings for receiving and pouring liquid.

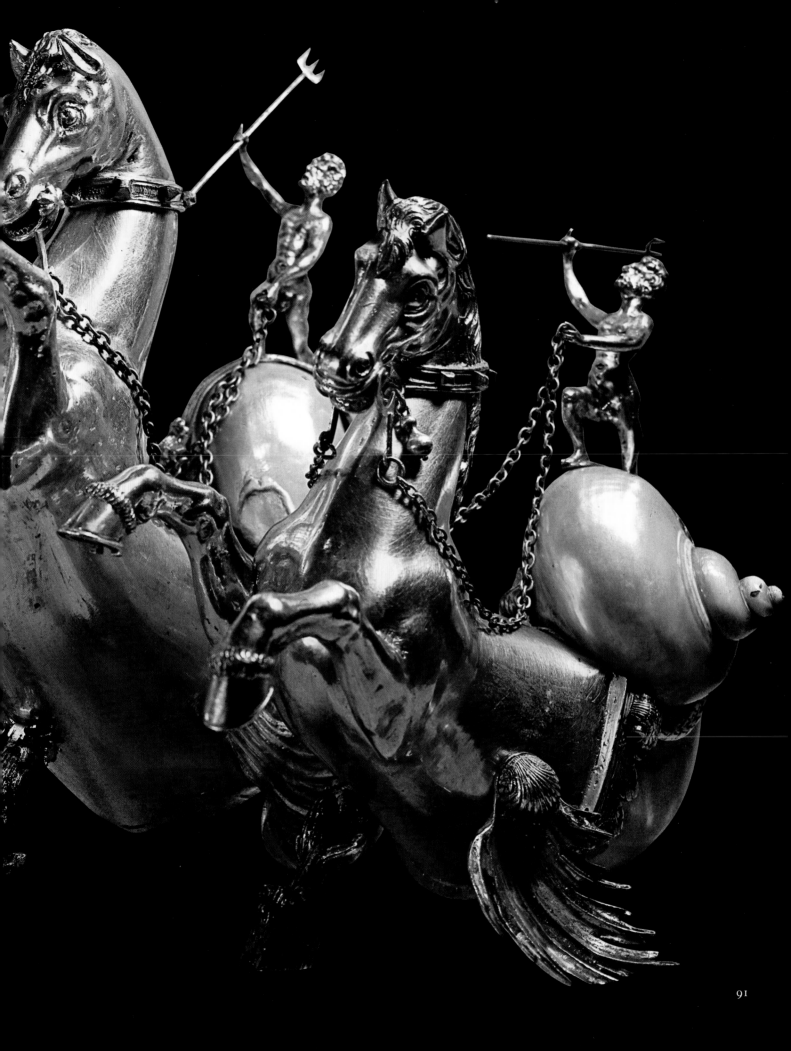

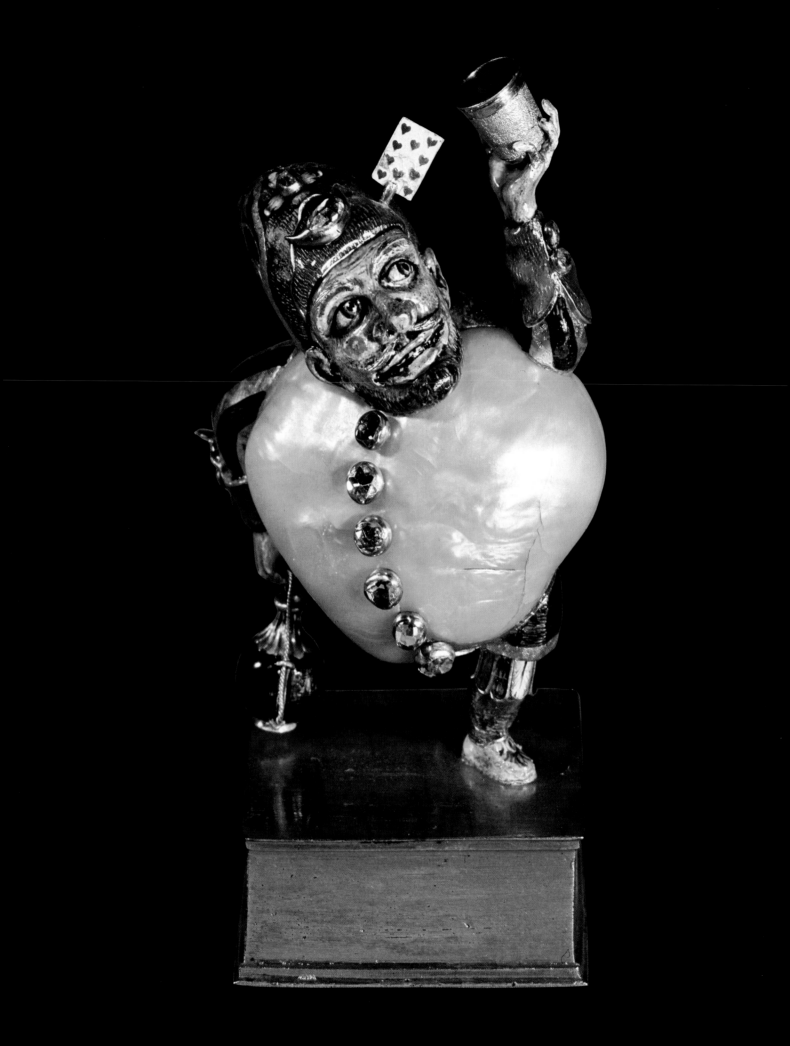

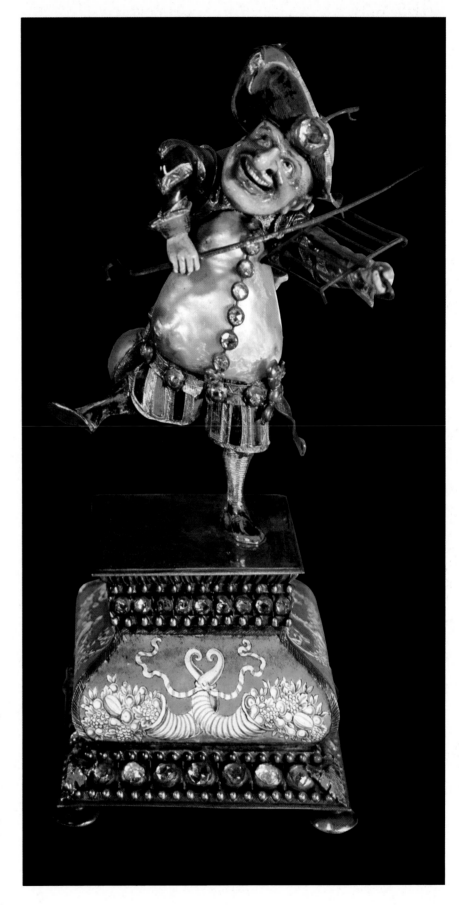

Two giant pearls, fitted with heads and limbs of enameled metal, form two tiny buffoons. The jolly cook at right wields a grate and spit as if they were a fiddle and bow. Together with its jeweled base, the figure is less than five inches tall. The three-inch-high dwarf opposite performs a trick with a playing card and a cup, while he totes a jug with his free hand. Augustus owned a large collection of these pearl manikins—which he used as dinner-table decorations—including a portrait of his own court dwarf, complete with a wig of human hair.

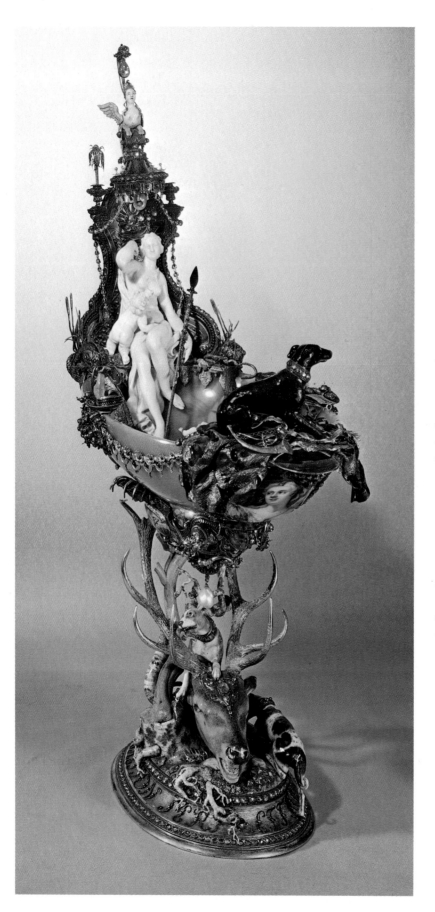

A black hound guards Diana's clothes while the naked goddess—carved in ivory—prepares to bathe in the luminous cup at left, made in 1704 by Dinglinger. He used chalcedony for the cup itself, and gold, silver, steel, various gems, pearls, and enamels for its complex mounting—which relates an episode from classical mythology. According to the myth, Diana was so outraged when the hunter Actaeon saw her in her bath that she transformed him into a stag. The unfortunate hunter was then torn apart by his own hunting dogs. On the base of the cup, in detail at right, two dogs worry the head of the dead stag, whose shining antlers form the cup's stem. One of Dinglinger's talented brothers, Georg Friedrich, painted the beautiful enamels of the eager dogs, the head with its sad eye and torn ear, and the woodland floor where the head lies. Metal letters around the foot of the base spell out, in French, the moral of the story: "Impudence ruins, discretion preserves."

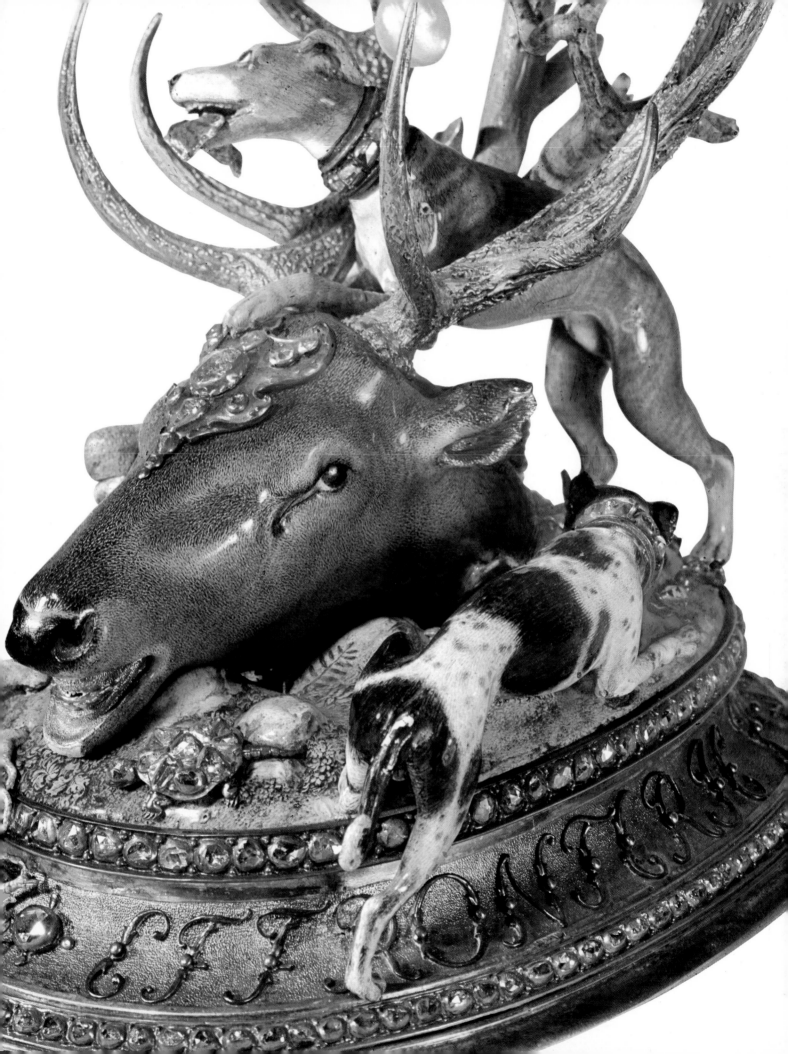

A bright diamond belt, diamond armlets, and low-slung, gold-spangled draperies barely cover the brown flesh of the maiden below and in detail at left. She holds aloft a shell-shaped cup bearing a dragon. Dinglinger fashioned both the woman and the cup from rhinoceros horn, which Augustus may have prized because it supposedly had the power to destroy poison. Dinglinger said he spent about eight years making the piece, which represents an alluring Moorish girl from North Africa.

On the lid of the shallow gold-and-enamel chalice above, three children—whose disheveled clothes reveal bodies of pearl—hold a Bacchanalia. Two dogs bark excitedly as one boy swigs from a bottle, another parades in an old-man mask, and a third collapses on the back of a goat: the symbol of Bacchus. With falling drawers and bare, pearly bottom, a fourth child climbs the chalice's stem, in detail at right, into the arms of a motherly looking woman.

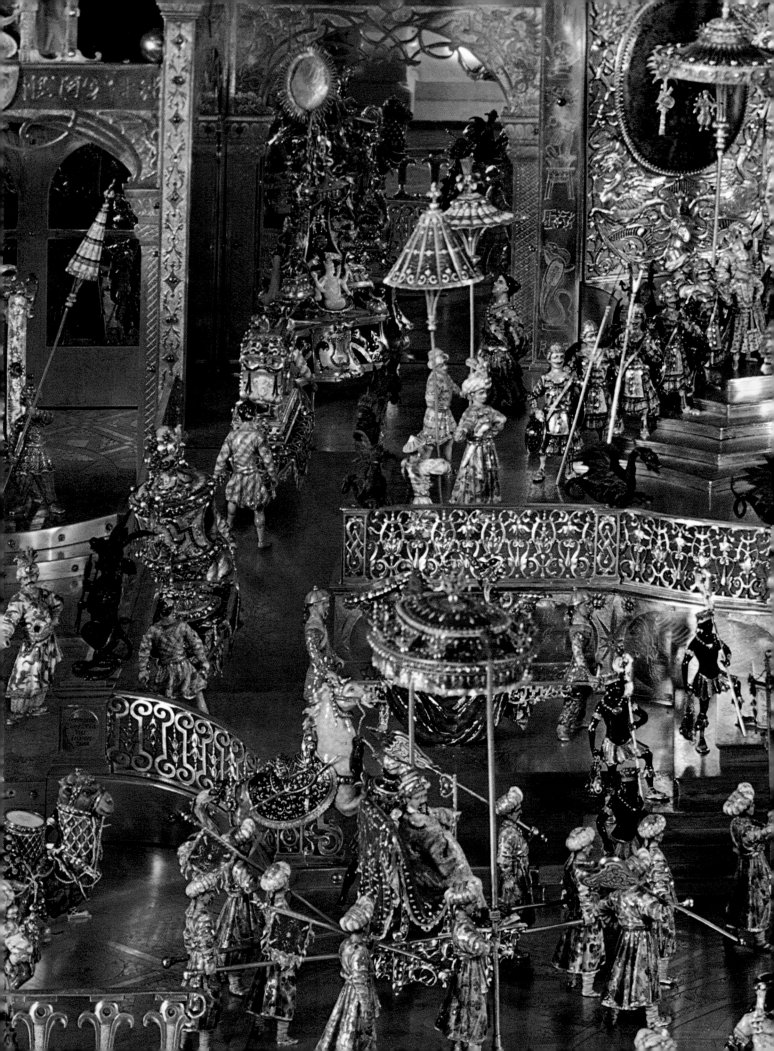

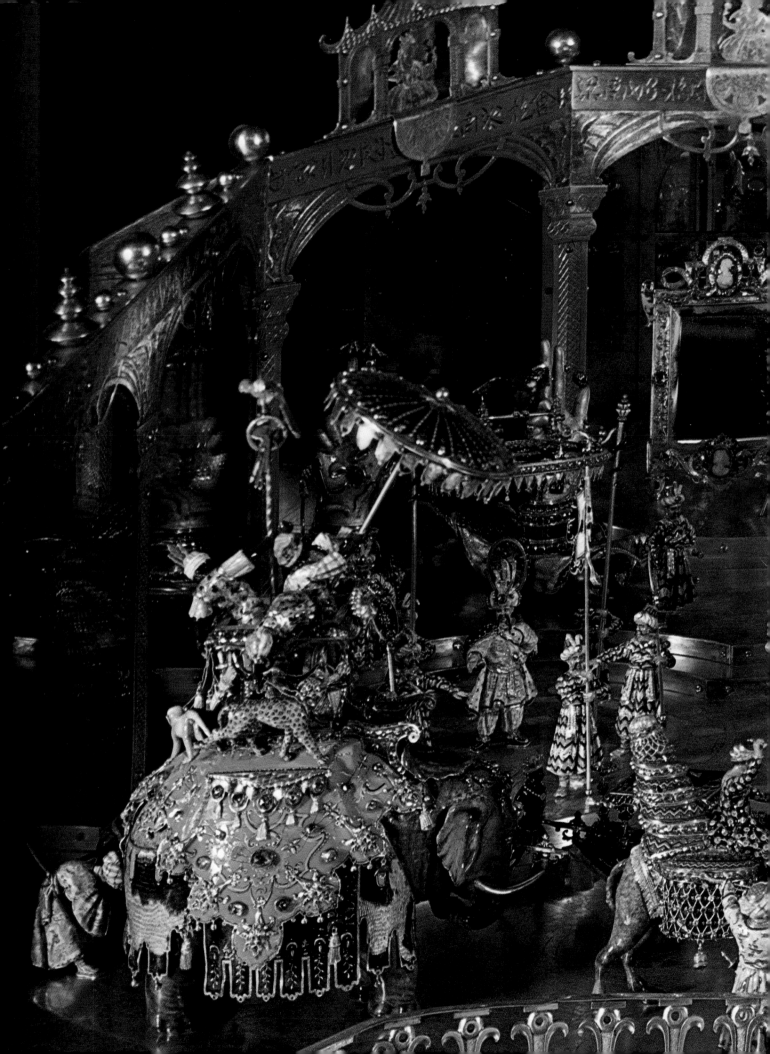

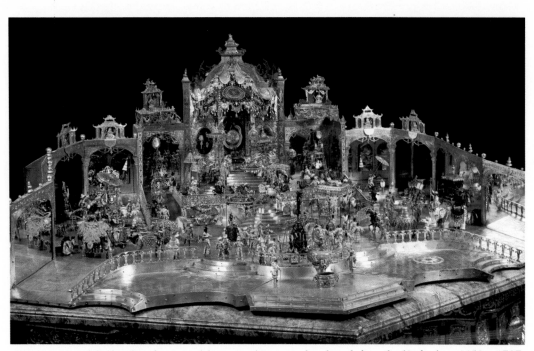

Augustus owned this bustling diorama of the court of Aurangzeb, who ruled much of India from 1658 to 1707.

In 1701 Johann Melchior Dinglinger's eagerness to delight his royal patron launched him on what may have been his greatest undertaking: a miniature diorama (above, opposite, and in the foldout) of the court of the Mogul emperor of northern India, Aurangzeb, on the occasion of the imperial birthday.

India was Europe's principal source of gemstones, ivory, luxury woods, and fabrics, and many Europeans believed Aurangzeb to be the richest and most powerful man on earth. Each year the emperor celebrated his birth by distributing to the poor his weight in gold and accepting magnificent gifts brought from all parts of his empire. Nothing could better charm the fantasy-ridden Augustus—Dinglinger doubtless reasoned—than a facsimile of the birthday celebration. To ensure complete authenticity of design, the goldsmith carefully studied all the literature he could find about Indian art, costume, and custom, including the writings of Jean-Baptiste Tavernier, an intrepid Dutch gem dealer who had witnessed one of Aurangzeb's birthday parties in 1670.

Assisted by his brothers Georg Christoph, who was a jeweler, and Georg Friedrich, Dinglinger spent almost a decade completing the project—a diorama almost 5 feet long and 4 feet wide, made entirely of precious metals, gems, and brilliant enamels and inhabited by 132 figures. The emperor sat in a gilded alcove attended by a throng of princely gift bearers and courtiers, each dressed according to his rank. Their gifts include clocks that work, a camel, horses, two elephants, a miniscule coffee service, mirrors, and a golden chest full of tiny weapons. More than five thousand diamonds as well as rubies, pearls, emeralds, cameos, and slabs of lapis lazuli and agate suffused the scene with color and light. With scholarship and consummate art, Dinglinger had created one of the most enchanting toys imaginable.

FOLDOUT: *The emperor's visitors, some accompanied by bearers with ornate canopies, crowd the golden staircase to the throne, where the great Mogul sits cross-legged on red cushions, scepter in hand.*

FOLDOUT ——▶

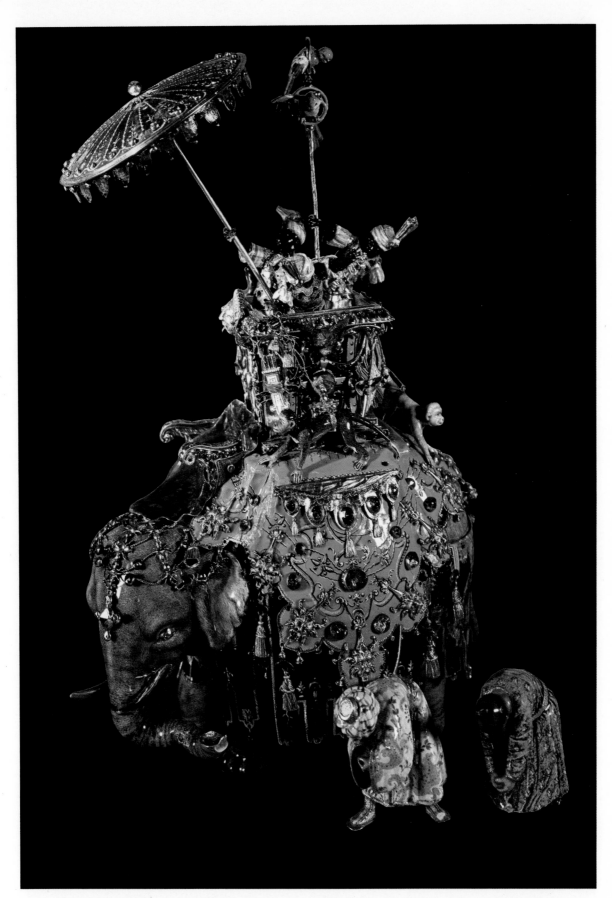

Two men bow low as they present a richly caparisoned gray elephant to the emperor. In the howdah, or riding compartment, on the beast's back, three attendants struggle to control a swaying parasol, a tall perch with parrots, and two monkeys on leashes. Like the other court figures, the elephant is made of solid gold, enameled in lifelike colors. The diamond-studded robes and howdah, fitted with quivers of arrows, equip the beast for one of the Moguls' favorite sports: hunting.

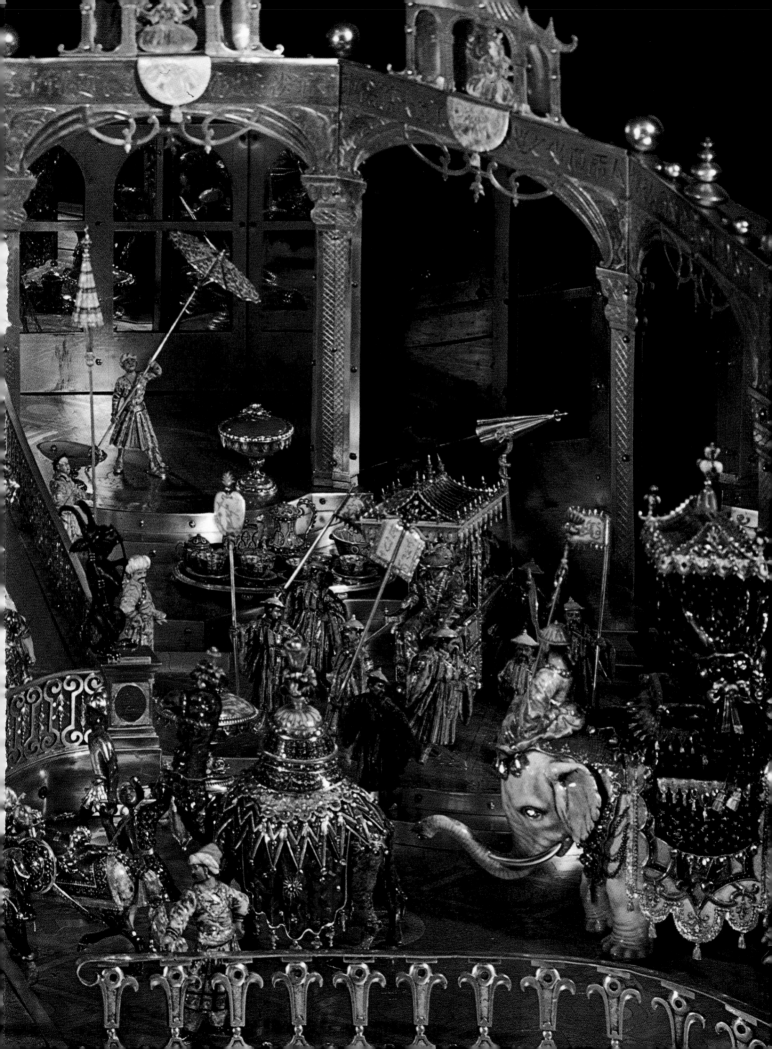

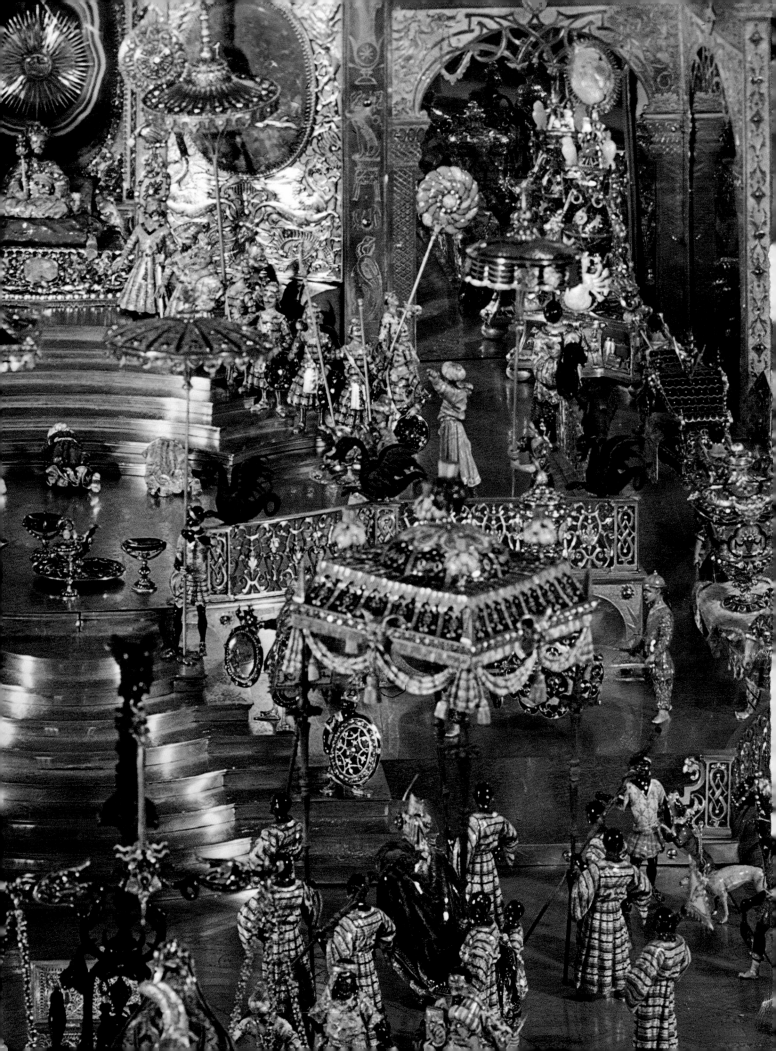

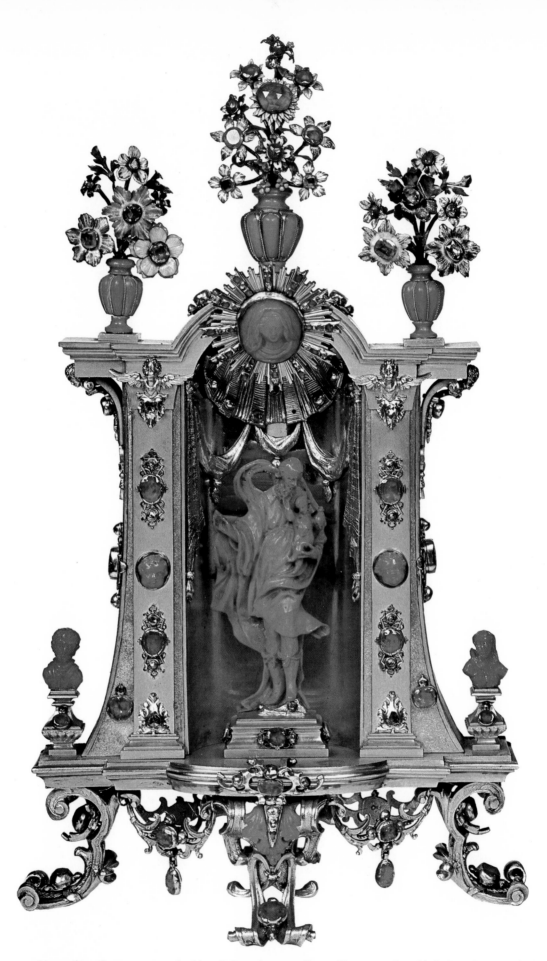

Vases of gay flowers, swags of golden cloth, and two small, coral busts give this gilded silver altarpiece the
feeling of a stage. In its niche stands a coral Saint Joseph holding Baby Jesus.

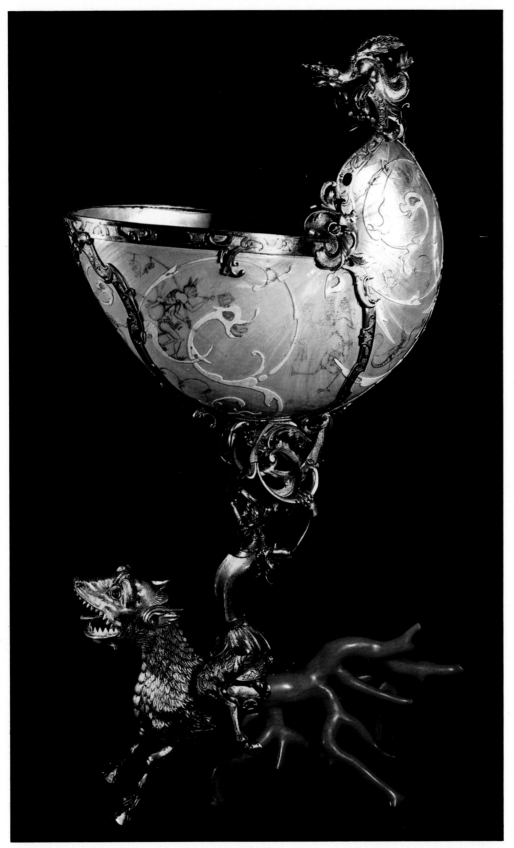

A golden dragon clings to the incised nautilus shell that forms the bowl of this goblet. Beneath it a faun—a mythical goat-man—wears a comic mask and rides a strange beast of silver gilt and coral.

OVERLEAF: *In a detail of the goblet above, the faun's arched torso and his mount's branching coral limbs give the inanimate object a sense of urgent motion, as if the faun were racing to Augustus's table with a fresh draft of wine.*

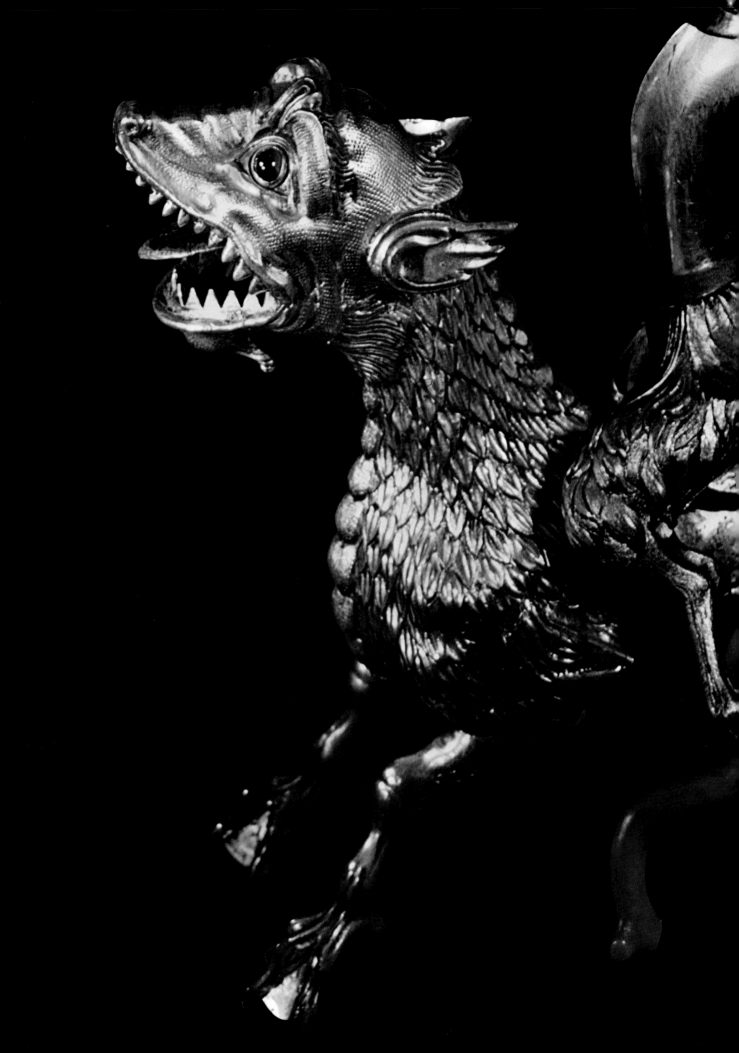

IV

EVERY INCH
A KING

FREDERICK THE GREAT

To his subjects—at least those who survived his wars—this gifted, irritable king of Prussia was Father Fritz, though he never had any children of his own. And he was only thirty-three years of age when, in 1745, they began to greet him in the streets of Berlin with shouts of "Long Live Frederick the Great!"—the name with which he was to go down in history. A brilliant strategist and tactician, Frederick II doubled the size of Prussia by seizing vast tracts of territory belonging to neighboring monarchs who were less skilled in the arts of war than he.

Frederick was also renowned as a philosopher-king who spent his happiest hours writing poetry in French, not German—a language he regarded as fit only for peasants—or playing his own sonatas for flute and harpsichord. He was a formidable collection of paradoxes: an enlightened despot, an idealist-pragmatist, a man of almost too many talents. "I am a dilettante in every field of endeavor," he confesses in one of his letters to Voltaire, the sharp-tongued man of French letters who became Frederick's literary mentor. On a typical

Frederick II, known as Frederick the Great, at right, brought Prussia to its peak of culture and power during his reign in the eighteenth century.

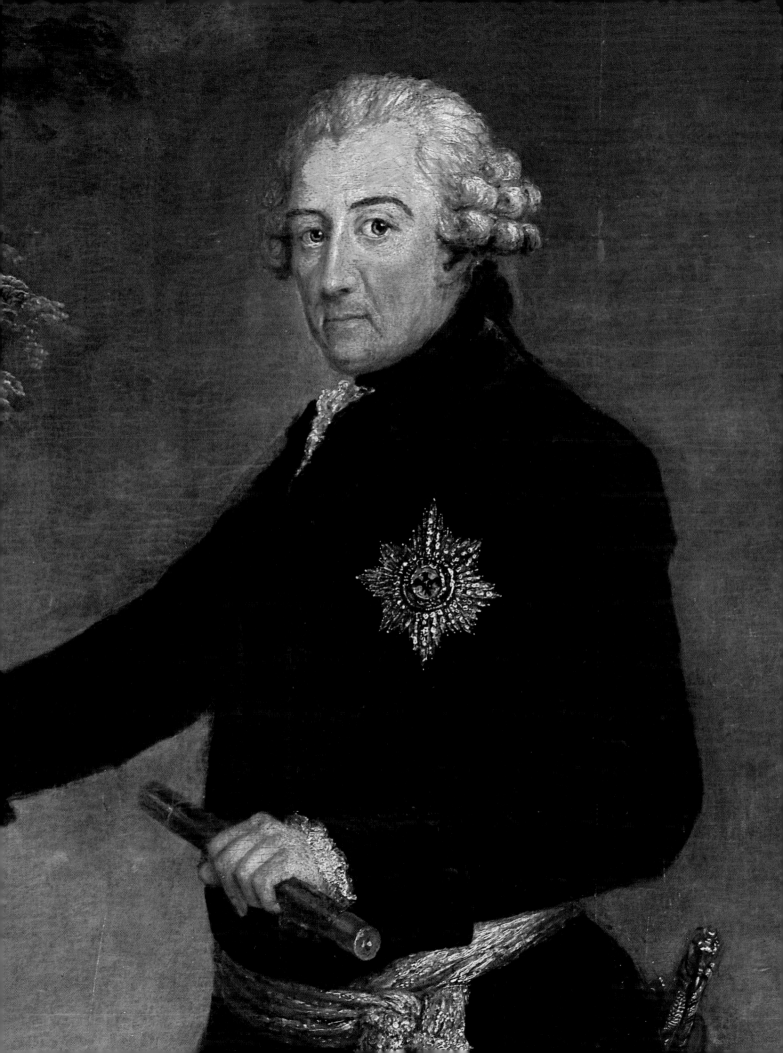

King Frederick William I, at the head of the table in the foreground, hosts a tabagie, *a fraternal smoking and drinking party. The future Frederick the Great—the youngster at right denied a pipe and a carafe of wine—eyes his cantankerous father.*

day, as he himself described it, his work schedule might include, "writing a letter to the king of France, composing a solo for the flute, writing a set of verses for Voltaire and revising the standing orders of the army."

Thomas Carlyle, the nineteenth-century Scottish historian whose multivolume biography of Frederick the Great ranks as his literary masterpiece, provides a memorable portrait of this complex and extraordinary personage: "a king every inch of him, though without the trappings of a king," since he was to be seen not in a crown, which Frederick derided as "a hat that lets the rain in," but an old military cocked hat. He carried a walking stick instead of a scepter and wore a soldier's blue coat in lieu of royal robes. "The man is not of godlike physiognomy, any more than of imposing stature or costume: close-shut mouth with thin lips, prominent jaws and nose, receding brow, by no means of Olympian height; head, however, is of long form, and has superlative gray eyes in it." Everyone noticed the eyes, variously described as blue or gray; "those eyes," as one Frenchman noted, "which, at the bidding of his great soul, fascinated you either with seduction or with terror."

The rest of Europe had hardly taken notice of Prussia before Frederick turned it into a household word. It had been a kingdom for only thirty-nine years when he succeeded to the throne. Despite the name its heartland was not the duchy of Prussia but Brandenburg, a sandy, barren region around Berlin. The seventeenth-century prince-electors of Brandenburg were tough, ambitious lords of the house of Hohenzollern who acquired a conglomerate state that stretched across northern Germany from the Baltic to the Netherlands, but in an incomplete jigsaw pattern, so that they had to travel for days across other people's territory in order to reach their outlying domains. In the east they ruled the duchy of Prussia (later the province of East Prussia); in the west they held the duchies of Cleves, Mark, and Ravensburg and the countships of Lingen, Mörs, and Krefeld. Not until 1701 did one of the Hohenzollern princes persuade the Hapsburg emperor, in Vienna, to grant him the title of "king"— but he was obliged to call himself "king *in* Prussia," in recognition of

the fact that there was another part of Prussia—West Prussia—that belonged to the king of Poland.

The first king in Prussia, Frederick I, crowned himself at Königsberg in 1701 with, it was felt, rather too much pomp and circumstance for what was after all a very modest, even parvenu kingdom. But Frederick knew how to enjoy his new dignity: he built his wife a splendid Italian-style palace on the outskirts of Berlin and banqueted lavishly while twenty-seven instrumentalists performed his dinner music.

The son who succeeded him in 1713, Frederick William I, was made of infinitely sterner and more unpleasant stuff. Culture, and especially French culture (there was hardly any other worthy of the name), was anathema to him. He fired all his father's entertainers and transformed his court into a sort of military garrison; hence his well-earned nickname: the soldier-king. Voltaire, never one to mince words, described him as "the most intolerable and most parsimonious of kings." Frederick William's first and last love was the Prussian army, which he enlarged to make it the third-largest army in Europe, after Russia and France. His favorite toy was the regiment of seven-foot-tall guardsmen that he liked to exercise personally on the parade ground at Potsdam, the royal country seat about twenty miles from Berlin. But he was careful not to embroil his superbly trained soldiers in any really bloody campaigns. His men were far too cherished and expensive to be risked on the battlefield, and peace was the best policy for keeping his regiments intact.

Frederick William ruled his children with the same unrelenting discipline. From his earliest years as the crown prince, Frederick the Great lived like a cadet at a particularly odious and sadistic military academy. His mother gave him the rudiments of a cultivated upbringing in accordance with the prevailing French taste, but Frederick William removed the boy from her influence as soon as he could and instructed his tutors to "instill in him a true love for the military profession."

When it became apparent that the prince showed a preference for literature and music, the hot-tempered king took to beating and

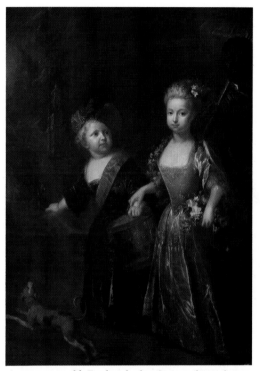

A two-year-old Frederick the Great, dressed in a gown in keeping with the custom of his era, looks adoringly at his sister Wilhelmine in this portrait, which hung in their mother's bedroom. The young prince and princess—so alike in appearance that they were often mistaken for twins—clung to each other in their parents' harsh household.

The famed composer Johann Sebastian Bach, above, considered Frederick an accomplished musician and told him so, complimenting the king's grace on the flute. The composer's son Karl Philipp Emanuel led elegant concerts at Frederick's favorite residence—the Sans Souci palace.

humiliating him at every opportunity. On one occasion, as Frederick told his favorite sister, Wilhelmine, "as soon as I entered the room he threw me to the floor, and after beating me all over with his strong fists, dragged me to the window and wrapped the curtain-cord around my neck. Fortunately I had time to seize his hands, but when he pulled the cord tight with all his might and I felt myself being strangled I called for help. A footman rushed in and had to use force to free me from the king's hands."

The hatred between father and son reached such a pitch that the eighteen-year-old crown prince made an abortive attempt to run away to England during the summer of 1730. He and his best friend, Lieutenant Hans Hermann von Katte (the son of a general and grandson of a field marshal), were arrested and charged under military law with desertion. The court martial's findings were too mild to suit the king, who imprisoned his son and sentenced von Katte to be beheaded for treason. Frederick was forced to watch from the window of his cell as guards led his friend to the scaffold.

Frederick was not released from prison until 1732, when he agreed to a political marriage that was abhorrent to him: his bride, the duchess Elisabeth Christine of Brunswick, was a niece of the Hapsburg emperor and a pawn in the king's foreign policy. Frederick regarded her with ill-concealed indifference—it seems doubtful that he was ever seriously interested in any woman—and banished her from his royal presence as soon as the old king was dead. But Frederick William did not oblige his son in this respect until 1740. Meanwhile the dutifully married crown prince was at last able to lead a reasonably royal existence at the little chateau of Rheinsberg, a town about forty miles north of Berlin.

These were the happiest years of his life: a time of music, literature, philosophy, and art. He renovated the chateau frugally but elegantly and filled it with paintings, sculptures, and a treasured collection of French books. He wrote his first letter to Voltaire from Rheinsberg: "Monsieur—Although I have not the satisfaction of knowing you personally, you are not the less known to me through your Works. They are the treasures of the mind, if I may so express

myself; and they reveal to the reader new beauties at every fresh perusal. . . ." Voltaire, who was flattered by the attentions of a crown prince eighteen years younger than he, replied in equally complimentary terms; soon an active correspondence united these very dissimilar thinkers.

Under Voltaire's influence, Frederick wrote an essay refuting the argument, advanced by the Italian statesman and political philosopher Niccolò Machiavelli in his book *The Prince*, that all's fair in war and statecraft. According to the idealistic principles Frederick expounded in his *Anti-Macchiavel*, "the prince is not the absolute master, but only the first servant of his people." Indeed, when it was Frederick's turn to become king in Prussia, the whole of Europe expected him to live up to these brave pronouncements. All the signs pointed to it; one of his first decrees as king abolished the use of torture in obtaining criminal confessions. Another dissolved his father's ornamental regiment of giant guardsmen. Yet at no time did Frederick loosen the screws of absolutism that allowed the king to rule Prussia as a private fief without so much as an advisory council of nobles; his ministers were merely the head clerks of their departments. Within months of coming to power, he embarked on a ruthless policy of territorial expansion that would have done credit to the most Machiavellian of princes.

When the Austrian emperor, Charles VI, died in 1740, he left the Hapsburg dynasty without a male heir. In the great dynastic scramble that followed, his daughter Maria Theresa inherited his lands but not his imperial title. Seeing the Austrians ruled by a woman and weakened by attacks from several enemies, Frederick seized the chance and marched his troops into the rich mining and textile-weaving province of Silesia, to which he had only the most tenuous claims. Since her armies were tied down elsewhere, Maria Theresa had no choice but to recognize his conquest—of Lower Silesia in 1742 and of the remainder in 1744–1745. Thus, almost at a single stroke, Frederick had annexed a territory that was larger than any other Prussian province.

After signing a peace treaty at Dresden on Christmas Day, 1745,

Frederick expounds a point to Voltaire during the great French philosopher's visit to Sans Souci. Though the two men had a stormy relationship, Frederick admitted to Voltaire in a letter, "I admire in you the finest genius that the ages have borne."

FROM PACIFIST PRINCE
TO WARRIOR-KING

Outnumbered nearly two to one, Frederick audaciously takes on the Austrians in the battle of Leuthen (above), in 1757. Shrewdly dispatching his crack army in staggered formations, Frederick caught the enemy off guard: the key Silesian village of Leuthen, in the background across the blackened battlefield, fell to Frederick in a few hours.

For a self-described dilettante, Frederick the Great was anything but effete as commander of Prussia's armed forces. Here was a brilliant warrior-king who earned his epithet not so much for his diplomacy or patronage of the arts, but for his leonine aggressiveness on the battlefield. Frederick triumphed over enemies often better manned than he; the battle of Leuthen—in southwest Silesia—pictured opposite, was only one engagement where the king scored a smashing victory against the strongest of odds. Frederick's heroic performances sprang from theory: his writings on the art and science of warfare influenced other great conquerors of his age, including France's emperor Napoleon Bonaparte.

With the gaining of ground as his objective, Frederick took the offensive in battle, ranking his men in oblique lines to attack at odd angles, from unexpected directions. At Frederick's command the Prussian soldiers bravely stepped toward the enemy to fire guns at close range and lunge with bayonets.

In addition to Frederick's meticulous battle plans, Prussian advances in warfare included marching in step, the use of iron ramrods to efficiently reload muskets, and horse-drawn artillery to support the infantry. Brightly colored banners and distinctive drum beats helped Frederick's men identify each other on chaotic, smoke-clouded battlefields.

As the creator and leader of Europe's most formidable army, Frederick the Great—who had dreaded playing soldier games as a pacific young prince—was modest about his military prowess. Shrugging off his success in Silesia, he said, "I was young, had plenty of money and a large army, and wanted to see my name in the newspapers."

Frederick resolved that henceforth he "would not fight a cat" if he were left alone—"from this day, Peace to the end of my life!" Having satisfied his political ambitions, Frederick could then give free rein to the more elaborate of his architectural ambitions. He had never been to Italy, but he had seen prints of Roman and Tuscan buildings that he wanted to recreate on the sandy plains of Brandenburg. As his Italian friend and adviser Count Francesco Algarotti noted in 1748, "The king, the greatest lover of every art, desires to see vistas of Rome, such as the Piazza del Popolo and the Capitol!" No sooner said than done. The little country town of Potsdam suddenly took on a grand neoclassical look as Frederick's architects lined its broad streets with copies and adaptations of the king's favorite Italian palaces and temples.

Frederick's crowning architectural achievement was a bandbox pleasure palace, one story high, set on the brow of a low hill, with pleasant views of gardens and other hills all about. The palace's lines were the purest, most elegant rococo, with sinuous gilded garlands and emblematic cartouches in low relief decorating the doors, shutters, and walls. Frederick himself partly sketched the plans and then turned over the detailed designing to his court architect, Georg Wenzeslaus von Knobelsdorff, who had also supervised the construction of a sumptuous court opera house in Berlin. On the curved lintel of the main doorway, Frederick inscribed the name he had chosen for this favorite among his palaces, Sans Souci—"Without Care"—which was how Frederick hoped to live amid these idyllic surroundings that were a day's ride from the aggravations of his busy capital, Berlin.

He surrounded Sans Souci with formal gardens in the French manner and decorated its garden paths with marble gods and cupids: a selection of the five thousand works of sculpture by both classical and contemporary artists he acquired in the course of his reign. He filled his picture gallery with elegant French paintings by Jean Antoine Watteau and Nicolas Lancret, later adding pictures by such fifteenth- and sixteenth-century Italian masters as Allegrida Correggio, Paolo Veronese, Raphael, Leonardo da Vinci, and Titian. He

told his agents to get "good historical pictures or classical material," but not pictures of "sickly saints." Payment for his acquisitions came out of the privy purse or from the annual surplus of his frugal peacetime budgets. Other rulers taxed their subjects to pay for paintings, but King Frederick emphatically declared, "that is not my way of doing things."

In the interior of Sans Souci he made lavish use of the apple-green stone known as chrysoprase, which was found in Silesia. To remind him of his proudest new territorial possession, he also had the court goldsmith carve this Silesian chalcedony into some of the innumerable snuff boxes (see pages 119–131) that he kept in his palaces for all occasions: they were bedecked with gold, diamonds, and other jewels and contained the best of Spanish snuff tobacco for the royal nose, though a certain amount was regularly spilled on his uniform coat. Later, too, there was to be a royal porcelain factory to produce magnificent Prussian dinner services, so that he would no longer have to import them from Saxony.

Frederick reserved only three rooms in Sans Souci for his own use: one of them the library, another an alcove with an iron bedstead. His luxuries were of the aesthetic rather than sumptuary variety. Above all he wanted to compensate for his father's grimly unmusical regime by giving Prussia a brilliant resurgence of opera and chamber music, most of it paid for out of his own pocket. His agent in Venice recruited the finest Italian voices for the king's troupe of opera singers; among its stars were both female coloraturas and the eunuch sopranos known as castrati. He was not the easiest of impresarios to work for. "In the opera-house as in the field," reported the English musical traveler Dr. Charles Burney, "His Majesty is such a rigid disciplinarian that, if a mistake is made in a single movement or evolution, he immediately remarks and rebukes the offender; and if any of his Italian troops dares to deviate from strict discipline by adding, altering, or diminishing a single passage in the parts they have to perform, an order is sent *de par le Roi* ["in the name of the King"] for them to adhere strictly to the notes written by the composer at their peril." Once, when a recalcitrant prima donna

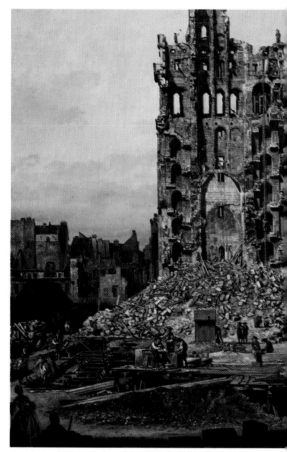

Citizens of Dresden pitch in to rebuild the Church of the Holy Cross, a sad ruin after Frederick bombarded the medieval structure in 1760 to rid it of suspected artillery observers. Prussian artillery destroyed 226 buildings in the Saxon city during this siege in the Seven Years' War, waged against Saxony, Austria, Russia, Sweden, and France.

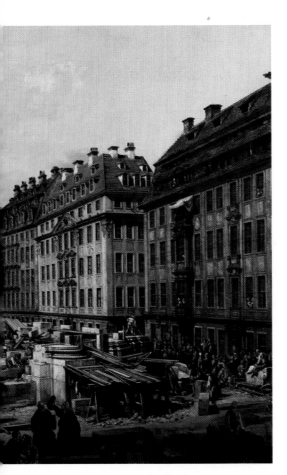

pretended to be ill on the day of an important premiere, Frederick sent a carriage and eight dragoons to bundle her off to the opera house, mattress and all—and the performance was a rousing success.

His happiest musical evenings, however, were of a far more intimate kind and featured Frederick himself as flute soloist. These chamber concerts usually took place at Sans Souci or in the music salon of the palace at Potsdam, before an audience consisting exclusively of courtiers and connoisseurs. At such times he was not a princely amateur but an accomplished virtuoso; according to reliable witnesses, many listeners "could scarcely hear him without tears." He himself composed much of the music he played during these recitals—4 flute concertos and 121 sonatas.

The musician who regularly accompanied him on the harpsichord was Karl Philipp Emanuel Bach, second son of Johann Sebastian Bach, renowned for his genius as an organist and composer and a master contrapuntist. It was through the younger Bach that Frederick prevailed on the aged cantor of Leipzig to visit him in Potsdam in order to display his legendary skill as a contrapuntist. One evening in May 1747, just as Frederick had joined his chamber players for the customary concert, an officer brought him a written list of strangers who had arrived in Potsdam that day. The younger Bach never forgot what happened next: "With his flute in his hand he ran over the list, but immediately turned to the assembled musicians and said, with a kind of agitation, 'Gentlemen, old Bach is come.' The flute was now laid aside, and old Bach, who had alighted at his son's lodgings, was immediately summoned to the palace."

There was no flute concert that night. Frederick took Bach through the palace from room to room to show him some of his fifteen Silbermann pianofortes, then the latest development in keyboard instruments. Bach played improvisations on each of them and then asked the king for a theme on which to improvise a fugue— to the amazement of everyone present, Bach performed it on the spot without so much as stopping to think about it. After his return to Leipzig, Bach composed and engraved an entire set of fugues and canons on what he called Frederick's "right Royal theme." He then

dedicated this *Musical Offering* to His Royal Majesty in Prussia.

Thus, for one brief moment there was Sans Souci, and Frederick living a passionate life of the arts. But in 1756 the musicales came to a sudden end as Europe was plunged into the Seven Years' War. Frederick took his army into the field to launch a preemptive strike against Saxony, which had joined an anti-Prussian alliance that was to include Austria, Russia, Sweden, and France. Though he had the best-drilled grenadiers in Europe and maritime support from Great Britain, Frederick could not prevent his enemies from invading much of Prussia, including Berlin and Silesia.

Frederick spent most of the war on the defensive in the hinterlands, winning just enough battles to stave off a defeat that seemed inevitable in view of the odds against him. But his luck held: the new czar who succeeded to the throne of Russia in 1762, Peter III, had long been a fervent admirer of Prussia's philosopher-king. He took Russia out of the war, reversed alliances, and placed his troops at Frederick's disposal. The Swedes then withdrew from the field, the French were exhausted by their overseas losses against England, and war-weary Austria was in no mood to continue the struggle.

The peace treaty that ended the war, in 1763, again confirmed Frederick in the possession of his coveted Silesia—and established beyond any doubt that parvenu Prussia had become one of the major nations of the continent. Henceforth Berlin was to rival Vienna as a center of power and prestige among the coalescing German states. And when Frederick acquired West Prussia in the 1772 partition of Poland, he slipped another large, crucial piece into the jigsaw puzzle of Prussian geography; he now ruled over a vast, uninterrupted swath of territory that dominated the Baltic coast and the center of northern Germany.

When Frederick died, in 1786—as the result of a chill he got while reviewing his troops during a rainstorm—the mourners at his funeral sang a solemn ode calling him *Vater des Landes*, the "Father of the Nation." A small change in the title Frederick passed on reflected the transformation he had wrought in German realpolitik; he and his successors were now kings *of* Prussia.

POCKETS FULL
OF TREASURE

A still life tops this dainty snuffbox of agate, trimmed with diamonds and gold. Frederick the Great, inveterate user of snuff, prized his paraphernalia as fine jewels.

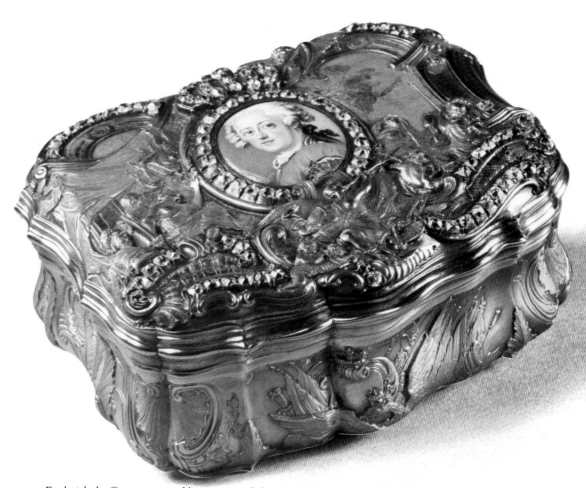

Frederick the Great presented his cousin and close friend Prince Leopold I of neighboring Anhalt-Dessau with the snuffbox above and in detail opposite. Diamonds highlight the golden swirls and figures on the treasure, a token of the king's gratitude to the prince for coming to his rescue in a 1745 battle.

Ladies and gentlemen of Frederick's court could make no more stylish a gesture than to delicately dip their fingers into a snuffbox. The king himself habitually took snuff—a fragrant compound of pulverized and fermented tobacco—and made it the rage throughout Europe's smartest circles. Normally averse to showy displays of wealth, Frederick amassed over fifteen hundred snuffboxes, which were the most fashionable accessories of his time.

Intent on establishing a veritable snuffbox industry in Prussia, Frederick brought goldsmiths, jewelers, enamelers, and lapidaries to his court. These artists worked with the costliest materials to fashion compact masterpieces of gold and semiprecious stones such as red jasper and green chrysoprase. The king's interest in their work was passionate: he could not resist snooping around the artists' studios, and he even tried his hand at designing a few boxes.

Lest anyone accuse him of wasteful indulgence, Frederick swore that one of his little treasures had actually saved his life in battle: according to the royal account, a snuffbox, snug inside his vest pocket, caught a musket ball intended for the king's heart.

Framed and crowned with diamonds, the portrait of wide-eyed, white-wigged Frederick opposite is the painted enamel centerpiece of the snuffbox above. Surrounding Frederick are allegorical characters in gold relief, representing the king's heroic deeds.

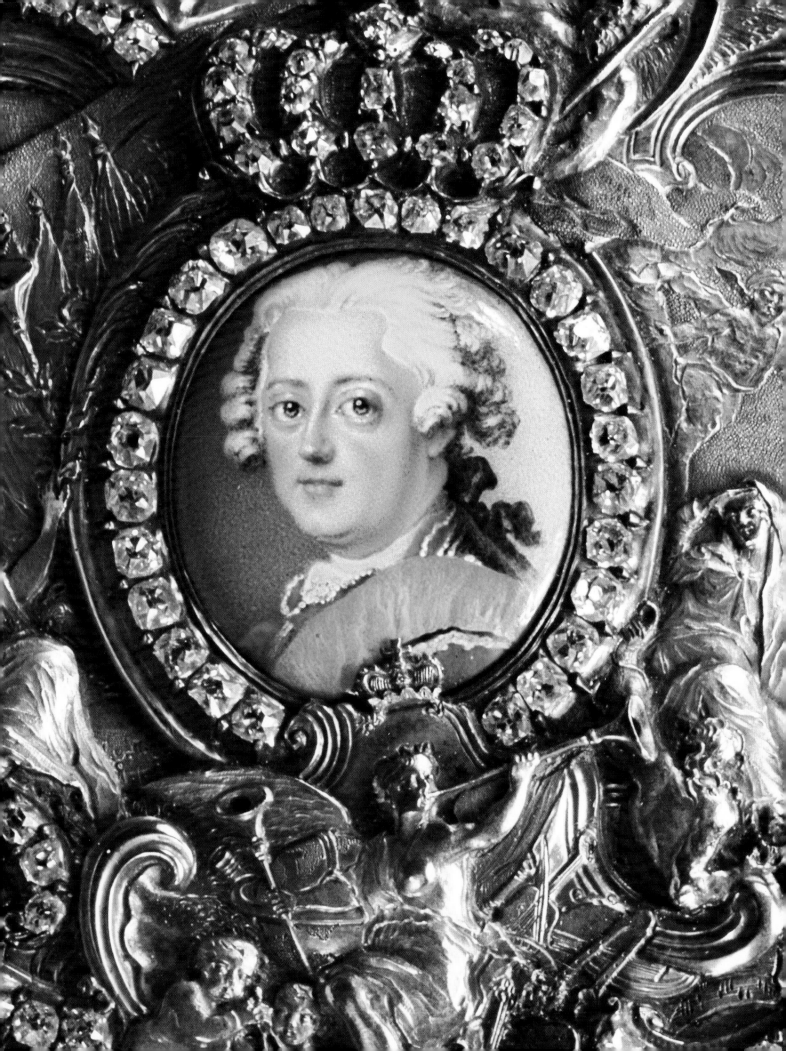

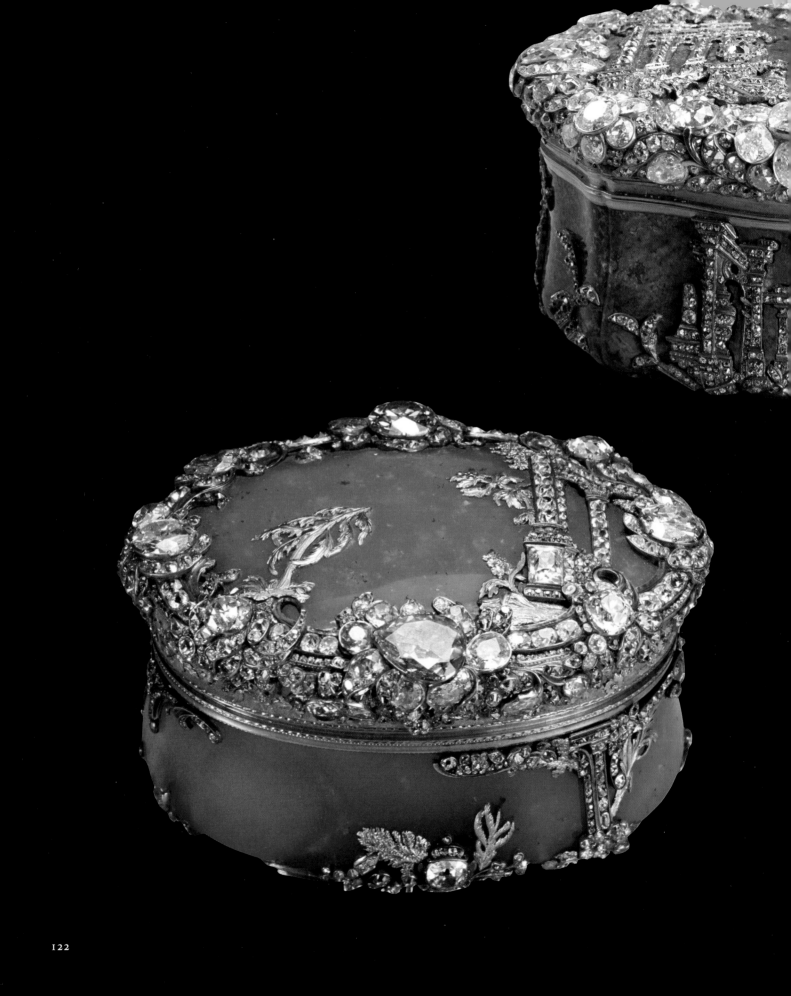

Finished in gold, diamonds, and semiprecious stones, each of these gracefully carved boxes is no more than four inches in length. Frederick could slip one into a soft-lined pocket before attending a musicale or strolling through his gardens. Removing a heavily jeweled lid, the king might offer the fragrant contents to a companion or take a pinch of snuff himself. The box at left and in detail overleaf is made of red jasper, and the two below are of the king's favorite stone, chrysoprase, which occurs in a wonderful variety of green shades. Columns and urns adorning the boxes recall the ancient world, which Frederick, a student of the classics, cherished.

Ancient ruins and tropical trees evoke an exotic landscape in this detail from the top of the red jasper snuffbox at center on pages 122–123. Yellow and white diamonds, thickly clustered around the edge, frame a colonnade, an urn on a pedestal, and palm trees—a scene the eighteenth-century jeweler created entirely in diamonds.

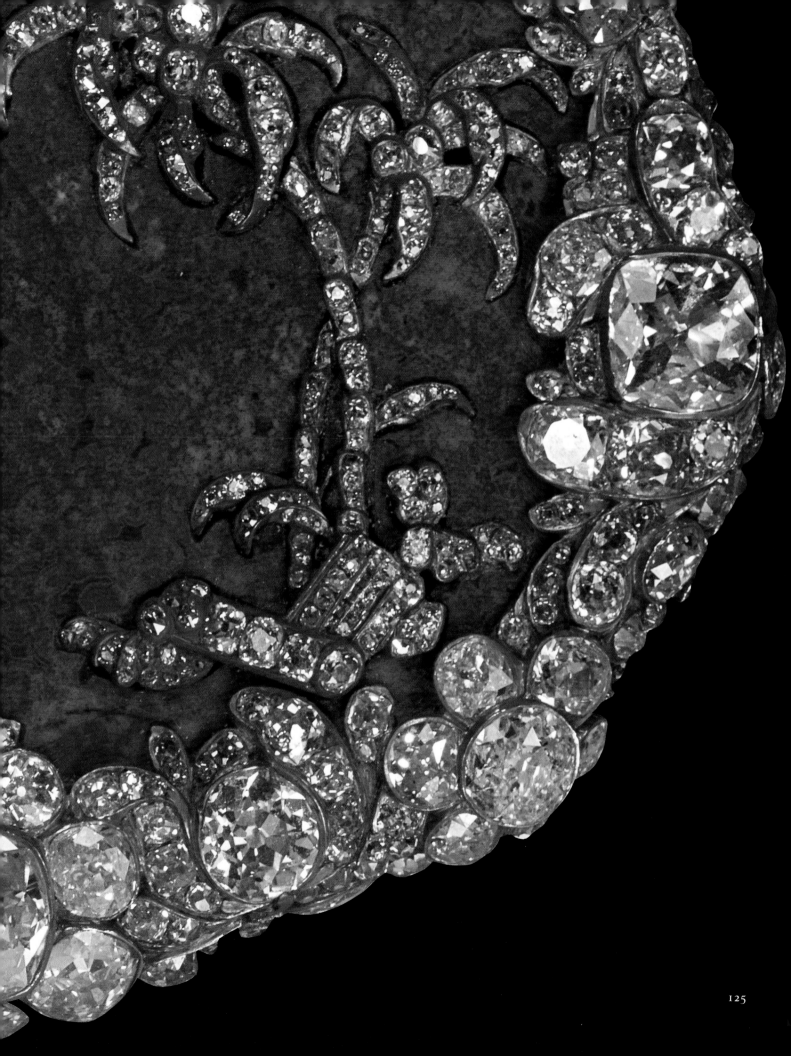

The goddess Diana dallies with her attendants in various scenes on the box at right. John William George Krüger, a Paris-trained artist whom Frederick brought to his Prussian court, painted these vignettes from classical mythology—a favorite subject of the royal patron. He encrusted the box with diamonds and semiprecious stones, sometimes setting the stones on gold foil to intensify their color and brilliance.

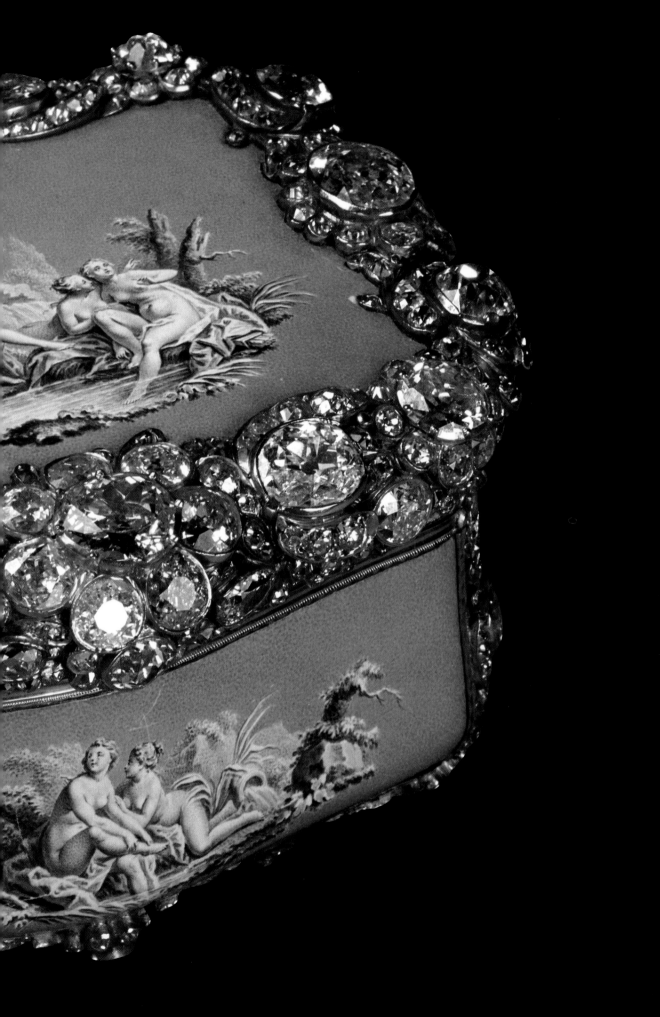

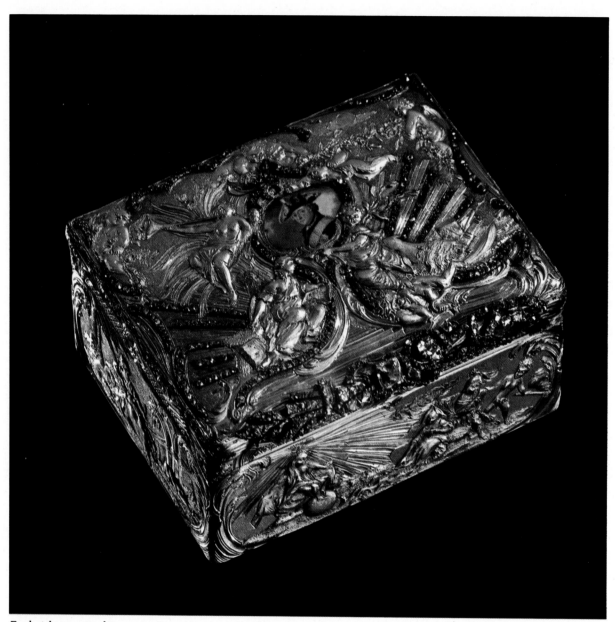

Frederick, sporting his trusty tricorn in a tiny enamel portrait, peeks out from the lid of a rich gold box, its decorative lines and figures accentuated with diamonds. Daniel Baudesson, famed Berlin goldsmith, designed the box in 1760.

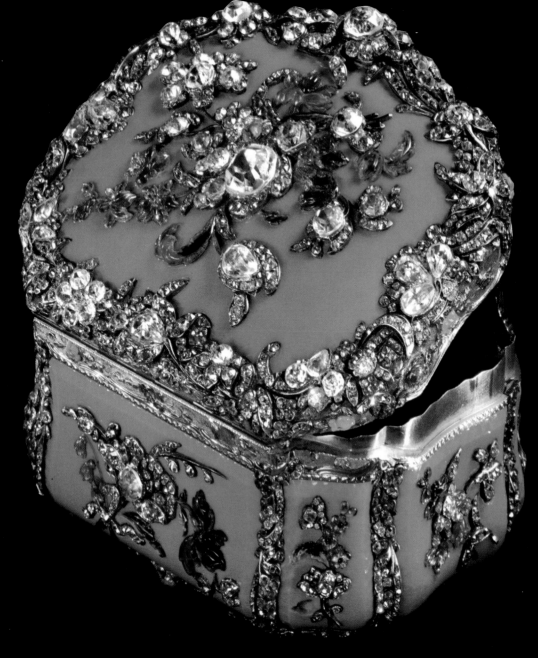

Flowers, dear to Frederick, trail over the rich blue semiprecious stone box above, which the king filled with his best snuff and kept on a table in one of his palaces. A garland of diamonds trims the slightly ajar lid.

OVERLEAF: A huge spray of diamonds and other gems, their colors heightened by foil backings and gold mountings, creates a grand floral centerpiece for the Berlin-made snuffbox above.

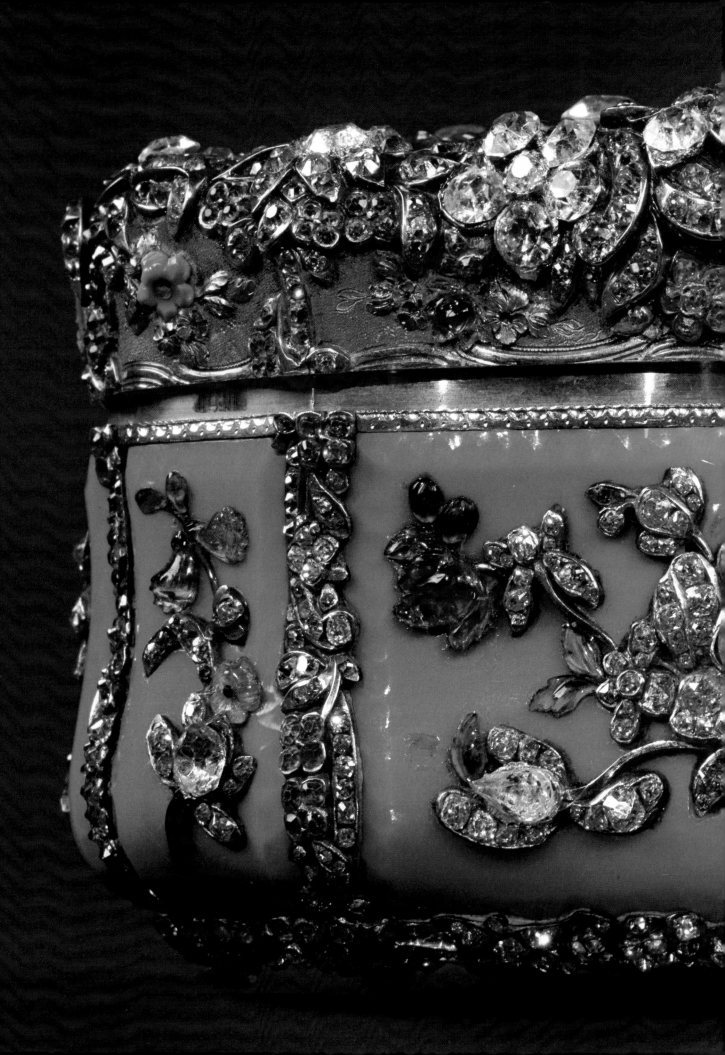

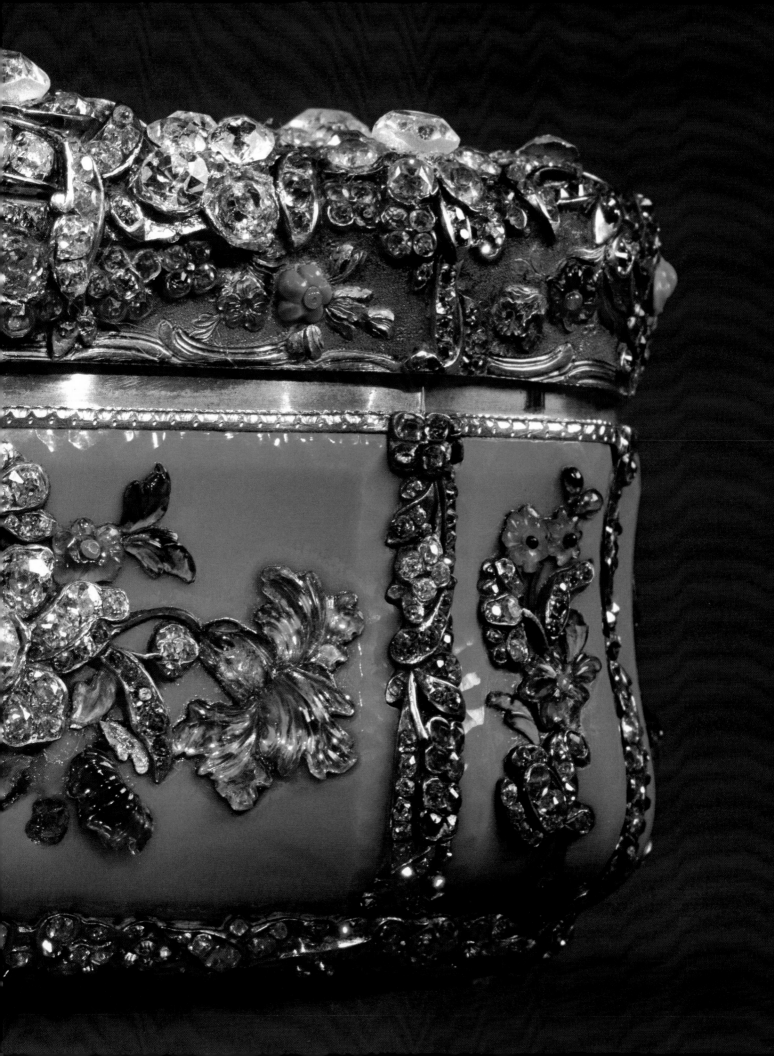

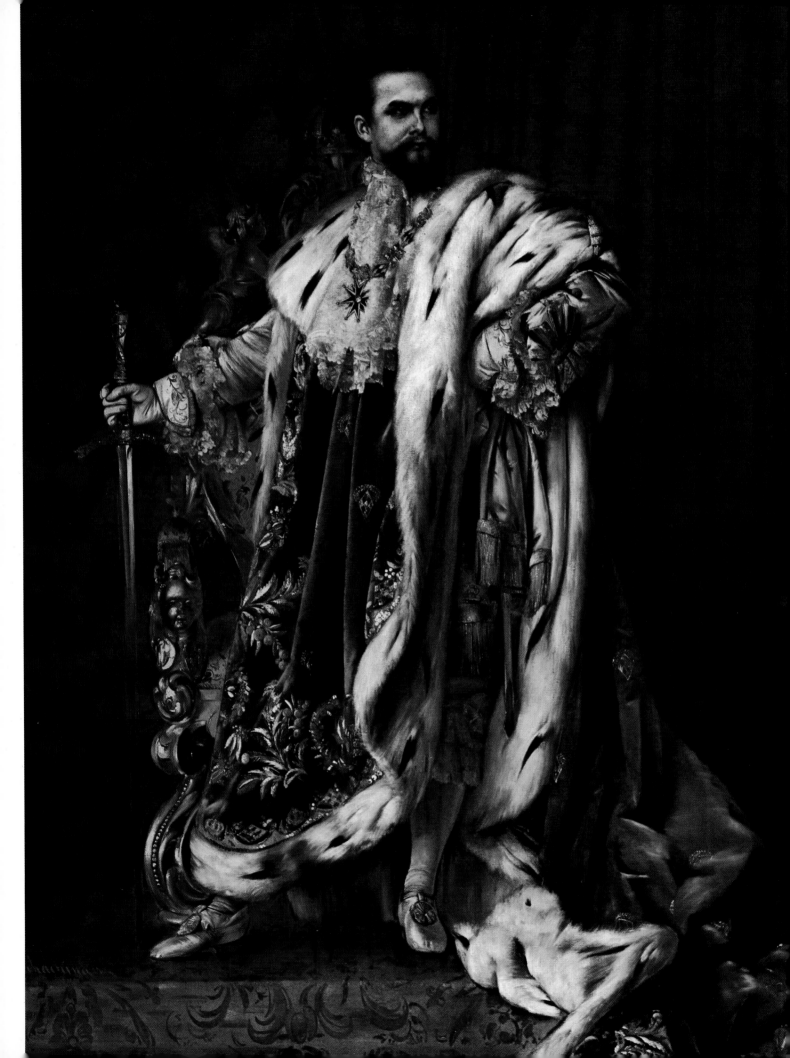

to perform." An immediate transfusion of funds from Ludwig's private account into Wagner's convinced the composer that his lean years were over at last and that at fifty-one he had found "the complete ideal of my dreams."

The king's passionate admiration for Wagner and his works shines through his correspondence with the composer, revealing a relationship that was an effervescent mixture of art, money, and psychoneurosis. They wrote nearly six hundred letters and telegrams to each other, always in the most rapturous, exalted tone—almost as though they were characters in a Wagner music drama.

In a typical letter, Ludwig writes to Wagner: "Warmly beloved! My only one! More and more does my soul long for you! For you are everything to me! The desire to know you completely, to hear more of you, becomes steadily stronger! I would like to comprehend the development of your spirit in all its details so as to understand you wholly; I want to steep myself in your ideas and opinions. For I want to live only in your beliefs; to die and be saved by your faith! ...Eternally yours, Ludwig."

Wagner replied with a whole sheaf of letters couched in the same overblown style: "My dearest beloved, my only, most magnificent friend! With tears in my eyes I ask: How are you? Are you sad? Are you happy? How does my most gracious king feel....Highest glory of my life, sun that shall light up my nights, redeemer, savior of my existence....In loyalty yours forever, Richard Wagner."

Ludwig was not the first devout Wagnerite, but he was the first and only Wagner lover to possess the really massive resources that were needed to underwrite the composer's program for staging his so-called music of the future. It entailed not just the production of his music dramas in existing opera houses but also the building of a special festival theater, a *Festspielhaus*—"festival performance house"—which would enable Wagner to stage his work precisely as he envisaged it. Such a theater was in fact planned for Munich, but encountered so much opposition that it was eventually moved elsewhere, to Bayreuth, a city about one hundred miles north of Munich. To this day at Bayreuth the Festspielhaus serves as the

Elizabeth, empress of Austria, was Ludwig's cousin and lifelong model of ideal womanhood. The two rulers shared a dislike of court routine. In 1867 Ludwig proposed marriage to Elizabeth's youngest sister, Sophie, but he twice postponed the wedding and finally canceled it.

The composer Richard Wagner gazes fondly at his wife, Cosima, in this photograph taken in 1872, two years after their marriage. Ludwig was a passionate devotee of Wagner's operas and gave the composer huge sums to produce his works.

center and principal monument of the international Wagner cult.

Ludwig, of course, provided a major share of the building costs and also undertook to keep Wagner personally solvent. At one point, presented with yet another request for funds from Ludwig's privy purse, the treasury officials claimed to have run out of bills and tried to embarrass Wagner's errand-lady, Cosima von Bülow, by making her accept payment in coins. Undismayed, she had them count out the coins into sacks, which she then carted off to the composer in a hansom cab. Thanks to the king's generosity, Wagner was able to complete the scores of *Die Meistersinger von Nürnberg, Siegfried, Götterdämmerung,* and *Parsifal* in far greater comfort and security than he had ever known before.

Ludwig loved going to the opera or the theater, but hated it when the audience trained its opera glasses on the royal loge: "I can get no sense of illusion so long as the public ogles me." As usual his solution to the problem was simple and to the point: he had the court opera and theater companies perform for him alone in the famous *Separatvorstellungen,* "private auditions," that soon became the talk of theatrical Europe. He liked to sit in solitary splendor, peering out between the drawn curtains of the royal box, while the performers acted and sang to an empty house—an eerie experience for the actors, who were well aware that Ludwig knew almost every piece by heart and had personally supervised the design and construction of the stage sets.

When Ludwig's advisers suggested that he show himself to the people more often, he told them irritably, "You know I can't stand this business of dealing with plebeians." It was clear that he did not aspire to being a citizen-king with the common touch so dear to the nineteenth-century middle classes. (Strangely enough, Ludwig could have great rapport with commoners, if he could do so on his own terms. He liked to wander through the countryside, supposedly incognito, and talk to lone foresters and pat peasant children on the head.) Instead, the private performances led him, by easy stages, to the idea of a total theatrical environment in which he himself would be the only actor on a stage of his own devising.

Accordingly, Ludwig left the serious business of state to his ministers while he dedicated himself to redesigning the royal way of life. Court protocol in Munich bored and exasperated him; to make his existence in the royal palace more tolerable he converted its roof into the exotic Winter Garden, to which only his closest intimates were ever invited. A princess of Spain who was a cousin by marriage was one of the few to penetrate this inner sanctum and wrote an ecstatic account of it in a letter to her mother. "I could not believe my eyes. There before me was an enormous garden, illuminated in Venetian style, with palms, a lake, bridges, huts and castellated buildings. 'Come in,' said the King, and I followed him fascinated. . . . A parrot was swinging on a gold ring and shouted 'Good Evening' to me, while a peacock gravely and proudly strutted by. We crossed a primitive wooden bridge over a small illuminated pond and saw before us under a chestnut tree an Indian village." Farther along they came to a blue silk tent decorated with roses and containing a chair supported by two carved elephants resting on a lion skin. From there a narrow path led to the edge of the pond, "in which an artificial moon was reflected, softly lighting up the water lilies and other aquatic plants. A boat, such as troubadours used in olden times, was fastened to a tree."

A hidden orchestra played Spanish music in honor of the guest, and when they moved on to a Moorish pavilion the princess thought she had been magically transported to Spain. As they dined, an unseen choir sang softly. "Suddenly a rainbow appeared. 'Oh!' I cried involuntarily, 'this must be a dream.' 'Ah! but you must see my Castle Chiemsee,' said the King."

Ludwig had, in fact, allowed his decorative imagination to roam just as freely in the three fantasy castles that he was building in the mountains of Upper Bavaria—Herrenchiemsee, Linderhof, and Neuschwanstein (see pages 149–169). His palace on an island in the Chiemsee, the largest lake in Bavaria, boasted a Hall of Mirrors copied from the one at Versailles and a great many other rooms modeled on those of Louis XIV of France, whom Ludwig tried to emulate in his own life-style. The castle was never quite finished, but

The robust Ludwig Schnorr von Carolsfeld, costumed for one of the title roles in Wagner's opera Tristan und Isolde, *stands at the helm of a stage ship during a performance in 1865. Before hearing the first performance, Ludwig wrote to Wagner, "Oh, Tristan, Tristan will come to me! The dreams of my boyhood and youth will be realized!"*

TEXT CONTINUED ON PAGE 146

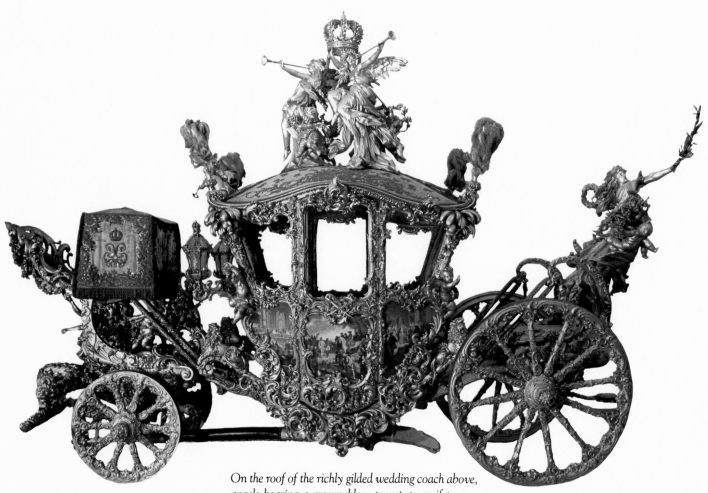

On the roof of the richly gilded wedding coach above, angels bearing a crown blow trumpets as if to announce the arrival of the king.

A KING'S CONVEYANCES

Although Ludwig abhorred the public duties of kingship, he gloried in all the spectacle associated with power and was particularly conscious of the impression he made as he traveled. During his reign he assembled a full complement of royal vehicles, including state coaches used for ceremonial occasions, simpler carriages for shuttling among his country residences, and sleighs for travel in winter. Ludwig carefully supervised the design of his coaches, taking his inspiration from his spiritual mentors—the wealthy and all-powerful monarchs of prerevolutionary France.

Ludwig's most elaborate creation was his so-called wedding coach (above and in detail opposite)—a display of pure ostentation considering that it was built years after all likelihood of a royal wedding had vanished. Ludwig had the body of the coach decorated with detailed scenes of life at the French court of Versailles, painted on copper panels. Ludwig even ordered a second set of these panels in case he grew tired of the first, but, as it turned out, he never found occasion to use the coach.

Ludwig holds the honor of being the last of the great coach builders. After his death, in 1886, designers began to shift their attention away from decoration to concentrate on making technological improvements. And before long, automobiles had replaced carriages on all but the most formal state occasions. Had Ludwig lived into the automobile age, the quiet Bavarian nights would have been abuzz with the sound of some outlandish motorized fantasy.

Blue velvet, embroidered with gold, lines the interior of Ludwig's wedding coach (opposite). The painted panel to the left of the door depicts an opera being performed at Versailles.

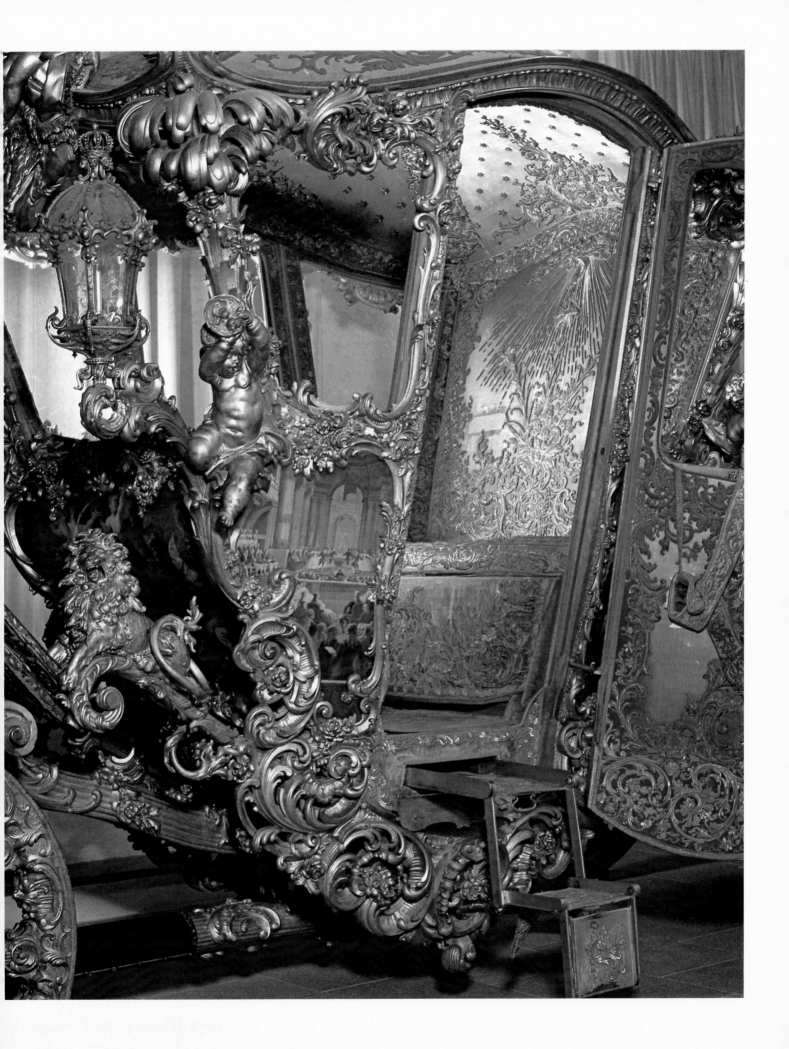

Thrust forward like a ship's figurehead, a graceful mermaid holds two blue globes to light the path of the sleigh. Made of gilded carved wood, on a scale quite modest by Ludwig's standards, the sleigh was designed to be drawn by two horses, with an attendant riding behind the king.

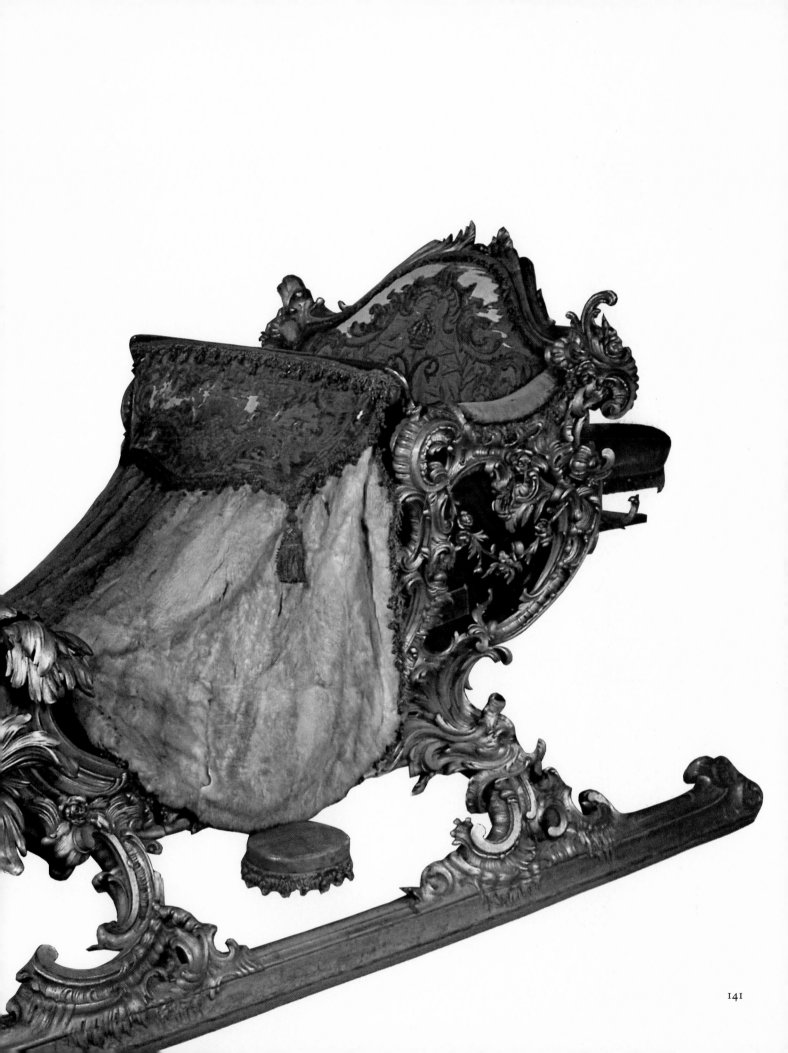

The insomniac king takes one of his frequent nocturnal sleigh rides in this painting done in 1880. Living out his fantasies of absolute monarchy, Ludwig ordered his horsemen to dress in the three-cornered hats and blue velvet jackets that were the fashion in eighteenth-century France. From time to time Ludwig's sleigh rides brought

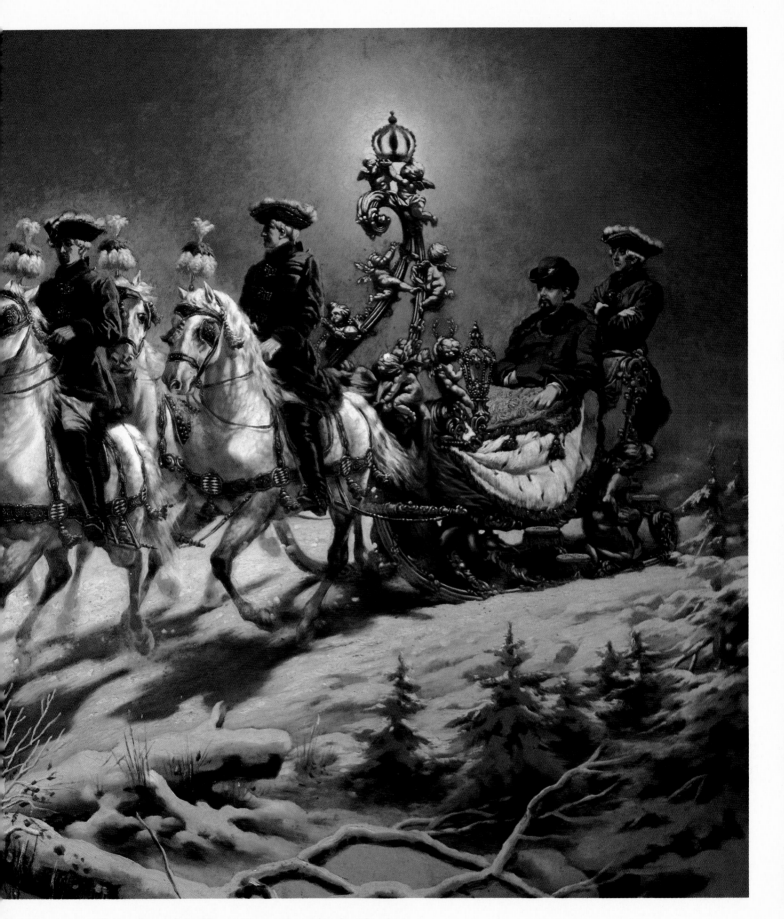

him into contact with his subjects. In sudden snowstorms he might take refuge in a peasant's hut and converse cheerfully with his bewildered, sleepy host until the storm passed. Afterward he often sent presents of flowers—a gesture worthy of a fairy-tale king, but perhaps not the gift his subjects would have chosen.

This gilded sleigh, with cherubs holding aloft a lantern shaped like a crown, is the one Ludwig favored for his midnight rides. The lantern was powered by an electric battery concealed within the sleigh. The ermine blanket thrown over the seat kept the king much warmer than his attendants. In the detail opposite, one of the sleigh's gilt Tritons—mythological sea gods—blows a conch-shell trumpet.

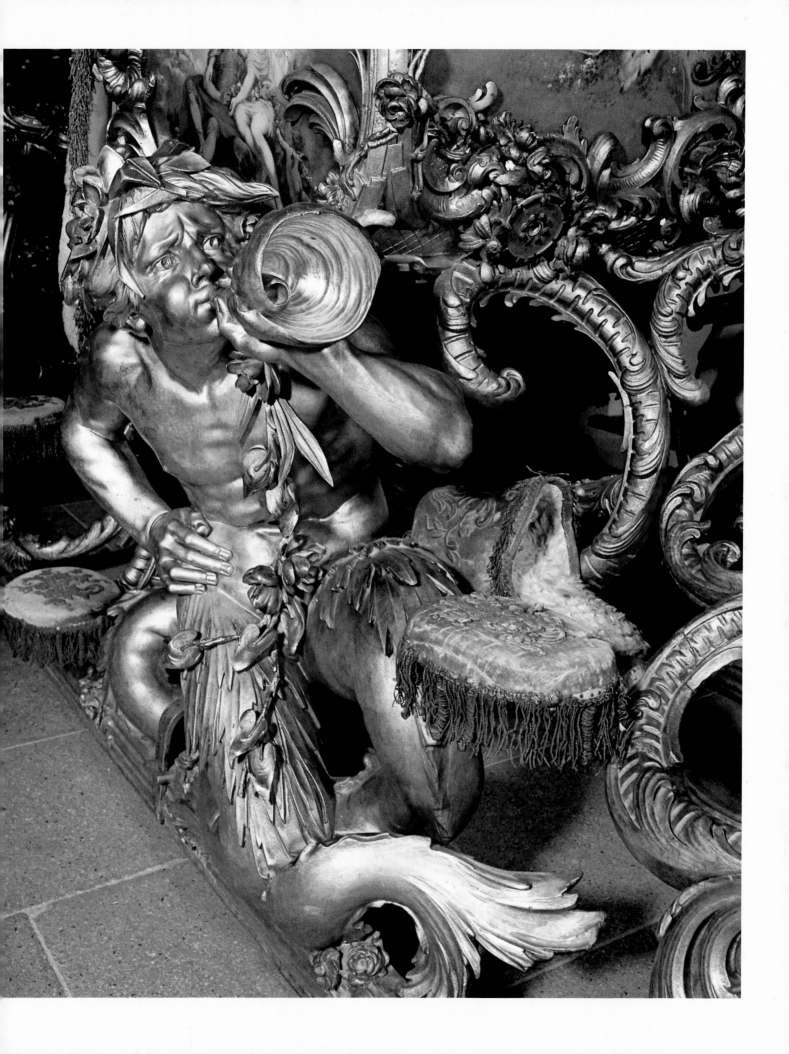

TEXT CONTINUED FROM PAGE 137

Ludwig still managed to use it. On one occasion he had his lackeys light twenty-five hundred candles while he walked up and down the Hall of Mirrors from nine at night until six in the morning, discussing plans for yet another castle that was to be built for him high on a mountain precipice. But the most famous of Ludwig's creations was the spectacular Neuschwanstein—his many-turreted castle in the Alps that looks like everyone's idea of a fairy-tale castle.

Fate moved faster than the king's workmen, however, and Ludwig never saw his dream castle totally brought to life. He lived long enough to inhabit only the gatehouse of his crenellated masterpiece. For even as he sat alone in his court theater, watching performances that were undefiled by plebeian eyes, the world of political reality was beginning to close in around the king. In 1866 a long-simmering conflict between Prussia and Austria led to the Austro-Prussian War, in which Bavaria fought on the side of the Austrians. Prussian discipline and superior weaponry—their terribly efficient needle gun and breech-loading artillery—easily carried the day. Ludwig seemed strangely unaffected by his army's military debacle: friends and relatives tried to inform him, discreetly, that his subjects were "embittered and full of ill will because you think only of the performances of Wagner's operas."

Otto Edward Leopold von Bismarck, Prussia's so-called Iron Chancellor, took advantage of his victory to unite all the German states north of the Main River, but permitted the south Germans to go scot-free—after forcing Bavaria, Baden, Wurttemberg, and the remnant of Hesse to join a secret alliance that pledged them to place their troops under the king of Prussia in time of war. Bismarck's next opportunity came in the summer of 1870, when tension between France and Prussia allowed him to provoke Napoleon III, the emperor of France, into declaring war. The Bavarian army duly fought on the side of the Prussians, helping them crush the French in a lightning campaign that brought the Germans to the gates of Paris in less than three months.

On January 18, 1871, at a gathering of German princes and officers in occupied Versailles (see pages 146–147), Bismarck stage-managed

King William I of Prussia, the white-whiskered man standing on the dais, is proclaimed emperor of a united Germany in January 1871 by the Prussian chancellor Otto von Bismarck, who is wearing a white cuirassier's uniform.

the proclamation of the king of Prussia as Emperor William I of a newly united German *Reich,* or "rule." He permitted Bavaria to retain its own king and internal organization, but henceforth its rights as a sovereign and autonomous state were gradually eroded. The German *Reichsmark* replaced all local currencies, including the Bavarian florin, for example, and a new set of Reich laws took the place of the Bavarian criminal code. Although Ludwig's mother was herself a Hohenzollern princess and sister of the emperor, Ludwig heartily detested this new state of affairs that had been imposed upon him by the Prussians' superior might. In his confidential correspondence he bemoaned the fact that "this last war, which in many respects ended so gloriously for Bavaria, should have forced myself and my country into the iron clutches of that damned German Reich with its Prussian coloring."

From now on, as he wrote to a friend, Ludwig lived "more in my beloved books than in the detestable present." He might have abdicated if his brother Otto, the next in line to the throne, had not become incurably insane by 1873. The crowds of Munich, and Ludwig's ministerial councillors, saw less and less of their reclusive king. The completion of his castles kept him going: "I must build, or die." But though he paid for them from his privy purse and not the public treasury, the dream castles proved to be his undoing. In 1884 and 1885 his finance minister had to negotiate two huge private loans. His hard-pressed ministers thought it was time for this spendthrift eccentric to be deposed—and schemed to have him declared legally insane.

When a delegation came to Neuschwanstein to arrest Ludwig, he simply closed the castle gates, ordered the local police to seize the delegates, and shut them up in the castle. But a second delegation succeeded in taking Ludwig into custody and brought him to the palace of Berg on the Lake of Starnberg. He was placed in the care of a psychiatrist, Dr. Bernard Aloys von Gudden, who certified his patient's insanity, though a few weeks earlier another psychiatrist had declared him perfectly sane. A passion for stage decoration and fantasy architecture is not really enough to qualify a man for the

Ludwig gazes dreamily from the balcony of his castle Neuschwanstein, far from the stormy centers of German politics. He awaits the coming of night, when he would wander the rooms of Neuschwanstein all alone, dressed as Lohengrin—the swan-knight of medieval German legend.

asylum—except a king, that is, who pursues unpopular policies.

The deposed king told his warders, "I can bear that they take the government from me, but not that they declare me insane." On June 13, 1886, he and the elderly Dr. von Gudden went for an afternoon walk along the shore of the Lake of Starnberg and were never again seen alive. They were found that evening: the doctor's body with his feet on dry land but face down in the water, as though he had been held there until he drowned. Farther out lay Ludwig's body, in shallow water. The circumstances of their deaths have never been fully clarified, but apparently the powerful forty-year-old king killed his doctor and then committed suicide by drowning. In any case the facts were hushed up so that Ludwig's body could be buried in consecrated ground, at the Wittelsbach court chapel—while his heart was laid to rest among the score of royal and princely hearts preserved in the votive church of the Black Madonna in the town of Altötting in Upper Bavaria.

The kingdom of Bavaria survived for another thirty-two years, thanks in large measure to the uncommon good sense of Ludwig's uncle Luitpold, who ruled as prince regent until 1912. His successor, however, was overthrown six years later, in the aftermath of World War I—the great bloodletting that undid the work of Bismarck and led to the destruction of the old Europe, impoverishing both victors and vanquished. Hard on its heels came a second and even bloodier war, fomented by a new class of plebeian politicians—Adolf Hitler's Nazis—who thought they could reverse the verdict of the first. This time the whole of Europe had to be rescued from "the iron clutches of that damned German Reich" before a semblance of peace could be restored. Partitioned and truncated, a Germany that had been shrunk back almost to its medieval boundaries was able to make a new start, both inwardly and in its relations with its neighbors. Though its present leaders are no longer princes, they often speak of working toward a modern renaissance of the things that so many Germans have done so well—music, theater, literature, painting— a world, in short, rather like that envisaged a century ago by mad King Ludwig of Bavaria.

THE DREAM KING AT HOME

Above a washstand in Ludwig's bedroom at Neuschwanstein stands a silver swan, the symbol of Lohengrin and a design motif much favored by Ludwig.

NEUSCHWANSTEIN

Most monarchs with a passion for building constructed monuments to outlive themselves and carry reports of their glory to future generations. For Ludwig all honor and glory resided in the past. He built three castles in Bavaria, each designed to erect an imaginary world around himself—to transport him back into happier eras. Neuschwanstein was the first of Ludwig's projects. He began making plans for the castle within a few years of taking the throne, partly to provide himself with a refuge from his mother. But what he had in mind was no ordinary country retreat. Built on the site of a ruined medieval castle on a mountaintop in the Bavarian Alps, Neuschwanstein was nothing less than a shrine to medieval German chivalry and legends—a world made real to Ludwig in the operas of Richard Wagner.

Two stories in particular inspired the decor of Neuschwanstein: the tale of Tannhäuser, a medieval minstrel knight, and the legend of Parsifal, a youthful knight caught up in the quest for the Holy Grail, the chalice used by Christ at the Last Supper. Both tales dealt with a theme that fascinated Ludwig—the conflict between virtue and lust. Tannhäuser, for example, endured terrible suffering because he chose the pagan charms of the goddess of love, Venus, over the love of a virtuous woman.

The foundations of Neuschwanstein were laid in 1869, but work progressed slowly, and the castle was not quite finished at the king's death in 1886. Nevertheless, Neuschwanstein remains his triumph and has become one of the great architectural landmarks of the world—a perfectly realized fairy-tale castle and the centerpiece of Ludwig's elaborate and sometimes bizarre fantasy life.

To reach his private quarters, Ludwig passed through the artificial grotto opposite, covered with stalactites and illuminated by colored lights that could be changed to suit his mood. The grotto was inspired by the Tannhäuser legend, in which the knight dallies in the grotto of Venus. One of Ludwig's ubiquitous swans rests on a pedestal in the background.

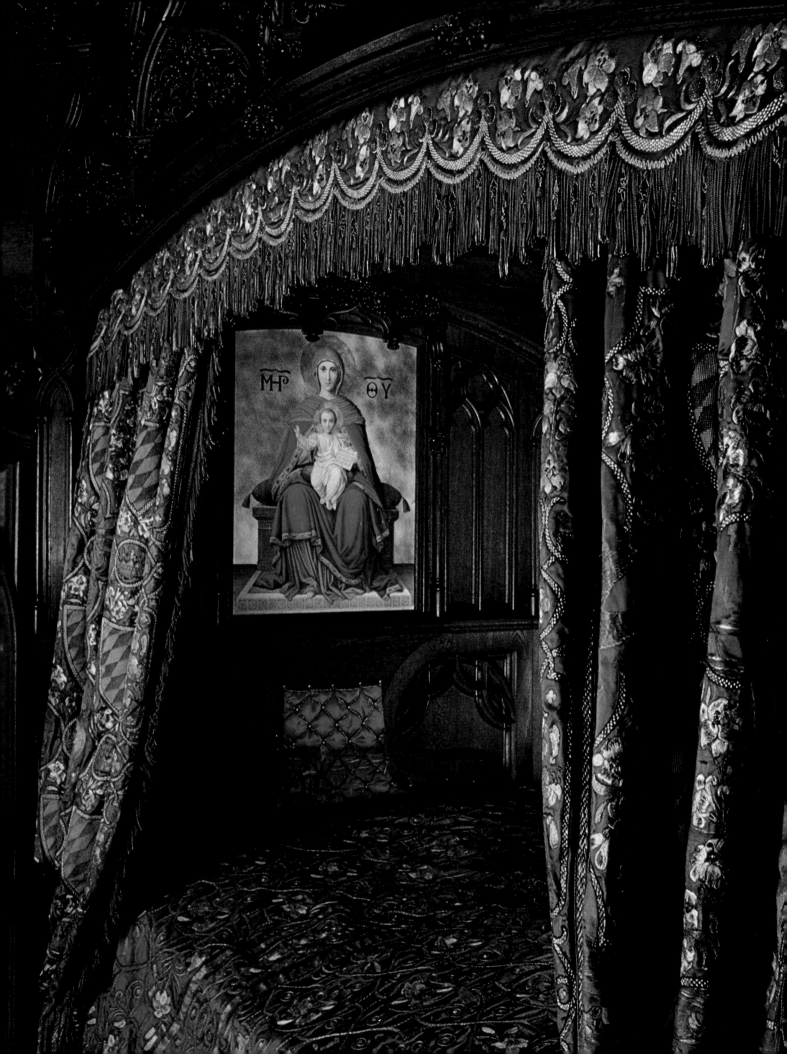

Gilded brass candelabra, above, cast a dim light over the wash-stand beside Ludwig's bed in the royal bedchamber. Water for the washbasin flowed through the neck of a silver swan and streamed out its beak, carried by natural pressure from a source high in the mountains. Heavy curtains, at left, embroidered with the Bavarian coat of arms, enclose the royal bed—a somber Gothic structure of carved walnut. Above the bed Ludwig's decorators hung a Madonna and Child, copied from an icon.

OVERLEAF: Dark oak paneling and paintings of the Tannhäuser legend enfold the king's study at Neuschwanstein. Ludwig once wrote that his greatest joy was to immerse himself in historical books, where he could find consolation from the "bitter and painful things" of the nineteenth century.

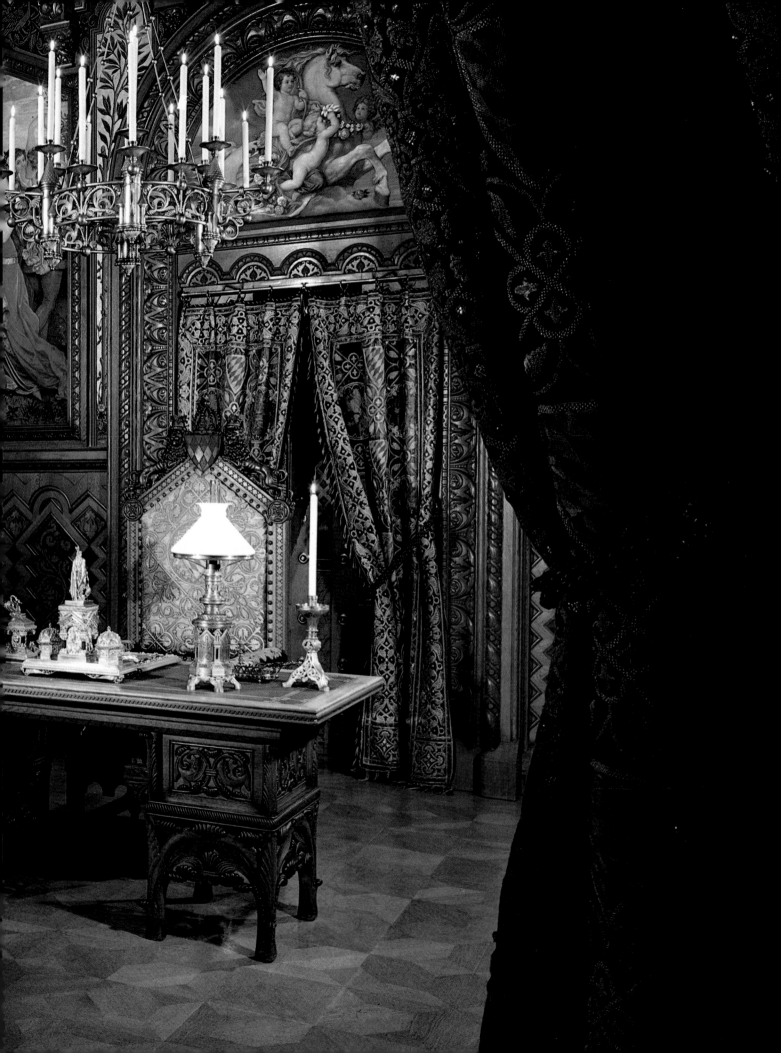

GAWANS·KAMPF·MIT·DEM·LOEWEN·
·AUF·SCHASTELMAREILE·

Over the doorway at the entrance to the so-called Singer's Hall, a carved and painted figure of a medieval astronomer holds a compass and a blue globe representing the heavens.

In a mural behind marble columns in the Singer's Hall, the knight Gawain faints from his wounds after slaying a lion—a scene from the tale of Parsifal. The Singer's Hall itself evoked an episode from the legend of Tannhäuser—a minstrel's contest in which Tannhäuser sings of his profane affair with Venus and thus breaks the heart of a maiden who loves him.

OVERLEAF: Elaborate carved and painted woodwork adorns the minstrel's gallery in the Singer's Hall. Just beyond the columns lies an enchanted forest—a stage set painted by court designer Christian Jank.

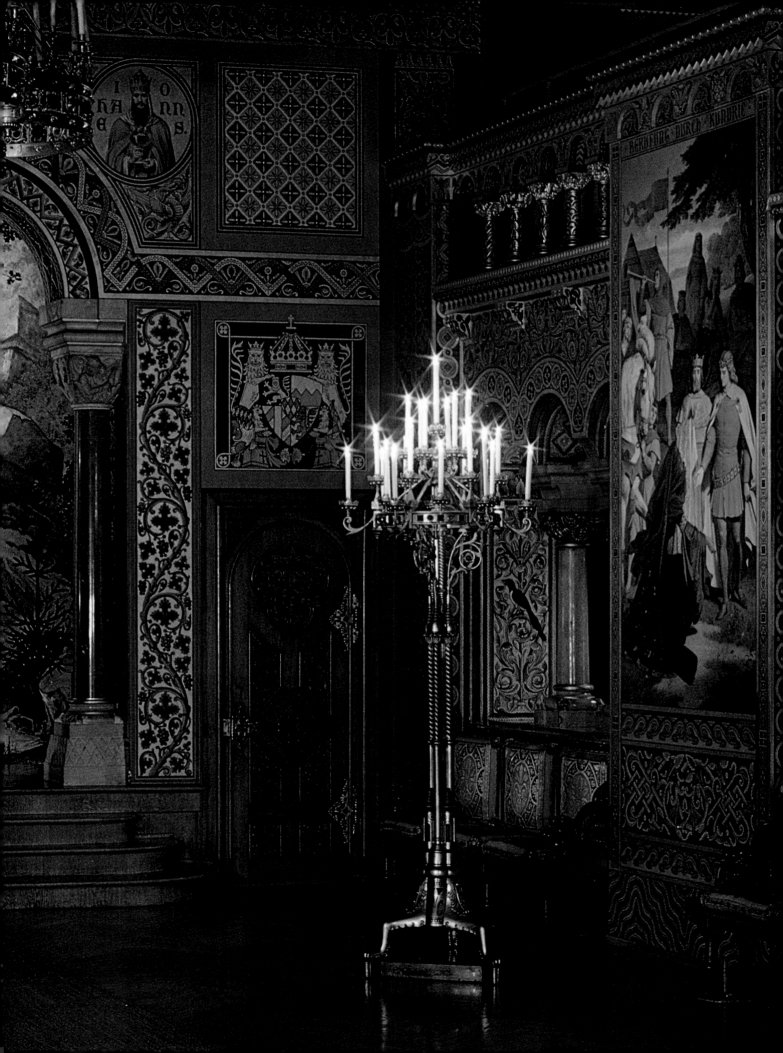

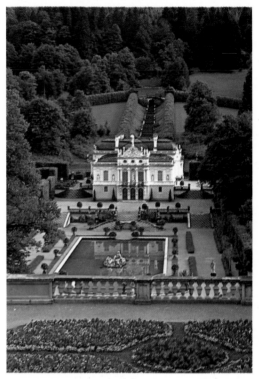

LINDERHOF

As soon as construction was underway at Neuschwanstein, Ludwig turned his attention to a new project fifteen miles to the east—Linderhof. Like most nineteenth-century monarchs who had to answer to ministers, Ludwig longed for the days when kings were answerable to no one, and he created Linderhof as a tribute to absolutism. On the terraced grounds surrounding the palace, Ludwig installed a Moorish kiosk—an oriental pavilion where he could relax in the style of a sultan—and a grotto even more elaborate than the one at Neuschwanstein. Linderhof's opulent charms made it the king's favorite residence.

Built into the hillside a few hundred yards above the palace Linderhof is the Venus Grotto, inspired by the Tannhäuser legend and partly based on a natural grotto at the island of Capri, off Italy. Ludwig liked to visit the grotto at night, feed the swans he kept there, and then step into the seashell boat, rowed by a servant, for a tour of the subterranean lake. Behind the scenes mechanical devices produced waves, rainbows, and a waterfall—modern technology in the service of Ludwig's romantic illusions.

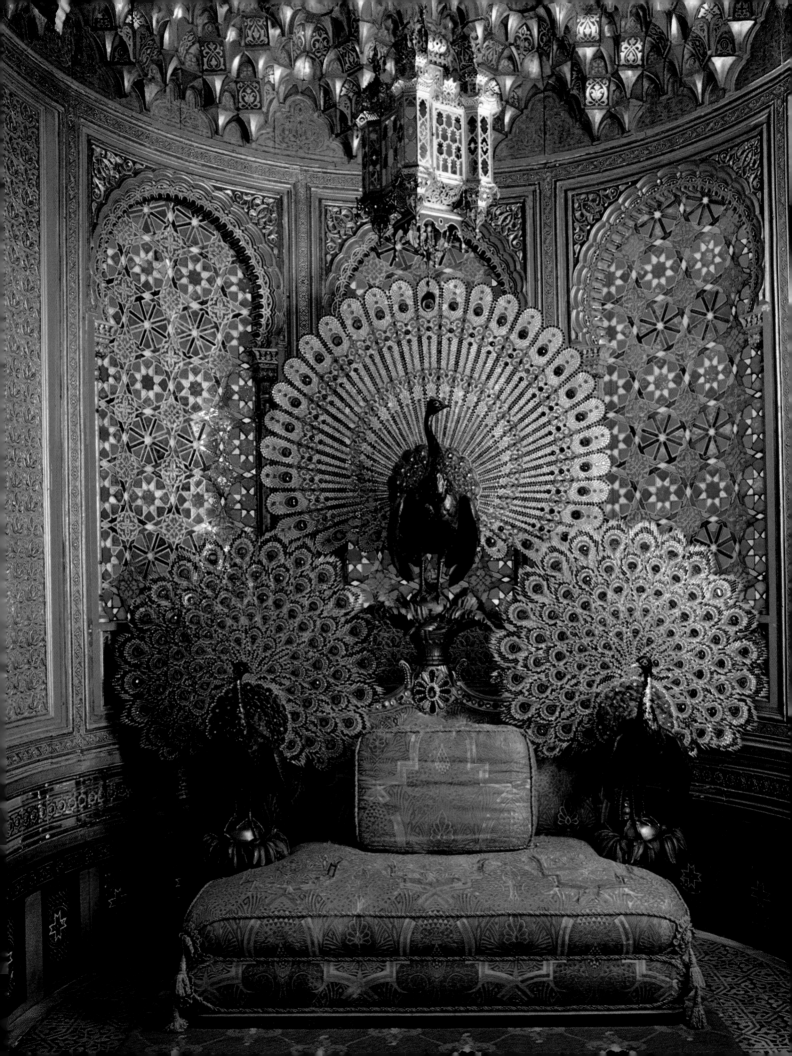

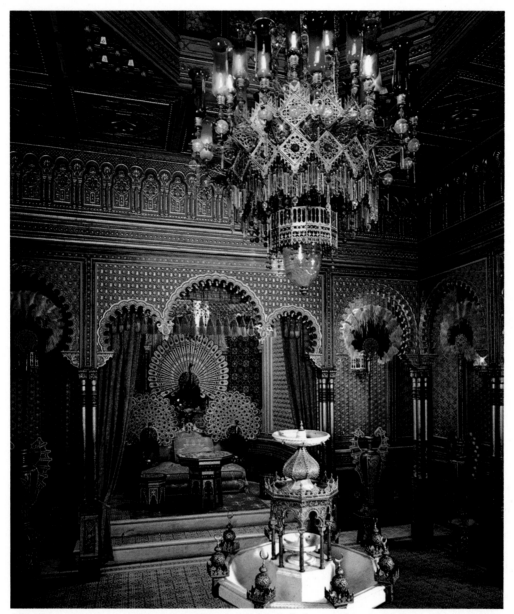

The shimmering interior of the Moorish Kiosk at Linderhof, above, reflects Ludwig's fascination with the Orient, another locus of exotic royal extravagance and absolutism. The central feature of the kiosk, the Peacock Throne opposite, was designed in Paris especially for him. Three magnificent enameled peacocks, their tails made of brightly polished Bohemian glass, preside over a silk-covered divan.

At Herrenchiemsee, the most extravagant of Ludwig's palaces, the king recreated the splendors of the French palace at Versailles. The location of the palace bespeaks Ludwig's yearning for isolation: he built it on an island in the middle of a lake. Of the hundreds of rooms at Versailles, Ludwig chose to reproduce the most glamorous: the great Hall of Mirrors, the Parade Bedroom, and the private quarters of Louis XV Ludwig personally reviewed the architectural plans and penned scathing notes in the margins wherever he detected inaccuracies. The king stayed in his expensive monument only once: a ten-day visit in September 1885.

HERRENCHIEMSEE

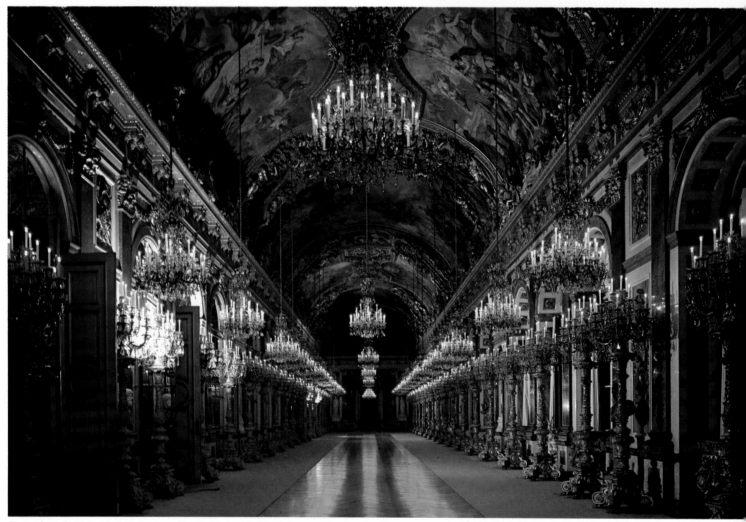

By night, almost two thousand candles light the Hall of Mirrors. During the day, mirrors intensified the light from the seventeen arched windows.

164

Ludwig's Parade Bedroom (opposite) gleams in the reflected glow of three hundred candles. Louis XIV conducted state business from the prototype for this room in Versailles. Although Ludwig never intended to use the room, he loved its symbolic importance as the ceremonial center of Herrenchiemsee and placed the order for the bed coverings a full three years before construction on the palace began.

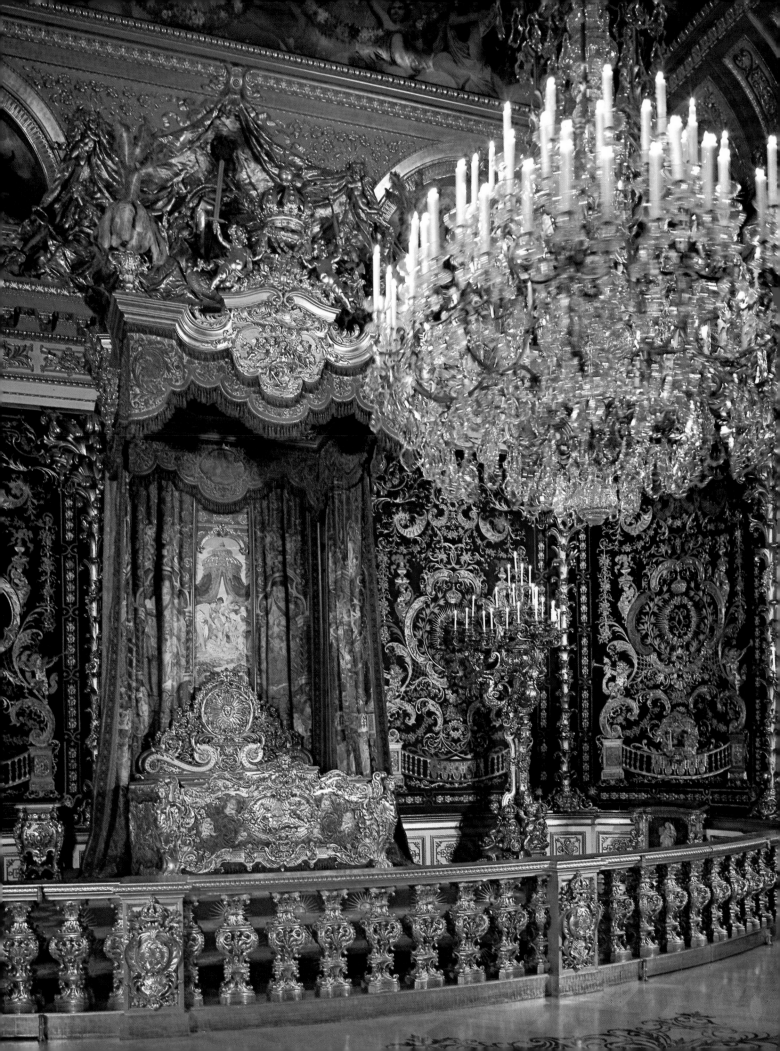

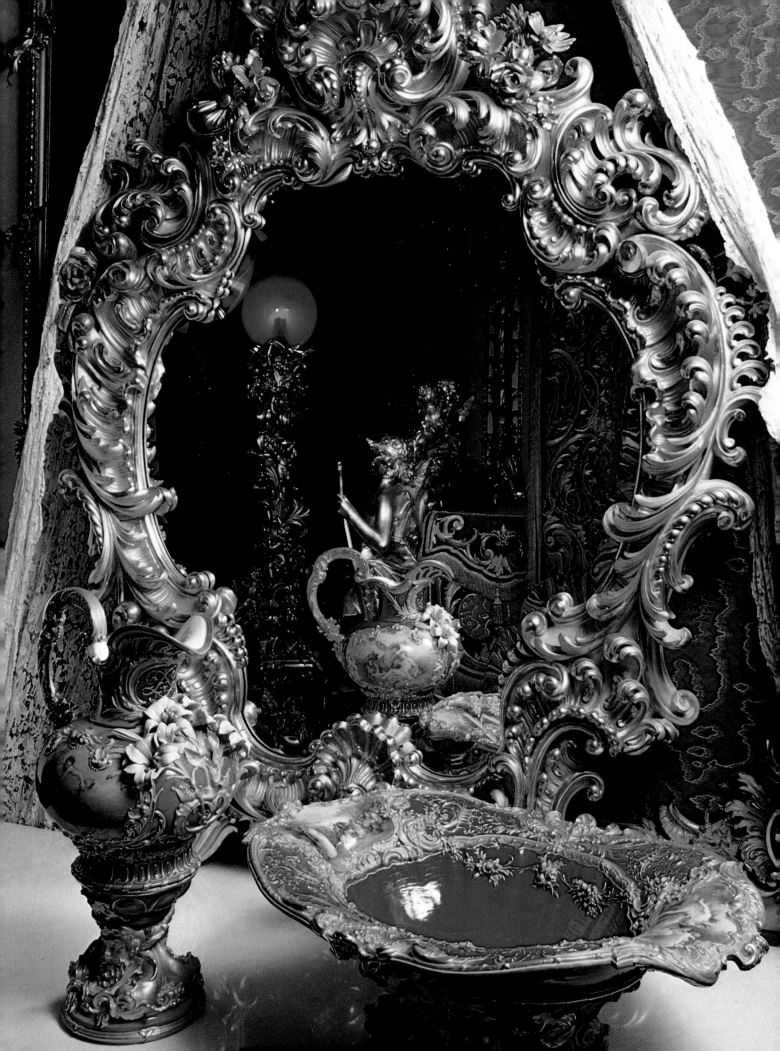

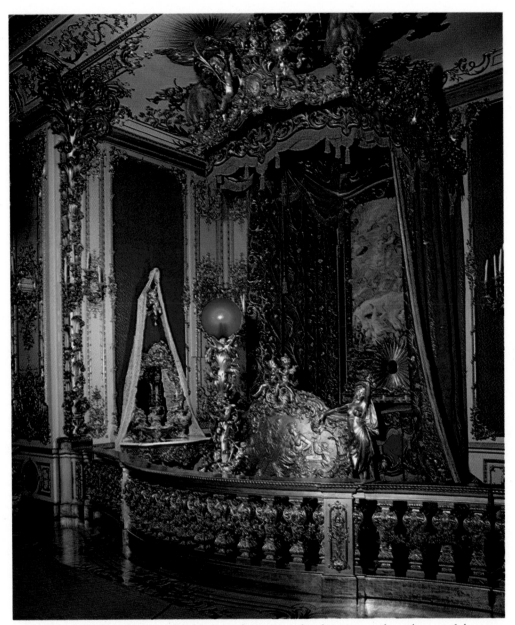

In Ludwig's private bedroom a gilded balustrade separates his sleeping area from the rest of the room, which is decorated throughout in royal blue: from the silk and velvet bed coverings to the Meissen porcelain toilet set, opposite, on the washstand. Ludwig did not collect many objets d'art—virtually every object in all of his castles was designed and made expressly for him.

OVERLEAF: *Figures of the mythical lovers Cupid and Psyche flank the ornate foot of Ludwig's bed; beside it shines his night light, an ethereal blue globe. One of the king's designers went mad in his attempts to produce the exact shade of blue that Ludwig desired.*

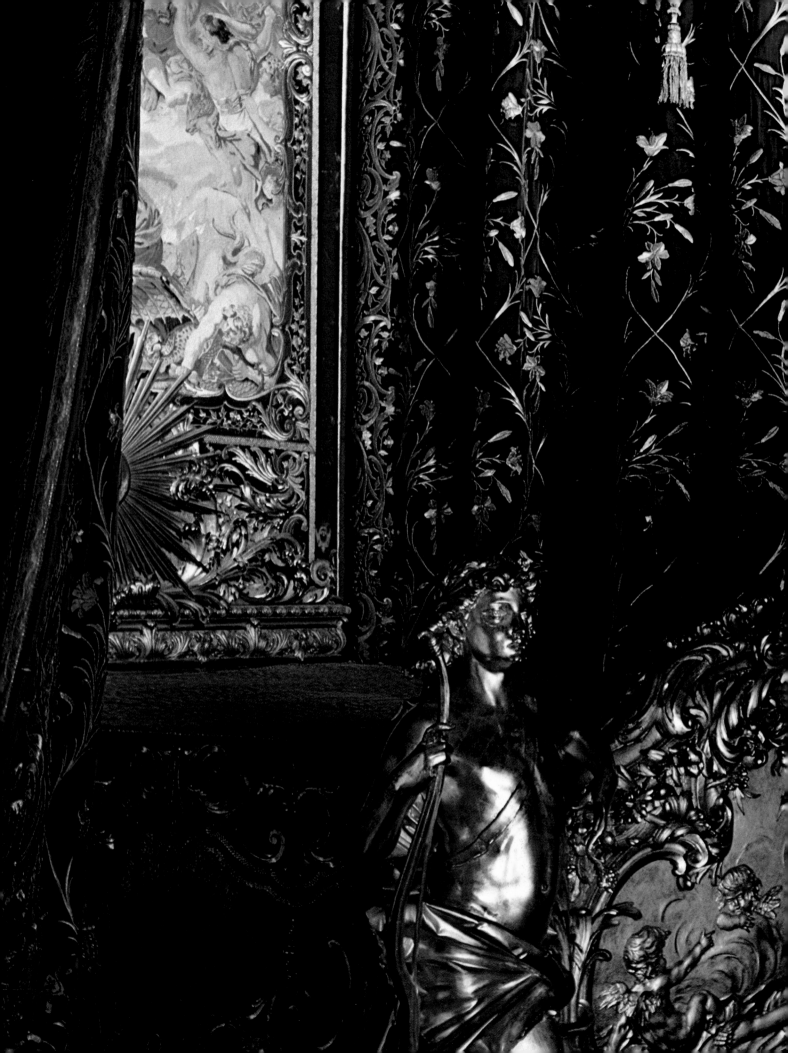

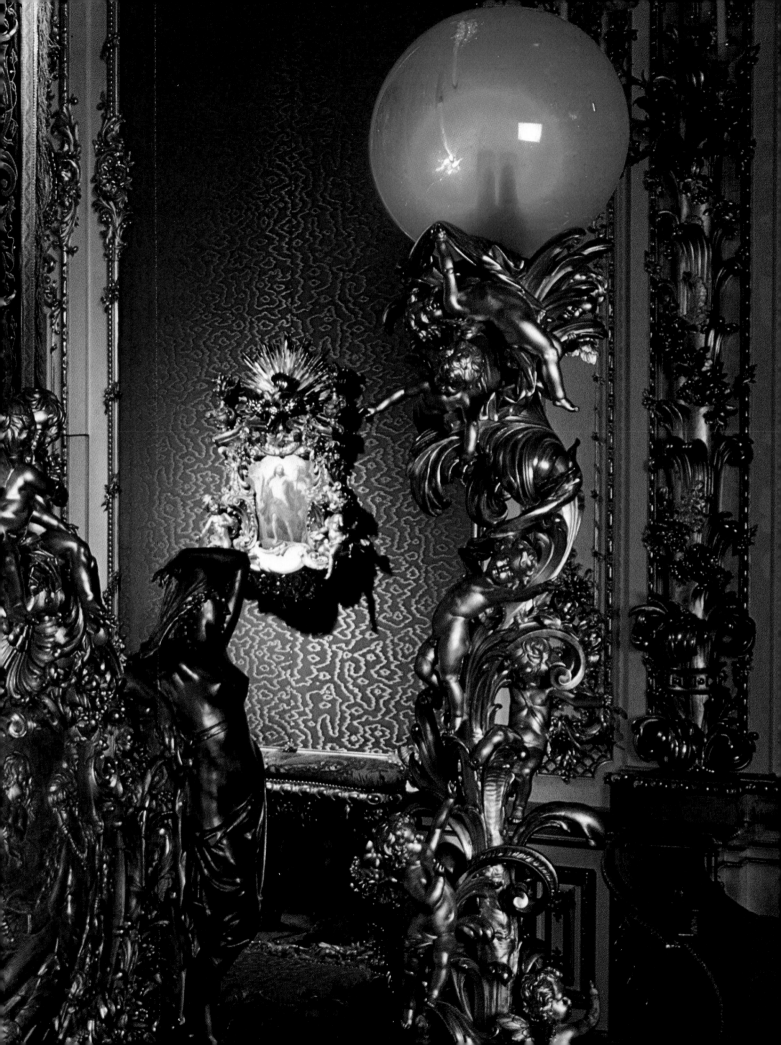

GERMANY: A CHRONOLOGY

	PEOPLE AND EVENTS		ART AND ARCHITECTURE

THE OTTONIANS AND HENRY II

r. 919–936	Henry I, the Fowler, king of Germany		
r. 936–973	Otto I, king of Germany, Holy Roman Emperor		
r. 973–983	Otto II, king of Germany, Holy Roman Emperor		
r. 996–1002	Otto III, king of Germany, Holy Roman Emperor		
r. 1002–1024	Henry II, king of Germany, Holy Roman Emperor	1002	Saxons give Henry their sacred lance Henry orders illuminated pericope
r. 1002–1024	Kunigunde, queen of Germany	1004	Henry builds cathedral at Bamberg
		1014	Henry receives gem-studded crown of Holy Roman Empire
		c. 1019	Henry builds cathedral at Basel
1146	Henry II canonized		
1200	Kunigunde canonized		

ALBERT V

r. 1550–1579	Albert V, duke of Bavaria	c. 1550	Albert's agents in Italy send sculptures, jewels, paintings, and books
		1558	Albert assembles 11,000-volume library
		1563–1567	Albert builds Kunstkammer to house his art objects
r. 1564–1576	Maximilian II, Holy Roman Emperor	1565	Albert designates items for Schatzkammer
1568	William, Albert V's son, marries Renata of Lorraine	1568	Orlando di Lasso creates music and theater for William's wedding
		1569	Albert designs Antiquarium to house his sculptures
		c. 1575	Saracchi brothers of Milan commissioned to make treasures for Albert
r. 1579–1597	William V, duke of Bavaria		
		c. 1586	William commissions reliquary of Saint George
r. 1597–1651	Maximilian I, duke of Bavaria		
1618–1648	Thirty Years' War		
1648	Peace of Westphalia ends Thirty Years' War		

AUGUSTUS II

r. 1674–1696	John III Sobieski, king of Poland		
r. 1691–1694	Johann Georg IV, elector of Saxony		
r. 1694–1733	Frederick Augustus I, elector of Saxony		
r. 1697–1704	Frederick Augustus I rules Poland as King Augustus II		
		1701	Dresden palace gutted by fire
		1701–1708	Johann Melchior Dinglinger creates the diorama Court at Delhi on the Birthday of the Mogul Emperor Aurangzeb
1702	Charles XII of Sweden defeats Augustus's army in Northern War		
		1704	Dinglinger creates statue Diana in the Bath
1706	Swedes take Polish throne from Augustus	1708	Johann Friedrich Böttger produces first pieces of European porcelain
r. 1709–1733	Augustus II regains throne of Poland		

		PEOPLE AND EVENTS		ART AND ARCHITECTURE
AUGUSTUS II (CONTINUED)			1722	Zwinger Palace completed in Dresden
			1723	Green Vault opened
			1730	Augustus's Lustlager in Zeithain
	r. 1733–1763	Augustus III, king of Poland also ruled as Frederick Augustus II, elector of Saxony		
			1743	Augustus III purchases Dresden Green, world's largest green diamond
FREDERICK THE GREAT	r. 1701–1713	Frederick I, king in Prussia		
	r. 1713–1740	Frederick William I, king in Prussia		
	1730	Crown Prince Frederick attempts escape to England with Hans Hermann von Katte— Frederick imprisoned and von Katte beheaded		
	1732	Frederick released from prison		
	1733	Frederick marries Elisabeth Christine of Brunswick		
	1740	Maria Theresa inherits lands of Hapsburgs but not title of empress	1740	Frederick writes *Anti-Macchiavel*
	1740–1786	Frederick II (Frederick the Great) king in Prussia		
	1742–1745	Frederick conquers Silesia and annexes it as part of Prussia		
			1745–1747	Frederick builds Sans Souci at Potsdam, designed by Georg Wenzeslaus von Knobelsdorff
			c. 1747	Frederick acquires French and Italian paintings for his gallery at Sans Souci Johann Sebastian Bach composes *Musical Offering* for Frederick
	1756–1763	Seven Years' War		
			c. 1760	Daniel Baudesson designs gold and precious-stone snuffboxes for Frederick Frederick commissions Prussian-made porcelain
	1772	Frederick adds West Prussia to his Prussia and Silesia		
LUDWIG II	r. 1848–1864	Maximilian II, king of Bavaria		
			1861	Ludwig sees *Lohengrin*, his first music drama of Richard Wagner
	r. 1864–1886	Ludwig II, king of Bavaria		
			c. 1865	Ludwig begins patronizing Wagner
	1866	Austro-Prussian War		
			1867	Ludwig converts Munich palace roof into Winter Garden
			1869	Ludwig begins Neuschwanstein and Linderhof castles
	1871	Otto von Bismarck, chancellor of Prussia, unites German states William I, king of Prussia, crowned emperor of united Germany		
			1872	Ludwig has Festspielhaus built at Bayreuth for Wagner music dramas Ludwig views opera and theater in his Separatvorstellungen
			1878	Ludwig begins Herrenchiemsee castle
	r. 1886–1912	Luitpold, prince regent of Bavaria		

ACKNOWLEDGMENTS & CREDITS

Abbreviations:
SM—Steven Mays, N.Y., with kind permission of Baye-
rische Verwaltung der Staatlichen Schlösser, Gärten
und Seen, Munich
CH—Claus Hansmann, Stockdorf

The Editors are particularly grateful to Dee Pattee and Karen Denk, Munich, and to Brigitte Rückreigel, Bonn, for their extensive research and coordination; to Steven Mays for special photography; and to Lufthansa German Airlines.

The Editors would also like to thank the following for their assistance: Inge Kügle and the staff of Schloss Neuschwanstein, Neuschwanstein, West Germany; Pearl Lau, N.Y.; Michael and Margarete Müller, Schloss Linderhof, Linderhof, West Germany; Liselotte Renner, Handschriften Abteilung, Bayerische Staatsbibliothek, Munich; Dr. Burkard von Roda, Bayerische Schlösser Verwaltung, Munich; Willi Schmökel, Schatzkammer der Residenz, Munich; Dr. Lorenz Selig, Bayerische Schlösser Verwaltung, Munich; and the staff of the Diözesan Museum, Bamberg.

Map by H. Shaw Borst
Endsheet design by Cockerell Bindery/TALAS

Cover: SM. 2: Erich Lessing, Vienna. 4-5: CH. 6: SM. 10: Foto-Limmer, Bamberg. 12-13: Staatsbibliothek, Bremen. 14-17: Bayerische Staatsbibliothek, Munich. 18-19: Foto-Limmer, Bamberg. 20-21: Emil Bauer, Bamberg. 23: CH. 24, 26-29: Ann Münchow, Aachen. 30-31: Foto-Limmer, Bamberg. 32-33: SM. 34-37: Giraudon. 38-39: Bayerische Schlösser Verwaltung, Munich. 40: Alte Pinakothek, Munich. 42: Bayerische Staatsbibliothek, Munich. 43: CH.

44-47: Münchner Stadtmuseum, Munich. 49-71: SM. 72, 74-75: Deutsche Fotothek, Dresden. 76: Helmut R. Schulze, Leimen-Lingental, West Germany. 77: Giraudon. 78-79: Kenneth Garrett/Woodfin Camp. 80-82: CH. 83: CH, Courtesy Royal Smeets Offset, Weert, Holland. 84-85: N.Y. Public Library Picture Collection. 86: CH. 87: Kenneth Garrett/Woodfin Camp. 88, 90-97: CH. 98: Johann Willsberger, Zurich. 99-103: CH. 104: Johann Willsberger, Zurich. 105-107: CH. 108-109: Cliche Musées Nationaux, Paris. 110: Ullstein Bilderdienst. 111: Jörg P. Anders, Schloss Charlottenburg, Berlin. 112: Mansell Collection. 113: Ullstein Bilderdienst. 114: John Freeman, London. 116-117: Erich Lessing, Vienna. 119: Cliche Musées Nationaux, Paris. 120-127: Jörg P. Anders, Schloss Charlottenburg, Berlin. 128: Roger Guillemot/Edimedia—Connaissance des Arts. 129-131: Metropolitan Museum of Art, Robert Lehman Collection, 1975. 132: Bayerische Schlösser Verwaltung, Munich. 134: Werner Neumeister, Munich. 135: Erich Lessing, Vienna. 136: RWG/NA. 137: Bayerische Staatsoper, Munich. 138-141: SM. 142-143: Werner Neumeister/Robert Harding. 144-145: SM. 146-147: Interfoto Friedrich Rauch, Munich. 148: Werner Neumeister, Munich. 149: SM. 150: Alan Clifton/Black Star. 151-153: SM. 154-155: Werner Neumeister/Robert Harding. 156-159: SM. 160: Kim Hart/Black Star. 160-161: Werner Neumeister, Munich. 162-163: SM. 164(top): Alan Clifton/Black Star. 164(bottom)-165: Werner Neumeister, Munich. 166-169: SM.

SUGGESTED READINGS

Arnold, Janet et al., Princely Magnificence, Court Jewels of the Renaissance, 1500-1630. Debrett's Peerage Ltd. in association with the Victoria and Albert Museum, 1980.

Beckwith, John, Early Medieval Art: Carolingian, Ottonian, Romanesque. Oxford University Press, 1964.

Blunt, Wilfred, The Dream King, Ludwig II of Bavaria. Penguin Books, 1978.

Heer, Friedrich, Holy Roman Empire. Frederick A. Praeger, 1968.

Maurois, André, An Illustrated History of Germany. Viking Press, 1966.

Menzhausen, Joachim, The Green Vaults. Edition Leipzig, 1968.

Menzhausen, Joachim, ed., The Splendor of Dresden: Five Centuries of Art Collecting. The Metropolitan Museum of Art, 1978.

Ritter, Gerhard, Frederick the Great. University of California Press, 1968.

Steingraber, Erich, Royal Treasures. Macmillan, 1968.

INDEX

Page numbers in **boldface type** refer to illustrations and captions.